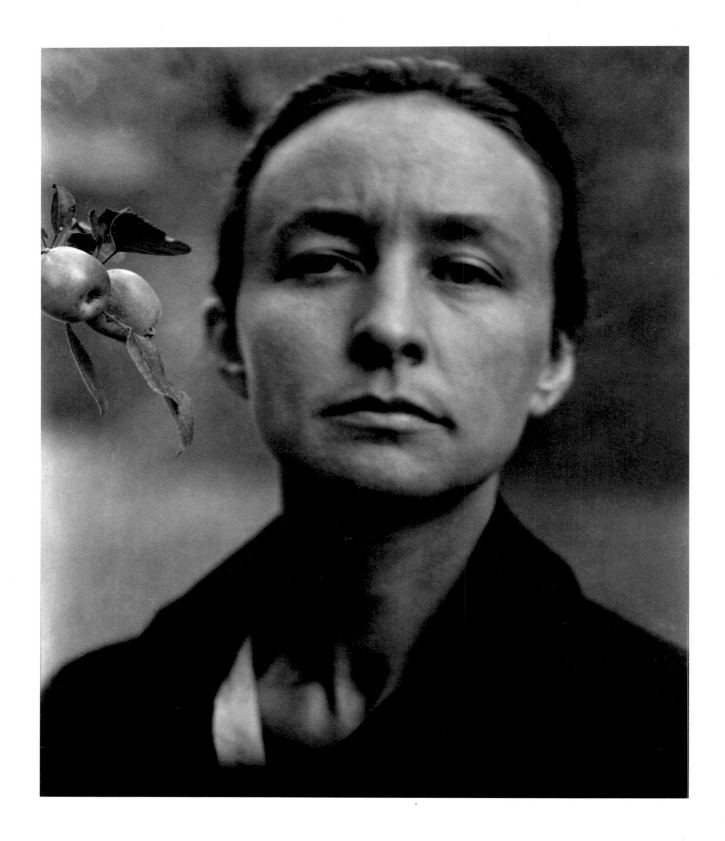

Charles C. Eldredge

GEORGIA O'KEEFFE

AMERICAN AND MODERN

Yale University Press, New Haven and London

In association with InterCultura, Fort Worth

The Georgia O'Keeffe Foundation, Abiquiu

THE NATIONAL GALLERY OF ART and the Geor-
gia O'Keeffe Foundation have begun production of
the Georgia O'Keeffe catalogue raisonné. This multi-
volume publication will illustrate and document
O'Keeffe's oeuvre. The author, Barbara Buhler
Lynes, is seeking unpublished works by O'Keeffe as
well as any information – particularly correspon-
dence and photographs – relevant to them or to pub-
lished works. Please contact the Georgia O'Keeffe
Foundation with any such information on known or
lost works.

Frontispiece: *Georgia O'Keeffe: A Portrait – Head,*
about 1920–1922. Alfred Stieglitz. National Gallery
of Art, Alfred Stieglitz Collection.

Designed by Eleanor Caponigro
Edited by Fronia W. Simpson and Robin Jacobson
Set in Bembo with Syntax by Finn Typographic
Duotone film by Robert Hennessey
Printed in Italy by Amilcare Pizzi s.p.a., Milan

FIRST EDITION

Library of Congress Catalogue Card Number 93-60148
A catalogue record for this book is available from The British Library.

ISBN 0 300 05576 5 hardback
ISBN 0 300 05581 1 paperback

GEORGIA O'KEEFFE: AMERICAN AND MODERN

EXHIBITION ITINERARY AND CREDITS

Hayward Gallery, London
April 8, 1993 – June 27, 1993

El Museo del Palacio de Bellas Artes, Mexico City
July 15, 1993 – October 1, 1993

Yokohama Museum of Art, Yokohama
October 30, 1993 – January 16, 1994

THIS EXHIBITION has been organized by InterCultura, Fort Worth, Texas, in association with the Georgia O'Keeffe Foundation, Abiquiu, New Mexico. Additional assistance has been provided by the Dallas Museum of Art, Dallas, Texas; the National Gallery of Art, Washington, D.C.; and the United States Information Agency, Washington, D.C.

The presentation of this exhibition in London has been made possible owing to the expert organizational assistance of the South Bank Centre, London, and the sponsorship of American Airlines.

In Mexico City, El Instituto Nacional de Bellas Artes and El Museo del Palacio de Bellas Artes have kindly provided organizational assistance. El Instituto Nacional de Bellas Artes and the Enron Corporation, Houston, Texas, have graciously supplied the funds needed to make the exhibition possible in Mexico.

The Yomiuri Shimbun of Japan and the City of Yokohama have provided constant organizational and financial assistance for the exhibition in Yokohama. The staff of the Yokohama Museum of Art have kindly given assistance and advice in making the exhibition a success in Japan.

All of the organizers and supporters in the United States, Great Britain, Mexico, and Japan have been essential in making the international tour of "Georgia O'Keeffe: American and Modern" a success. It is only through the effort, time, and financial support of these many devoted partners that this project has been made possible.

CONTENTS

INTRODUCTION

Yet I feel (+ know) O'Keeffe is a very great person – a rare artist. – And American. – You'll see for yourself.

ALFRED STIEGLITZ to Duncan Phillips, 1926

WITH "Georgia O'Keeffe: American and Modern," we present the first international exhibition of one of America's foremost painters. To many visitors, the show will serve as an introduction to the artist, whose career spanned the better part of six decades. To others more familiar with her large flower abstractions and desert landscapes, the exhibition will open whole new areas for consideration. "Georgia O'Keeffe: American and Modern" reveals the larger spectrum of the artist's concerns – from the startlingly inventive works on paper of the 1910s to the dynamic city pictures of the 1920s and the bold abstractions of the 1950s.

Although she had drawn and painted independently for years, Georgia O'Keeffe did not come to the attention of the American public until 1916, when a number of her charcoal drawings were exhibited at Alfred Stieglitz's "291," a small gallery in New York City. Arthur Dove, John Marin, Georgia O'Keeffe, and others championed by Stieglitz comprised the loose collective considered to be the emerging American modernists. American and modern: it is these two characteristics that Dr. Charles C. Eldredge, curator of the exhibition and author of the catalogue essay, suggests as determining impulses for Georgia O'Keeffe, and as a framework for understanding her art.

The critics of the exhibition of 1916, with some gentle and not-so-gentle prompting by Stieglitz, O'Keeffe's ardent advocate and later her husband, immediately noticed the work of this new arrival to his circle. Her drawings were considered remarkably modern particularly because of the way she investigated uncommon shapes as conduits for her most basic feelings. These same shapes stayed with O'Keeffe throughout her career; they served as elementary forms and established a vocabulary of marks to which she would often return. The public was not obliged to recognize the shapes in order to derive a feeling from them, to know their grace and their boldness. They can be found even in her landscape paintings, in the crook of a cliff or the contours of a flower.

In her earliest exhibitions, Georgia O'Keeffe must have seemed to her audience an artist who had emerged from the rural South and the remote plains of west Texas surprisingly mature in her vision and talent. However, she had not developed in isolation. Already by 1916, O'Keeffe had studied at the School of the Art Institute of Chicago, the Art Students League in New York, and Columbia University Teachers College.

The story of her initial break with formal training is legendary. Alone in her room in South Carolina, she lay out her work for examination. Later, she recalled of that moment: "I can't live where I want to – I can't go where I want to – I can't do what I want to. . . . I decided I was a very stupid fool not to at least paint as I wanted to. . . ."

It is easy to understand why Georgia O'Keeffe's name has come to signify an independent spirit and bold action. To many her life is a model of things American. O'Keeffe was American in her choice of subjects and in her profound regard for all aspects of national culture, from the vastness of the West to the heights of New York City. She rooted her ideology in the barns, the sky, the trees of the land, and also in the skyscrapers and the bridges of urban America – thus documenting the nation and evoking from its details her own, modern vision. The clarity and focus of her art is evident in the earliest charcoals and watercolors and equally in the powerful late abstractions, which distill the essence of a winter road or the subtle veil of the sky.

O'Keeffe may have been one of the most photographed artists of our time. Not only was she the subject of Alfred Stieglitz's extended portrait, which spanned nearly twenty years, she was a model for others as well, Ansel Adams, Laura Gilpin, Yousuf Karsh, Arnold Newman, Eliot Porter, Andy Warhol, and Todd Webb, to name a few. In many of their pictures, she is portrayed as alone and aloof. Whether or not she intended it, they served to reinforce her image as a person apart.

Though it is true that O'Keeffe valued her privacy and thrived in her solitude, she was considered by her close friends to be a spirited companion, a witty conversationlist, and someone full of spontaneous fun. She was not always the desert recluse she is often portrayed to be. Rather, in New York and at Lake George, she was an integral part of the Stieglitz circle, which included writers and critics such as Sherwood Anderson, Waldo Frank, Lewis Mumford, and Paul Rosenfeld; and painters Arthur Dove, Marsden Hartley, and John Marin. During her early years in New Mexico, O'Keeffe lived in the active social and artistic circle of Mabel Dodge Luhan.

Late in her life, O'Keeffe traveled widely and often. In addition, her letters, which are now housed in the Alfred Stieglitz – Georgia O'Keeffe Archive of the Beinecke Rare Book and Manuscript Collection at Yale University, reveal the artist to have been an active and thoughtful correspondent, gracing those privileged to call her a friend with her beautiful hand and vivid prose. The illustrated chronology in this catalogue depicts many aspects of his complex woman, and the presentation of both formal photographs from libraries and personal snapshots from the artist's own scrapbooks, many never before published, may help to dispel some of the worn myths concerning O'Keeffe.

Though a recent spate of biographies, some more fanciful than others, have brought the artist's life to the public's attention, the work of Georgia O'Keeffe, her strength as a painter, is what we recognize here. Surely she would have wanted that, above all, to be her legacy. We are honored to present "Georgia O'Keeffe: American and Modern" to audiences internationally. Her art does not represent an age gone by, but rather, the brilliance

of an American painter whose intuitions remain as provocative today as they were when her work was exhibited by Alfred Stieglitz on the walls of 291.

ELIZABETH GLASSMAN
President
The Georgia O'Keeffe Foundation

RAYMOND B. KELLY, III
Chairman, Board of Trustees
InterCultura, Inc.

ACKNOWLEDGMENTS

THE REALIZATION of an idea for an exhibition into the reality that is now "Georgia O'Keeffe: American and Modern" comes from the efforts and assistance of a great number of people. The three-country tour and the catalogue, which is published in English and Japanese, have come to fruition because of contributions from people who desired to see O'Keeffe's work presented to an international audience. In gratitude, the organizers would like to acknowledge the participation of the following:

In the United States, we would like to thank Dr. Charles C. Eldredge for his curatorial guidance in the selection of objects and for his scholarly essay; Elizabeth Glassman, President of the Georgia O'Keeffe Foundation, for her guidance and support; Richard Brettell, Consulting Director of the Hamon Building, Dallas Museum of Art, and Trustee of the Georgia O'Keeffe Foundation, for his assistance in securing loans and providing new insights into O'Keeffe's work; J. Carter Brown, formerly Director of the National Gallery of Art, for his help in securing loans; Eleanor Jones-Harvey, Curator of American Art at the Dallas Museum of Art, for suggestions regarding the catalogue and the selection of objects; and Juan Hamilton, Raymond K. Krueger, and June O'Keeffe Sebring, Trustees of the Georgia O'Keeffe Foundation, who, in addition to Richard Brettell and Charles C. Eldredge, provided continuous support for the project.

As well, we thank the staff members of the organizing institutions in the United States: Lori Al-Aqqad, Melanie Benjamin, Margaret Booher, Sherri MacNelly, Marcus Sloan, Gordon Dee Smith, and Sarah Voelker at InterCultura; Agapita Judy Lopez and Melanie Crowley at the Georgia O'Keeffe Foundation; Barbara Bernard, Ruth E. Fine, Sarah Greenough, Jay Krueger, Ann Robertson, Sarah Sanders-Buell, Julia Thompson, and the Visual Services Department at the National Gallery of Art, Washington, D.C.; and Susan Stirn and her staff at Arts America, a program of the United States Information Agency.

For their participation and involvement in presenting the exhibition in London, we wish to thank Andrew Dempsey, Greg Hilty, Lynne Richards, Tania Butler, Jeff Watson, and the staff of the South Bank Centre, London; and American Airlines for their sponsorship.

In Mexico, we would like to thank Gerardo Estrada and Ignacio Toscano of El Instituto Nacional de Bellas Artes; Miriam Molina, Director, El Museo del Palacio del Bellas Artes, Mexico City, and her staff; Bertha Cea and John Dwyer of the United States Information Service, United States Embassy, Mexico City; Rafael Tovar y de Teresa, Jaime Garcia Amaral, and Miriam Kaiser of El Consejo Nacional para la Cultura y las Artes, Mexico City, for their efforts in presenting the exhibition; and Enron Corporation, Houston, Texas, and El Instituto Nacional de Bellas Artes, Mexico City, for their kind and generous support.

For the presentation of the exhibition in Japan, we thank Heihachiro Tsuruta, Director; Atsushi Takeda, Chief Curator; Yuzo Otsuka, Kiyoko Sawatari, Sae Hayashi, and Shino Kuraishi, curators; and the staff of the Yokohama Museum of Art; and the staff of the Yomiuri Shimbun, Tokyo and New York, for their generous sponsorship and organizational assistance.

For her talent and skill in the production of the catalogue, we want to thank Eleanor Caponigro (who collaborated with O'Keeffe on other projects before her death) for the stunning design; John Nicolls, Gillian Malpass, Ruth Sachs, and their staffs at Yale University Press, London and New Haven, for their patience and expertise in catalogue production; Fronia Simpson and Robin Jacobson for their editing of the catalogue text; Malcolm Varon for his assistance with photography; and Barbara Buhler Lynes, author of the forthcoming catalogue raisonné, for her review of the titles of objects.

We especially appreciate the private collectors and other anonymous lenders who provided works from their homes and collections to the exhibition. Without their generosity and trust, this exhibition would not have been possible.

We sincerely thank the following institutions and individuals for helping to secure loans and for providing photographs and documentation:

Amon Carter Museum – Melissa Thompson. Archer M. Huntington Art Gallery, University of Texas at Austin – Jesse Otto Hite, Director; and Meredith D. Sutton. The Art Institute of Chicago – Jim Wood, Director; Mary Mulhern; Lieschen Potuznik; Charles Stuckey; and David Travis. The Beinecke Rare Book and Manuscript Library, Yale University – Patricia C. Willis and Lori Misura. Birmingham Museum of Art – Douglas Hyland, Director; Donna Antoon; Gail Trechsel; and John Wetenhall. The Brooklyn Museum of Art – Robert Buck, Director; Barbara Gallati; and Kathleen Flynn. The Carl Van Vechten Gallery of Fine Arts, Fisk University Museum of Art – Kevin Grogan. The Cleveland Museum of Art – Evan Turner, Director; Delbert Gutridge; and Tom Hinson. Colorado Springs Fine Arts Center – Kathy Reynolds. The Corcoran Gallery of Art – David Levy, Director; William Bodine; Jack Cowart; and Julie Solz. The Crispo Collection – Andrew Crispo. Dallas Museum of Art – Susan Barnes, Deputy Director; Kim Bush; Diane Flowers; Rick Floyd; and Liza Skaggs. Frederick R. Weisman Art Museum, University of Minnesota, Minneapolis – Lyndel King, Karen Duncan, and Shawn Spurgin. The Gerald Peters Gallery – Gerald P. Peters, Director; Jackie Chavez-Cunningham; Megan Fox; Sara Garcia; Katherine Hathaway; and Baird Ryan. The Gund Collection – Sara Miller. Hirshhorn Museum and Sculpture Garden, Smithsonian Institution – James Demetrion, Director; Mary O'Neill; and Douglas Robinson. Honolulu Academy of Arts – George Ellis, Director; and Jennifer Saville. Ira Spanierman Gallery – David Henry, Director; and Ellen Kutz. The Landau Center – Emily Fisher Landau, Judith Calamandrei, and Bill Katz. M. H. de Young Memorial Museum, The Fine Arts Museums of San Francisco – Harry Parker, Director; Mary Haas; Steven Nash; and

Marc Simpson. The Menil Collection – Paul Winkler, Director; and Nancy Swallow. The Metropolitan Museum of Art – Phillipe de Montebello, Director; Ida Balboul; William Lieberman; Marceline McKee; Lisa Messinger; Alleyn Miller; and Herb Moscowitz. Milwaukee Art Museum – Russell Bowman, Director; and Leigh Albritton. The Minneapolis Institute of Arts – Evan Maurer, director; Tina Anderson; Tom Hinson; Cathy Ricciardelli; and Peggy Tolbert. Munson-Williams-Proctor Institute Museum of Art – Paul Schweizer, Director; and Patricia Serafini. Museum of Fine Arts, Boston – Linda Thomas. Museum of Fine Arts, Museum of New Mexico – David Turner, Director; Victoria Andrews; Sandra D'Emilio; Tom McCarthy; Arthur Olívas; Katie Peters; and Joan Tafoya. National Gallery of Art – Earl A. Powell III, Director; Stephanie Belt; Sarah Sanders-Buell; Ruth E. Fine; Sarah Greenough; Lisa Mariam; Carlotta Owens; Hugh Phipps; and Judith Walsh. The Newark Museum – Samuel Miller, Director; Audrey Koenig; and Karen Montalbano. Paul Strand Archive, Aperture Foundation – Anthony Montoya. Philadelphia Museum of Art – Anne d'Harnoncourt, Director; Irene Taurins; and Ann Temkin. Phoenix Art Museum – James Ballinger, Director; and Heather Northway. Reynolda House, Museum of American Art – Nicholas Bragg, Director; and Annemarie Robins. San Diego Museum of Art – Steven Brezzo, Director; David L. Kencik; and Louis Goldich. San Francisco Museum of Modern Art – John Lane, Director; Bennett Fawn; John Lane; Steven Mann; and Marla Misunas. Spencer Museum of Art, The University of Kansas, Lawrence – Andrea Norris, Director; Janet Drieling; and Midori Oka. Saint Louis Art Museum – James Burke, Director; Jeanett Fausz; and Sidney Goldstein. University Art Museum, Nelson Fine Arts Center and Matthews Center, Arizona State University – Rudy Turk, former director; and Mary Jane Williams. University Art Museum, University of New Mexico, Albuquerque – Peter Walch, Director; and Kittu Longstreth-Brown. Virginia Museum of Fine Arts – Howell Perkins. Wadsworth Atheneum – Patrick McCaughey, Director; Mary Schroeder; and Martha Small. Walker Art Center – Kathy Halbreich, Director; and Gwen Bitz. Whitney Museum of American Art – David Ross, Director; Ellin Burke; Anita Duquette; and Barbara Haskell. Wichita Art Museum – J. Richard Gruber, Director; Henry Nelson; Barbara Odevseff; and Noveline Ross.

LENDERS TO THE EXHIBITION

Peter and Widgie Aldrich. The Art Institute of Chicago. Birmingham Museum of Art. The Brooklyn Museum of Art. The Carl Van Vechten Gallery of Fine Arts, Fisk University Museum of Art, Nashville. The Cleveland Museum of Art. The Corcoran Gallery of Art, Washington, D.C. The Crispo Collection. Dallas Museum of Art. The Fine Arts Museums of San Francisco. Frederick R. Weismann Art Museum, University of Minnesota, Minneapolis. The Georgia O'Keeffe Foundation, Abiquiu. The Gerald Peters Gallery, Santa Fe. Mr. and Mrs. Graham Gund. Hirshhorn Museum and Sculpture Garden, Smithsonian Institution, Washington, D.C. Emily Fisher Landau, New York. Edward

Lenkin and Katherine Meier. The Metropolitan Museum of Art, New York. Milwaukee Art Museum. The Minneapolis Institute of Arts. Munson–Williams–Proctor Institute Museum of Art, Utica. Museum of Fine Arts, Museum of New Mexico, Santa Fe. National Gallery of Art, Washington, D.C. The Newark Museum. Mr. and Mrs. Gerald P. Peters. Philadelphia Museum of Art. Phoenix Art Museum. Private collectors and anonymous lenders. Reynolda House, Museum of American Art, Winston–Salem. San Diego Museum of Art. San Francisco Museum of Modern Art. Spencer Museum of Art, The University of Kansas, Lawrence. Saint Louis Art Museum. Marion Boulton Stroud. University Art Museum, Nelson Fine Arts Center and Matthews Center, Arizona State University, Tempe. University Art Museum, University of New Mexico, Albuquerque. Wadsworth Atheneum, Hartford. Walker Art Center, Minneapolis. Whitney Museum of American Art, New York. Wichita Art Museum.

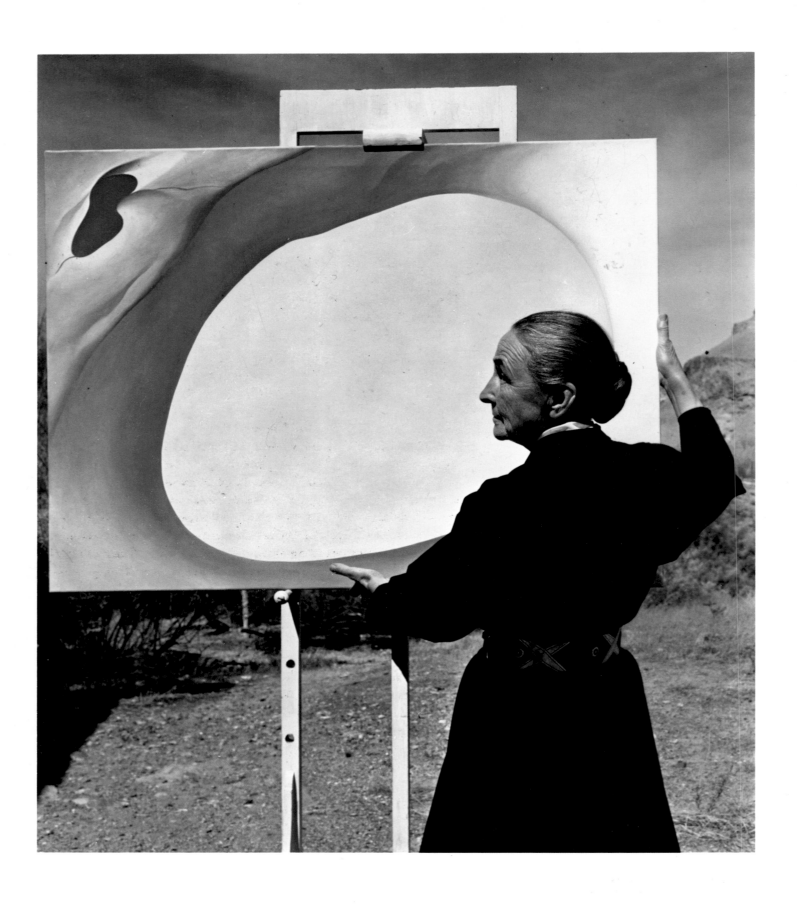

GEORGIA O'KEEFFE:

AN ILLUSTRATED CHRONOLOGY

Where I was born and where and how I have lived is unimportant. It is what I have done with where I have been that should be of interest.

GEORGIA O'KEEFFE, *Georgia O'Keeffe*

All art is a sort of hidden autobiography. The problem of the painter is to tell what he knows and feels in such a form that he still, as it were, keeps his secret. . . . Here lie precisely the attraction and the difficulty of dealing with the paintings of Georgia O'Keeffe: every painting is a chapter in her autobiography, and yet the revelation is so cunningly made that it probably eludes her own conscious appraisal.

LEWIS MUMFORD, "Autobiographies in Paint"

THE FOLLOWING is offered simply as an introduction to the artist. Georgia O'Keeffe frequently and consistently declined to explicate her work, believing that the painting should speak for itself. She had little patience with exegesis in terms of biographical detail, personality quirks, travel itineraries, and other factors extraneous to the art. Hence, this chronology attempts no interpretation of the artworks; nor does it speculate about the artist's life. Rather, as a compilation of the salient facts about both, it will, I hope, provide a basis for the appreciation of what O'Keeffe did with where she had been, and of the context in which the paintings can, and do, "speak for themselves."

1887

NOVEMBER 15: Georgia Totto O'Keeffe was born to Francis Calyxtus O'Keeffe and Ida (Totto) O'Keeffe at the family farm, approximately three miles from Sun Prairie, Wisconsin (population 704 in 1890). She was the second child and first girl in a family that ultimately included two sons and five daughters. Her childhood was spent on the family's prosperous dairy farm, which grew to 640 acres by the late 1890s.

1892

AUTUMN: O'Keeffe's education began at Town Hall School, a one-room schoolhouse on the Totto family's property. "My memories of childhood are quite pleasant," recalled O'Keeffe, "although I hated school. I left the local school when I was twelve."[1]

All photographs are silver gelatin prints unless otherwise noted.

Georgia O'Keeffe with "Pelvis Series — Red with Yellow," 1960. Tony Vaccaro. Copyright Tony Vaccaro.

The family farm, house built by Frank O'Keeffe, Sun Prairie, Wisconsin (undated).

The O'Keeffe home, Williamsburg, Virginia (undated).

1898

WINTER: O'Keeffe and two sisters began drawing instruction at home, being taught by their grammar school teacher, who was a boarder with the family; subsequently, O'Keeffe took art lessons with Sarah Mann, a Sun Prairie watercolorist.

ABOUT 1899

O'Keeffe announced to a playmate: "I am going to be an artist." Years later, she mused: "I don't really know where I got my artist idea. . . . I only know that by that time it was definitely settled in my mind."[2]

1901

AUTUMN: O'Keeffe enrolled as a boarding student at Sacred Heart Academy, near Madison, Wisconsin, and there spent "the one year I ever really learned anything."[3] At Sacred Heart she received her first formal art instruction, from Sister Angelique. One classmate recalled "how pleased her teacher was with the drawing of [a plaster cast of] hands she made," but O'Keeffe remembered only mortification at the sister's critique: "She said I had drawn the hand too small and my lines were all too black. She particularly emphasized the fact that it was too small. . . . I said to myself that I would never have that happen again. I would never, never draw anything too small."[4]

1902

The O'Keeffe family moved to Williamsburg, Virginia, having been lured by a land promoter, and by the prospect of escaping the harsh northern clime of Wisconsin and the threat of tuberculosis, which had killed Francis O'Keeffe's three brothers. Georgia and her older brother, Francis Jr., remained with an aunt in Madison, giving the young woman her first urban experience. She attended classes at Madison High School, where the art teacher used a jack-in-the-pulpit for a memorable lesson on natural form and color. O'Keeffe said that it was "the first time I remember examining a flower . . . looking very carefully at details."[5]

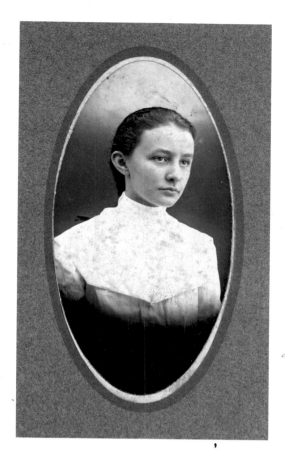

Georgia O'Keeffe, 1903.

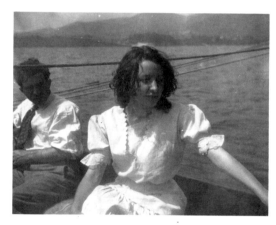

O'Keeffe on her first trip to Lake George with students of the New York Art Students League, 1908.

1903

SPRING: O'Keeffe joined her family in Williamsburg, and in the autumn enrolled as a boarding student at Chatham Episcopal Institute, Chatham, Virginia. As the sole art major in the class of 1905, she enjoyed the special attention of her art teacher (and school principal), Elizabeth May Willis, whose instruction proved inspirational. A fellow student recalled O'Keeffe's early sense of her own worth and her refusal to exchange pictures with classmates: "When I begged her for something she said, 'No,' very decidedly, and added 'I do not want any of my pictures floating around when I become famous.'"[6]

1905

O'Keeffe illustrated the *Mortarboard,* the school yearbook, with pen-and-ink drawings, her first "published" artwork. AUTUMN: Encouraged by Willis, O'Keeffe pursued studies at the School of the Art Institute of Chicago, where she especially enjoyed the life drawing classes of John Vanderpoel, "one of the few real teachers I have known."[7] By the end of the school year, she had taken top honors in his class.

1906

SUMMER: In Williamsburg, O'Keeffe was stricken with typhoid and spent a long convalescence at home; this was the first in a series of illnesses and recuperations that periodically interrupted her career.

1907

SEPTEMBER: O'Keeffe enrolled at the Art Students League in New York City, where she studied with F. Luis Mora, Kenyon Cox, and most importantly, William Merritt Chase, in whose class she earned a scholarship for still life.

1908

JANUARY: O'Keeffe agreed to pose for her classmate Eugene Speicher, in the first of many such portrait sittings she granted fellow artists over the years. With other students, she visited Alfred Stieglitz's avant-garde gallery (known as "291," for its Fifth Avenue address) to view an exhibition of Auguste Rodin's controversial drawings; she often returned to see shows of other modern artists. SUMMER: O'Keeffe attended the summer school of the Art Students League at Lake George, New York; this initial visit to an area that would figure prominently in later years also provided her with her first chance to paint outdoors. AUTUMN: Francis O'Keeffe's business reversals forced his daughter to drop out of the League; she abandoned painting in order to pursue a career as a commercial artist in Chicago, drawing lace and embroidery for newspapers and designing for Little Dutch Girl cleaner what became a long-lived commercial logo.

1909

Ida O'Keeffe moved with her younger children to Charlottesville, in the western mountains of Virginia, seeking relief from tuberculosis, which she had contracted in the tidewater region.

O'Keeffe at the University of Virginia, Summer 1915.

1910

O'Keeffe left commercial work after her eyesight suffered as an effect of the measles, and joined her mother and siblings in Charlottesville.

1911

SPRING: Substituting for Elizabeth May Willis, O'Keeffe offered art classes at Chatham Episcopal Institute; this was her first teaching experience.

1912

SUMMER: Enticed by her sisters, who were in Alon Bement's art course at the University of Virginia, O'Keeffe also enrolled in classes with Bement. His advocacy of Arthur Wesley Dow's innovative design principles and educational theory revived O'Keeffe's interest in painting. She remembered: "I had stopped arting when I just happened to meet him and get a new idea that interested me enough to start me going again."[8] Bement's invitation to O'Keeffe to assist him the following summer required that she gain teaching experience in the interim. AUTUMN: She therefore began a two-year stint as the high school art teacher in Amarillo, Texas, giving her an introduction to the American West.

1913

SUMMER: O'Keeffe taught art with Bement at the University of Virginia.

O'Keeffe with her family (Ida O'Keeffe in hammock at right, the artist underneath), about 1916.

1914

SUMMER: O'Keeffe returned to the University of Virginia to teach with Bement. AUTUMN: She enrolled at Columbia University Teachers College, New York, in order to study art with Arthur Wesley Dow. Often accompanied by her Columbia classmate and new friend, Anita Pollitzer, O'Keeffe visited Stieglitz's exhibitions of Braque and Picasso, Marsden Hartley, and John Marin. At Pollitzer's urging, O'Keeffe joined the National Woman's Party, which was then militantly campaigning on behalf of woman suffrage; for many decades following the passage in 1920 of the twentieth amendment (granting women the vote), she maintained her membership in the party.

O'Keeffe in Charlottesville, Virginia, about 1913.

O'Keeffe in Texas, about 1912.

1915

FEBRUARY 4–25: O'Keeffe's painting *Scarlet Sage,* a Texas subject, was included in the annual exhibition of the American Water Color Society at the National Arts Club, New York; this was the first public showing of her work. SUMMER: She taught art with Bement at the University of Virginia. SEPTEMBER: She began a one-year assignment as the art teacher at Columbia College, Columbia, South Carolina. Although remote from New York, O'Keeffe kept abreast of developments via periodicals and a lively correspondence with Pollitzer, with whom she exchanged ideas on art and art theory (for instance, Dow, Kandinsky, contemporary critics) and current events (the nascent suffrage movement). OCTOBER: Inspired by Dow's principles, O'Keeffe discarded old mannerisms and materials, and began a new series of abstractions drawn in charcoal, personal works that she shared with her confidante Pollitzer, as a sort of private, nonverbal communication.

1916

JANUARY 1: Pollitzer showed O'Keeffe's abstract drawings to Stieglitz, who was impressed by the works and retained them for possible display at 291. O'Keeffe and Stieglitz began their correspondence, which over many years grew to exceptional volume (and is now part of the rare book and manuscript collection at Yale University, but is sealed until the year 2011). MARCH: The artist returned to New York for spring semester classes with Dow. MAY 2: O'Keeffe's mother died of tuberculosis at Charlottesville. MAY 23: O'Keeffe's charcoal drawings were exhibited at 291, without her knowledge; she confronted Stieglitz to demand the dismantling of the exhibition, but he prevailed and the show remained on view through July 5. SUMMER: O'Keeffe taught one final session with Bement in Virginia. SEPTEMBER: She returned to Texas to become head of the art department at West Texas State Normal College in Canyon; she held this position until February 1918. NOVEMBER: O'Keeffe's (preabstract) drawing of a reclining debutante decorated the contents page of *Vanity Fair,* in the earliest reproduction of her work by the popular press. Stieglitz showed O'Keeffe's work in a group exhibition at 291 which included pieces by Marsden Hartley, John Marin, Abraham Walkowitz, Stanton Macdonald-Wright, and Stieglitz's ten-year-old niece, Georgia Engelhard.

1917

APRIL 3: Stieglitz opened O'Keeffe's first solo exhibition (through May 14), which was also the finale for the 291 gallery. The show resulted in her first sale; her charcoal drawing *Train at Night in the Desert* (1916; private collection) was purchased for $400. MAY 25–JUNE 1: From Texas, O'Keeffe made an unplanned visit to New York City, where she met Paul Strand and other members of Stieglitz's circle; Stieglitz rehung the exhibition for her private inspection and photographed her for the first time, often posing O'Keeffe with her artworks. AUGUST: With her youngest sister, Claudia, who was then in her care, she vacationed and painted in Colorado, near Rocky Mountain National Park; this was her first exposure to such dramatic scenery. En route, their train was detoured through New Mexico, providing a visit of several days to Santa Fe and introducing

O'Keeffe exhibition at 291, 1917. Alfred Stieglitz.

O'Keeffe in Canyon, Texas, 1916 or 1917.

O'Keeffe to the high desert and the Sangre de Cristo Mountains. She said of the area: "I loved it immediately. From then on I was always on my way back."[9]

1918

FEBRUARY: Suffering from influenza and shunned by militarist colleagues for her pacifist attitudes, O'Keeffe left her position at Canyon in order to recuperate at the home of a friend in Waring, in southern Texas. MAY: Stieglitz, worried about the condition of his newest protégé and correspondent, dispatched his associate Paul Strand to retrieve O'Keeffe. EARLY JUNE: After several weeks of indecision and emotional turmoil in Waring and San Antonio, she was convinced to abandon Texas and accompany Strand to New York. JUNE 10: Stieglitz met O'Keeffe at the train station in New York City. JULY: Stieglitz left his wife, Emmeline (Obermeyer), whom he had married in 1893, and moved into O'Keeffe's temporary quarters, a studio apartment belonging to his niece. During this time, he began to photograph O'Keeffe regularly, producing some of the most private and erotic images in his extended, composite portrait of her, which evolved over the next fifteen years. AUGUST: O'Keeffe accepted Stieglitz's offer of financial support and formally resigned from West Texas State Normal College in order to pursue painting in New York. LATE SUMMER: She accompanied Stieglitz to his family's vacation home at Lake George, where she met many of the clan for the first time. NOVEMBER 6: O'Keeffe's father died in Petersburg, Virginia, but the news did not reach her immediately. NOVEMBER 11: The armistice ended World War I; she learned of her father's death, writing: "Everything is very uncertain today. Papa is dead – . . . and as if to make things more queer – . . . the town is yelling and screaming and ringing and whistling over the Peace news – . . . Ive just wondered if a day could be much worse. . . ."[10]

O'Keeffe in Estes Park, Colorado, 1917.

Georgia O'Keeffe: A Portrait, 1918. Alfred Stieglitz.
National Gallery of Art, Alfred Stieglitz Collection.

1918 – 1929

Following a rigorous period of work in charcoal, O'Keeffe's interest in oil painting was rekindled, leading to colorful abstractions – some inspired by music – still lifes, and city- and landscapes. She annually joined Stieglitz's seasonal orbit between Manhattan and Lake George, drawing inspiration from each locale. At Lake George, the couple was often joined by like-minded artists and writers, especially during the productive autumn seasons after Stieglitz family members had departed.

1920

SPRING: O'Keeffe journeyed to York Beach, Maine, in the first of several such solo visits and the start of a pattern of travels separate from Stieglitz. AUGUST: At Lake George, she refurbished a weathered shed ("The Shanty") as a studio for herself and Stieglitz; soon, however, it became her domain alone. DECEMBER: O'Keeffe and Stieglitz moved to quarters in his brother's Manhattan home, where they lived until 1924.

1921

FEBRUARY: Stieglitz's portraits of O'Keeffe, some of them very intimate, were publicly exhibited for the first time at Anderson Galleries, New York, exciting the interest of many viewers. Marsden Hartley published the collection *Adventures in the Arts,* which included an appreciation of O'Keeffe tinged with sexual innuendo, establishing the tone for many of the Freudian interpretations that followed.

1922

O'Keeffe designed the distinctive typographic logo for *MSS.,* a little magazine published by several of Stieglitz's associates. OCTOBER: Paul Rosenfeld's article on O'Keeffe's paintings was published in *Vanity Fair,* bringing her new work to the attention of a wider and very fashionable audience. DECEMBER: She contributed an autobiographical statement to a special issue of *MSS.* devoted to the question: "Can a photograph have the significance of art?"

Georgia O'Keeffe: A Portrait – With Painting, probably 1922. Alfred Stieglitz. National Gallery of Art, Alfred Stieglitz Collection.

1923

JANUARY 29–FEBRUARY 10: Stieglitz presented a major exhibition of O'Keeffe's work, her first solo show in six years, at Anderson Galleries. APRIL 2: An exhibition of 116 new Stieglitz photographs, including numerous portraits of O'Keeffe, opened at the same venue (running through April 16).

1924

MARCH: Exhibitions by O'Keeffe (fifty-one paintings) and Stieglitz (sixty-one photographs) were simultaneously staged at Anderson Galleries, securing the painter's celebrity. O'Keeffe began her distinctive large floral paintings, as well as still lifes of enlarged leaves. SEPTEMBER 9: Stieglitz was granted a divorce from his wife. NOVEMBER: O'Keeffe and Stieglitz moved into the first apartment of their own. DECEMBER 11: They were married before a justice of the peace in Cliffside Park, New Jersey, with the painter John Marin serving as witness.

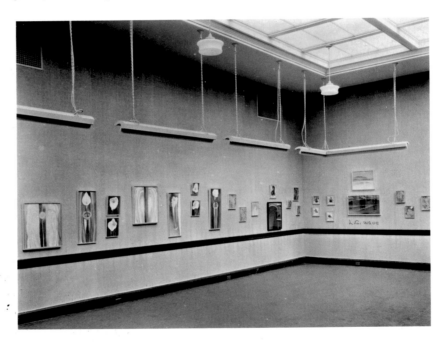

O'Keeffe exhibition at the Anderson Galleries, 1924. Alfred Stieglitz.

1925

O'Keeffe painted her first urban subject, *New York with Moon* (Thyssen-Bornemisza collection, Lugano). MARCH 9: At Anderson Galleries, Stieglitz opened his "Seven Americans" exhibition, which included O'Keeffe (thirty-one works) along with Marin, Hartley, Dove, Demuth, Strand, and the curator himself; the show generated considerable acclaim for O'Keeffe's giant flowers, which were shown there for the first time. NOVEMBER: O'Keeffe and Stieglitz moved to an apartment high in the new Shelton Hotel on Lexington Avenue; there she began her first paintings of Manhattan skyscrapers. DECEMBER: Stieglitz opened a new display space, the Intimate Gallery at 489 Park Avenue, in the same building that housed the Anderson Galleries; O'Keeffe generally supervised all exhibition installations in the new gallery, including the annual presentations of her own work.

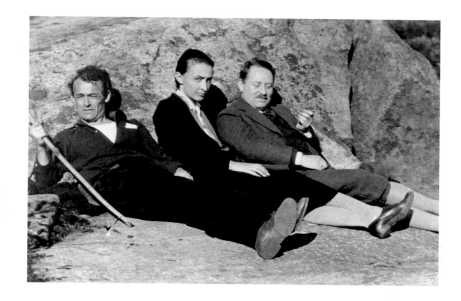

Emile Zoler, Georgia O'Keeffe, Paul Rosenfeld, early 1920s. Alfred Stieglitz. Private collection.

1926

FEBRUARY: At the invitation of Anita Pollitzer, O'Keeffe addressed the convention of the National Woman's Party in Washington, D.C. **MARCH 4**: Constantin Brancusi praised O'Keeffe's exhibition of new paintings at the Intimate Gallery (February 11–April 3): "There is no imitation of Europe here; it is a force, a liberating free force."[11] **SPRING**: The artist completed her first bird's-eye views (pastels and paintings) of the East River and the distant industrial boroughs of New York. **SEPTEMBER**: O'Keeffe traveled to York Beach, Maine, where she worked alone, producing a group of paintings and pastels based on clamshells.

1927

JANUARY 11–FEBRUARY: O'Keeffe presented her annual exhibition at the Intimate Gallery. **JUNE 1–SEPTEMBER 1**: The Brooklyn Museum presented O'Keeffe's first museum exhibition, a small retrospective of her work (no catalogue). **JULY**: O'Keeffe underwent surgery for removal of a (benign) breast tumor; the recollection of anesthesia and operating room inspired a unique composition, *Black Abstraction* (The Metropolitan Museum of Art, New York). **DECEMBER 16, 1927–JANUARY 12, 1928**: A group exhibition organized and selected by O'Keeffe was presented at the Opportunity Gallery in New York, apparently as a favor to its director, Alon Bement, her early mentor; the show was notable for its inclusion of women artists, who had created more than two-thirds of the paintings selected. **DECEMBER**: O'Keeffe was again hospitalized for breast surgery; her recovery from the second operation was slow.

1928

JANUARY 11–FEBRUARY 27: O'Keeffe's annual exhibition at the Intimate Gallery included numerous fruit and floral still lifes. **APRIL**: The New York and national art press gave extensive publicity to the reputed sale of six O'Keeffe paintings of calla lilies for the record price of $25,000. (Much later, the sale was shown to have been a fabricated publicity ploy.) **MAY**: Six of her calla pictures were presented in a special "private"

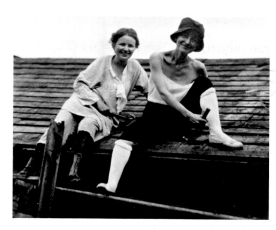

Elizabeth Stieglitz Davidson and Georgia O'Keeffe on Roof, 1920s. Alfred Stieglitz. Courtesy of Zabriskie Gallery, New York.

Georgia O'Keeffe: A Portrait, 1933. Alfred Stieglitz.
National Gallery of Art, Alfred Stieglitz Collection.

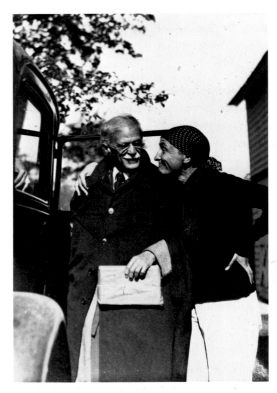

*Stieglitz and O'Keeffe at the door of Georgia's Model A
Ford*, 1932. Courtesy of the Beinecke Rare Book and
Manuscript Library, Collection of American
Literature, Yale University, New Haven.

showing before reportedly being shipped to their new owner in Paris. Shortly after the annual move to Lake George, O'Keeffe traveled alone to Maine for two weeks. JULY: She traveled to Wisconsin to visit her family and childhood home, thereby escaping both Stieglitz and the attention of the media. AUGUST: O'Keeffe returned to Stieglitz at Lake George. SEPTEMBER: He suffered his first serious heart attack.

1929

APRIL–AUGUST: O'Keeffe broke the Manhattan–Lake George orbit by visiting Taos, New Mexico, with Rebecca Strand (the wife of Paul Strand), as the guest of Mabel Dodge Luhan, the socialite, author, and arts advocate. O'Keeffe largely shunned the local art colony but was captivated by the desert landscape, beginning her pattern of summers spent painting in the Southwest. JUNE: Stieglitz closed the Intimate Gallery. OCTOBER 29: On "Black Monday," the American stock market crashed. DECEMBER: O'Keeffe was represented by five works in "Paintings by Nineteen Living Americans," the second exhibition at the new Museum of Modern Art, New York. Stieglitz opened his third and final gallery, An American Place, at 509 Madison Avenue.

1930

FEBRUARY 7–MARCH 17: O'Keeffe's New Mexican subjects — including Penitente crosses, adobe churches, landscapes, still lifes, and abstractions – were introduced at An American Place, in the first of her nearly annual shows held there until the gallery closed in 1950. JUNE–SEPTEMBER: O'Keeffe returned to Taos for a second summer of work as Luhan's guest; at the end of her stay (or possibly that of the following year),[12] she shipped eastward a barrel of bleached bones gathered from the desert; these souvenirs of the Southwest provided the basis for new still-life designs, which were first shown in January 1932.

1931

JANUARY 18–FEBRUARY 27: O'Keeffe's annual exhibition at An American Place. APRIL–JULY: She returned once again to New Mexico, and rented a cottage on the H&M Ranch, at Alcalde, in the Rio Grande valley. DECEMBER 27, 1931–FEBRUARY 11, 1932: O'Keeffe's second exhibition at An American Place in fewer than twelve months.

1932

APRIL: Over Stieglitz's objections, O'Keeffe accepted the commission to paint a mural for the ladies' powder room in Radio City Music Hall, fulfilling her wish "to paint something for a particular place — and paint it *big*."[13] MAY: The artist was represented by a triptych of Manhattan buildings in "Murals by American Painters and Photographers," an exhibition at the Museum of Modern Art. SUMMER: She stayed at Lake George instead of going to New Mexico. AUGUST: For her first experience outside the United States, O'Keeffe traveled to the Gaspé Peninsula in Canada, accompanied by Stieglitz's spirited niece, Georgia Engelhard. NOVEMBER: Technical problems with the fixative for the canvas caused O'Keeffe to cease work on the Radio City mural. She suffered a nervous breakdown and abandoned painting for more than a year.

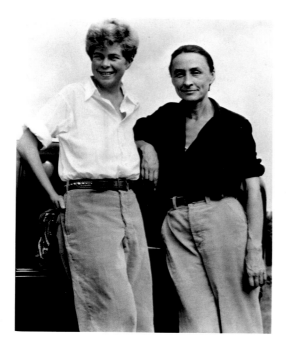

Georgia O'Keeffe and Georgia Engelhard, late 1920s.
Alfred Stieglitz. Private collection.

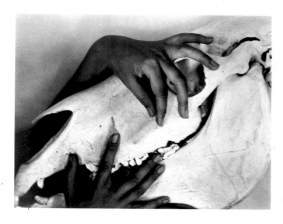

Georgia O'Keeffe: A Portrait – Hands and Bones, 1930.
Alfred Stieglitz. Private collection.

1933

JANUARY 7–FEBRUARY 22: O'Keeffe presented her annual show at An American Place, featuring recent Canadian subjects and flowers as well as still lifes from the previous decade. FEBRUARY – MARCH: She was hospitalized in New York for psychoneurosis; she recuperated in Bermuda from March to May and, from May onward, at Lake George. SPRING: Frank Lloyd Wright invited O'Keeffe to join the Taliesin Fellowship, the creative community at his home in Spring Green, Wisconsin; she did not accept, later explaining "Wisconsin just wasn't my kind of country."[14]

1934

JANUARY 29–MARCH 17: Stieglitz presented a retrospective of forty-four O'Keeffe paintings created between 1915 and 1927. He was pleased with the "extraordinary showing, and not a Calla Lily nor Cross or Bone to be seen!"[15] Officials at the Metropolitan Museum of Art were also pleased, and bought their first O'Keeffe painting from this show. MARCH – MAY: The artist completed her recovery with a Bermuda vacation. JUNE – SEPTEMBER: She returned to New Mexico for the first time in three years, staying initially at the H&M Ranch. Later, she moved to Ghost Ranch (approximately seventy miles west of Taos), amid the rugged red cliffs and eroded hills of the Chama River valley; this was her first visit to the area she eventually called her favorite.

1935

JANUARY 27–MARCH 11: The exhibition of twenty-eight O'Keeffe paintings at An American Place included works from 1919 through 1934. JUNE–NOVEMBER: The artist worked in New Mexico, staying at Ghost Ranch.

1936

JANUARY 7–FEBRUARY 27: O'Keeffe's exhibition of seventeen paintings, all new works from the previous summer, gladdened critics with "a resurgence of life and a resurrection of spirit."[16] JUNE–SEPTEMBER: The artist painted at Ghost Ranch. OCTOBER: O'Keeffe and Stieglitz moved from the Shelton Hotel to a penthouse apartment at 405 East Fifty-fourth Street, which was nearer An American Place.

1937

FEBRUARY 5–MARCH 17: O'Keeffe's annual exhibition at An American Place presented twenty-one recent works. SPRING: Elizabeth Arden's New York salon commissioned a large floral composition. JULY – DECEMBER: At Ghost Ranch, O'Keeffe stayed for the first time in the adobe house (Rancho de los Burros) that she later bought. She welcomed the photographer Ansel Adams to her summer home and, with him and the collector David McAlpin, toured Native American country in Colorado and Arizona. WINTER: Failing health forced Stieglitz to give up photography. DECEMBER 27, 1937 – FEBRUARY 11, 1938: The exhibition of O'Keeffe's twenty-seven new paintings included primarily New Mexican subjects; the customary exhibition brochure was expanded to reprint eight letters she had recently written to Stieglitz from New Mexico.

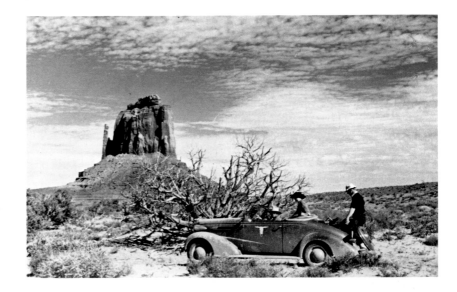

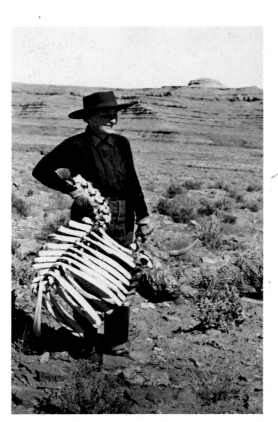

O'Keeffe and friends at Monument Valley, Utah, 1937.

O'Keeffe gathering bones, late 1930s.

1938

APRIL: Stieglitz suffered another heart attack, followed by pneumonia; O'Keeffe delayed her departure for New Mexico. MAY: O'Keeffe received an honorary Doctor of Fine Arts degree from the College of William and Mary in Williamsburg, Virginia; this was her first of many such honors. AUGUST—NOVEMBER: O'Keeffe stayed at Ghost Ranch. SEPTEMBER: With Ansel Adams, David McAlpin, and Godfrey and Helen Rockefeller, O'Keeffe traveled in California, making her first visit to the Sierra Nevada; the group spent seventeen days packing into remote scenic areas of Yosemite National Park, Adams's favorite site.

1939

JANUARY 22—MARCH 17: O'Keeffe's annual exhibition at An American Place. FEBRUARY—APRIL: As a guest of the Dole Pineapple Company, the artist traveled to Hawaii in order to produce paintings for corporate advertising, but was inspired only by flowers and the landscape; later, in New York, she reluctantly completed a painting of a pineapple for her sponsor. APRIL: She was honored as one of twelve outstanding women of the past fifty years by the New York World's Fair Tomorrow Committee; her painting *Sunset, Long Island* (private collection) was selected to represent New York State in the exhibition at the fair. SUMMER: O'Keeffe spent much of the season in New York instead of in New Mexico, recovering from a post-Hawaiian illness and exhaustion.

1940

FEBRUARY 1—MARCH 17: O'Keeffe exhibited twenty-one paintings, all but one of Hawaiian subjects, at An American Place. FEBRUARY—MARCH: She vacationed at Nassau, Bahama. JUNE—DECEMBER: She painted at Ghost Ranch. OCTOBER: She bought Rancho de los Burros, the house at Ghost Ranch and the first property she had ever owned.

1941

JANUARY 27—MARCH 11: O'Keeffe exhibited sixteen paintings, most of them New Mexican landscape and floral motifs, at An American Place.

Georgia O'Keeffe, Yosemite National Park, California, 1938. Ansel Adams. Copyright 1992 Ansel Adams Publishing Rights Trust. Courtesy of the trustees of the Ansel Adams Publishing Rights Trust. All rights reserved.

MAY – NOVEMBER: The artist stayed at Ghost Ranch. OCTOBER 17 – NOVEMBER 27: She was included in a group show with Stieglitz, Marin, Dove, and Picasso at An American Place.

1942

FEBRUARY 2 – MARCH 17: O'Keeffe's exhibition at An American Place. MAY: The artist received an honorary degree from the University of Wisconsin, Madison; she visited her family in Wisconsin and Chicago, and Frank Lloyd Wright at Taliesin. JUNE: O'Keeffe campaigned for "protection for the individual . . . regardless of sex" through an equal rights amendment to the United States Constitution.[17] OCTOBER: She moved with Stieglitz to a smaller apartment, at 59 East Fifty-fourth Street, which was even closer to An American Place.

1943

JANUARY – FEBRUARY: The Art Institute of Chicago presented O'Keeffe's first full-scale retrospective, including works from 1915 to 1941 and with a catalogue by the curator Daniel Catton Rich. MARCH 27 – MAY 22: O'Keeffe's exhibition at An American Place of twenty-one recent New Mexican works. APRIL – OCTOBER: The artist began a new series of paintings inspired by animal pelvis bones. She noted: "A particularly beautiful one that I found on the mountain where I went fishing this summer started me working on them."[18]

O'Keeffe with Bernie Martinez on the roof of the Ghost Ranch house, early 1940s.

1944

JANUARY 11 – MARCH 11: O'Keeffe introduced two new series of pelvis designs and cottonwood trees in her annual exhibition at An American Place. SPRING: She helped prepare the exhibition of Stieglitz's collection of modern American and European art, including photography, at the Philadelphia Museum of Art (July 1–November 1). APRIL – NOVEMBER: O'Keeffe worked in New Mexico.

Georgia O'Keeffe's "Black Place," about 1963. Todd Webb. Copyright Todd Webb. Courtesy of Evans Gallery, Portland, Maine.

Georgia O'Keeffe Hitching a Ride to Abiquiu with Maurice Grosser, 1945. Maria Chabot. Copyright Maria Chabot.

Georgia O'Keeffe and Mary Callery, Ghost Ranch, New Mexico, 1945. Eliot Porter. Copyright Amon Carter Museum, Fort Worth, Eliot Porter Collection.

1945

JANUARY 22 – MARCH 22: O'Keeffe's exhibition at An American Place. MAY – OCTOBER: The artist worked in New Mexico. DECEMBER 31: O'Keeffe acquired an abandoned adobe on three acres in Abiquiu, New Mexico, a historic village at the top of a mesa in the Chama River valley. She had long admired the historic structures and their expansive view, and bought the property from the Catholic church, reportedly for $10.[19] Over the next three years, with her friend and associate Maria Chabot, O'Keeffe refurbished and remodeled the derelict buildings to serve as her winter home and studio.

1946

FEBRUARY 14 – MARCH 27: O'Keeffe presented her annual exhibition of new oil paintings and pastels, featuring landscapes and bone and tree motifs. MAY 14: Her retrospective opened at the Museum of Modern Art, New York (running through August 25; no catalogue); organized by James Johnson Sweeney, it was the first solo show there to honor a woman. EARLY JUNE: O'Keeffe departed for New Mexico, for the first time making the trip by air. At Abiquiu, she painted *In the Patio I* (San Diego Museum of Art), the start of a lengthy patio series, which sustained her interest through 1960. JULY 10: She returned to New York when Stieglitz was stricken by a massive stroke; he died July 13 at the age of eighty-two. AUTUMN: O'Keeffe went back to Abiquiu, remaining there until late November.

1947 – 1949

O'Keeffe spent most of each year in New York, settling Stieglitz's estate and distributing his large art collection to public institutions; she spent summers in New Mexico but produced few paintings during this time.

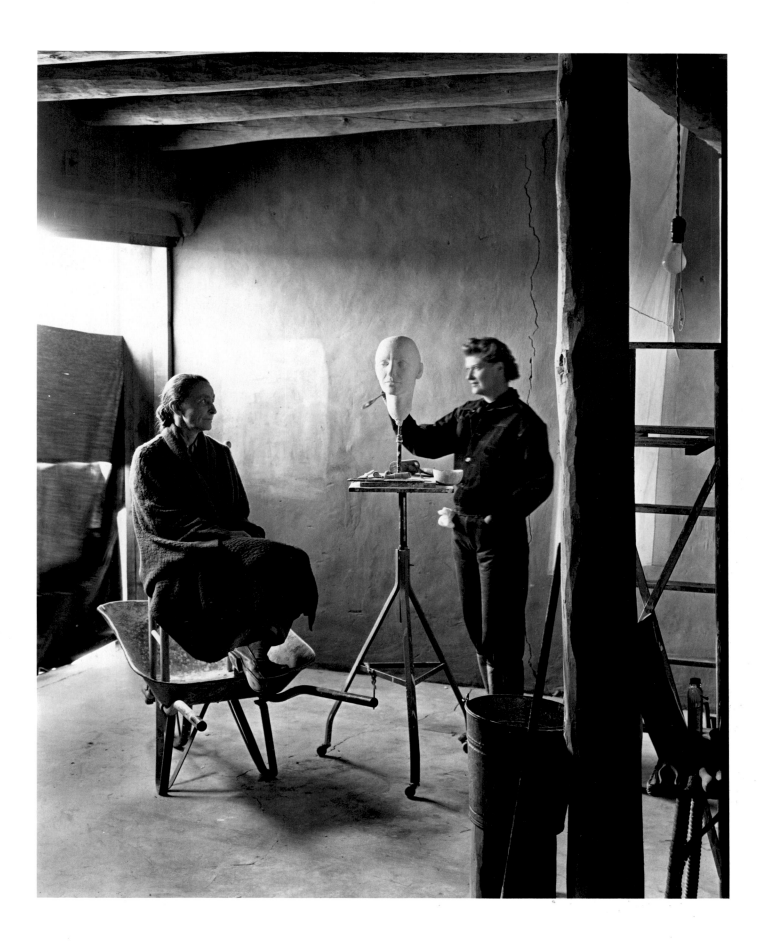

1947

JUNE 10: A special exhibition of Stieglitz's collection, which O'Keeffe helped organize, opened at the Museum of Modern Art, New York (running through August 25); the show subsequently traveled to the Art Institute of Chicago. AUGUST: For a State Department series on artists and their environs, O'Keeffe collaborated with Henwar Rodakiewicz on a film about herself and her life in New Mexico; the project ended in an argument between artist and filmmaker, rupturing their long friendship and leaving the film portrait incomplete. SEPTEMBER: O'Keeffe made a driving tour to Arizona, visiting Taliesin West (Frank Lloyd Wright's desert studio–home) at Scottsdale and the historic structures of Tucson.

1949

SPRING: O'Keeffe left New York to live permanently in New Mexico, generally dividing her time between Abiquiu (winters and springs) and Ghost Ranch (summers and autumns). She was elected to the National Institute of Arts and Letters. NOVEMBER: She visited Nashville, Tennessee, in order to oversee the installation of the inaugural exhibition of 101 works from the Stieglitz collection given to Fisk University; typically, her donation was made with the hope "that it may show that there are many ways of seeing and thinking, and possibly, through showing that there are many ways, give some one confidence in his own way, which may be different, whatever its direction."[20]

1950

OCTOBER 16–NOVEMBER 25: The O'Keeffe exhibition at An American Place marked the closing of the gallery; the Downtown Gallery, directed by Edith Gregor Halpert, became O'Keeffe's new dealer.

1951

FEBRUARY: O'Keeffe began a period of extensive international travels, with a first trip to Mexico, accompanied by the writer Spud Johnson and driving in tandem with the photographer Eliot Porter and his wife. In Mexico City, O'Keeffe met the artists Diego Rivera and Frida Kahlo, and visited Miguel Covarrubias, whom she had known in Taos in 1929 (the year his memorable caricature of O'Keeffe as "Our Lady of the Lily" appeared in the *New Yorker*). With Covarrubias and his wife, O'Keeffe toured the Mayan ruins in Yucatán; she also visited Cuernavaca, Oaxaca, and Guadalajara.

1952

FEBRUARY 19–MARCH 8: O'Keeffe's first show at the Downtown Gallery featured twenty-four pastels she had made from 1915 to 1945, suggesting the paucity of her recent work in oil.

1953

FEBRUARY 1–22: O'Keeffe's third retrospective exhibition (29 paintings), at the Dallas Museum of Art (and subsequently shown at Mayo Hills Galleries, Delray Beach, Florida). SPRING: The artist visited Europe (France and Spain) for the first time. Generally, she spent little time in museums during her travels, as "I mentally destroy the pictures I look at.

Alfred Stieglitz and Georgia O'Keeffe (taken at An American Place), 1944. Arnold Newman. Copyright Arnold Newman.

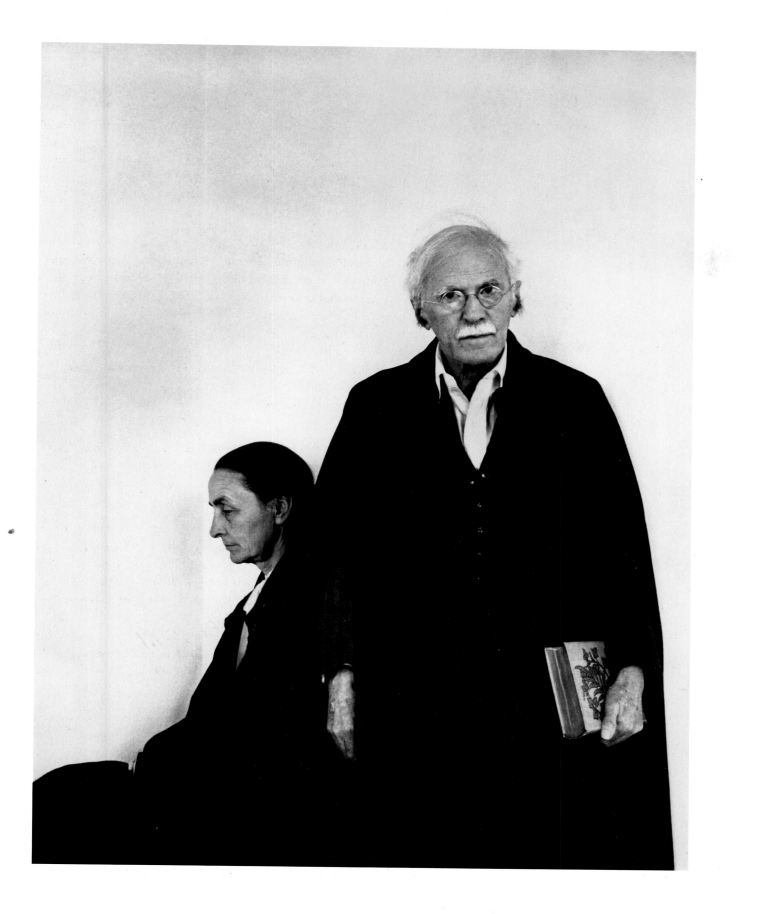

Georgia O'Keeffe's Studio, Abiquiu, 1960. Laura Gilpin.
Copyright Amon Carter Museum, Fort Worth, Laura
Gilpin Collection.

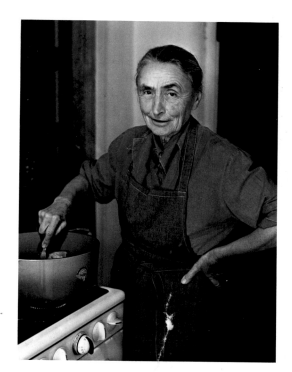

Georgia O'Keeffe Making a Stew, Ghost Ranch, 1961.
Todd Webb. Copyright Todd Webb. Courtesy of
Evans Gallery, Portland, Maine.

I'm very critical." Therefore, she was "so surprised when I went to the Prado . . . because everything there was so exciting to me," especially the paintings of Goya, whom she enjoyed "as much as any other Occidental artist."[21] SEPTEMBER 22–OCTOBER 17: O'Keeffe exhibited at the Downtown Gallery in New York.

1954

The artist returned to Spain for three months.

1955

MARCH 29–APRIL 23: Exhibition of seventeen new O'Keeffe paintings presented at the Downtown Gallery; this show was notable for its patio door and winter cottonwood themes.

1956

SPRING: O'Keeffe visited Peru for three months, in a trip that inspired a group of canvases based on coastal and Andean subjects, including Incan ruins. "I've never seen nature so absolutely terrifying," she later recalled of Peru.[22] Along with Mexico and Spain, it ranked among her favorite destinations.

1957

MARCH 2–30: O'Keeffe exhibited at the Downtown Gallery. DECEMBER: She made a return visit to Oaxaca, "the nicest place I found in Mexico."[23]

1958

FEBRUARY 25–MARCH 22: O'Keeffe displayed fifty-three watercolors from 1916 and 1917 at the Downtown Gallery; critics were surprised that "they predate styles that are currently being taken as up-to-the-minute modern," and found the group "astonishing and, in many ways, touching."[24] OCTOBER: O'Keeffe was represented at the Metropolitan Mu-

seum of Art in its survey "Fourteen American Masters," which included artists from colonial times to the modern era. She wrote: "I am in it with a room all to myself. I am quietly pleased."[25]

1959

SPRING: With a small tour group, O'Keeffe traveled around the world for three and a half months. The itinerary included seven weeks in India (a varied experience, from subtropical Bombay to the Himalayan foothills of Kashmir), as well as shorter stays in East Asia (Japan, Hong Kong, and Formosa [Taiwan]), Southeast Asia (Singapore, Vietnam, Thailand, and Cambodia), Pakistan, the Near East (Iran, Syria, Lebanon, Jordan, and Israel), and finally Rome. She wrote: "By the time I get home I should have seen enough to satisfy me for the rest of my life."[26] The experience of flight inspired a new series of paintings based on aerial views of riverine patterns.

1960

OCTOBER – DECEMBER: O'Keeffe's fourth retrospective exhibition, presented by the Worcester (Massachusetts) Art Museum, with Daniel Catton Rich as curator and catalogue author. OCTOBER: The artist embarked on a six-week trip to Japan, Formosa, the Philippines, Hong Kong, Cambodia, and the Pacific Islands, from which came new views of tropical landscapes and of islands glimpsed through clouds.

1961

APRIL – MAY: O'Keeffe presented her last exhibition at the Downtown Gallery, introducing her overhead views of rivers. AUGUST: With the photographers Eliot Porter and Todd Webb as well as other friends, she descended the Colorado River by raft (7 days, 180 miles), in the first of several such trips that inspired her *Canyon Country* series.

1962

O'Keeffe was elected to the American Academy of Arts and Letters, the most prestigious assembly of creative artists in the nation, filling the seat vacated at the death of e. e. cummings.

1963

O'Keeffe traveled to Greece, Egypt, and the Near East. She recalled: "I loved Greece. . . . Crete, though, was like a photograph of a painting. The restoration was too obvious."[27]

1965

JUNE: Using the double garage of her Ghost Ranch home as a studio, O'Keeffe began painting her largest canvas, *Sky Above Clouds IV* (8 x 24 ft.; The Art Institute of Chicago), the ultimate in a series of cloudscapes viewed from overhead.

1966

MARCH – MAY: O'Keeffe retrospective was presented by the Amon Carter Museum, Fort Worth (subsequently traveling to the Museum of Fine Arts, Houston), with a catalogue by Mitchell A. Wilder. The artist traveled to England and Austria. SEPTEMBER 8 – OCTOBER 13: The Art Mu-

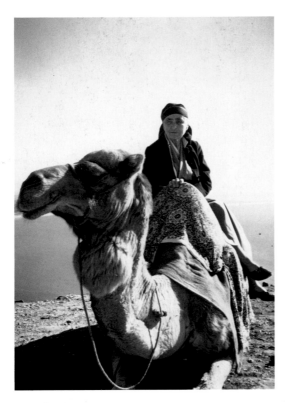

Georgia O'Keeffe on Camelback in Morocco, 1974. Juan Hamilton. Copyright Juan Hamilton.

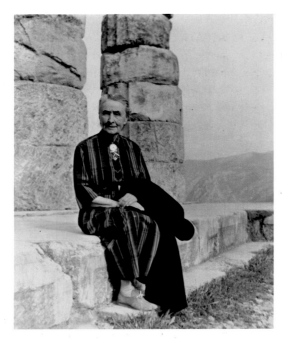

O'Keeffe in Greece, 1963.

Georgia O'Keeffe's Studio, New Mexico, 1963. Todd Webb. Copyright Todd Webb. Courtesy of Evans Gallery, Portland, Maine.

seum of the University of New Mexico, Albuquerque, presented the first solo exhibition of O'Keeffe's work in her adopted state.

1968

Doris Bry, who had assisted O'Keeffe with the distribution of the Stieglitz estate, replaced the Downtown Gallery as the artist's agent.

1969

O'Keeffe made a second descent of the Colorado River. She was named a Benjamin Franklin Fellow by the Royal Society for the Encouragement of Arts, Manufactures, and Commerce, London. She traveled to Austria.

1970

MAY: O'Keeffe was awarded the Gold Medal for Painting by the National Institute of Arts and Letters. SUMMER: She made her third rafting trip down the Colorado. OCTOBER 8 – NOVEMBER 29: A major retrospective, organized by Lloyd Goodrich and Doris Bry for the Whitney Museum of American Art, New York, heralded O'Keeffe's triumphant return to New York and resulted in a new generation of enthusiasts; subsequently, the show traveled to Chicago and San Francisco, winning the artist acclaim nationwide.

1971

AUTUMN: O'Keeffe lost her central vision and was left with only peripheral sight.

1972

O'Keeffe completed her last unassisted oil painting.

1973

SEPTEMBER: O'Keeffe met Juan Hamilton, a young artist working at Ghost Ranch. He became her assistant, helping her with her artwork, exhibits, and publications. Hamilton encouraged O'Keeffe in her new work with hand-built clay pots.

O'Keeffe, Colorado River, 1961. Todd Webb. Copyright Todd Webb. Courtesy of Evans Gallery, Portland, Maine.

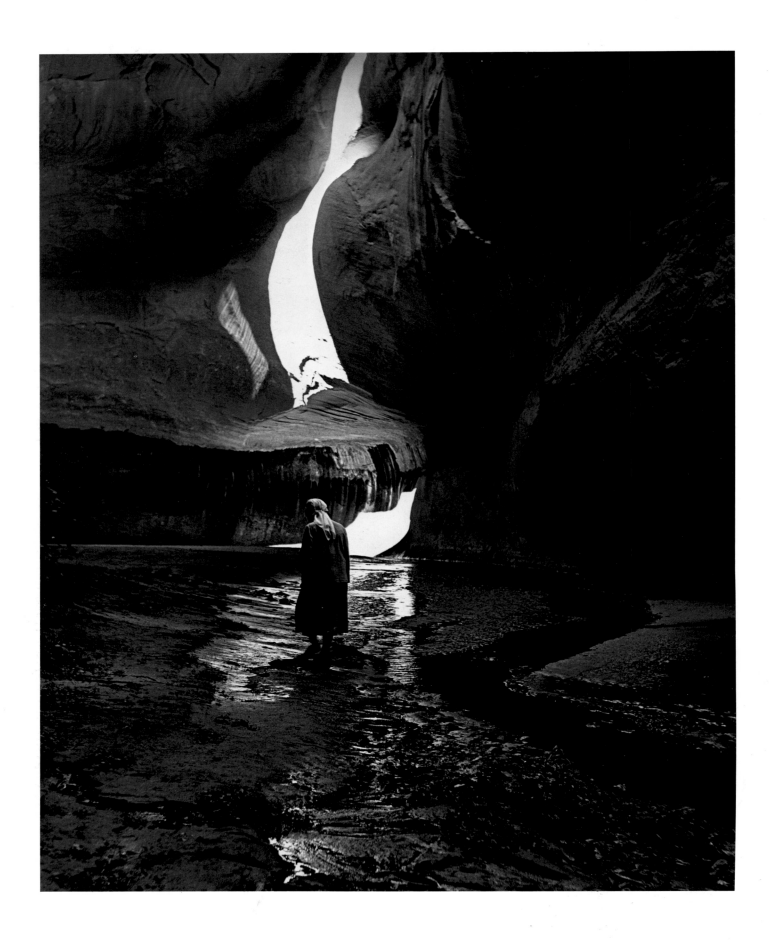

O'Keeffe in Twilight Canyon, Lake Powell, 1964. Todd Webb. Copyright Todd Webb. Courtesy of Evans Gallery, Portland, Maine.

Georgia O'Keeffe Sketching and Eliot Porter Photographing at Glen Canyon, 1961. Todd Webb. Copyright Todd Webb. Courtesy of Evans Gallery, Portland, Maine.

Georgia O'Keeffe Photographing the Chama River, 1961. Todd Webb. Copyright Todd Webb. Courtesy of Evans Gallery, Portland, Maine.

1974

JANUARY: Invited to join designer-architect Alexander Girard and his wife, Susan, O'Keeffe visited Morocco with them, also accompanied by Hamilton; this was the first of numerous trips she took with him. She wrote her acclaimed commentary to accompany a portfolio of reproductions of her works on paper, *Some Memories of Drawings.*

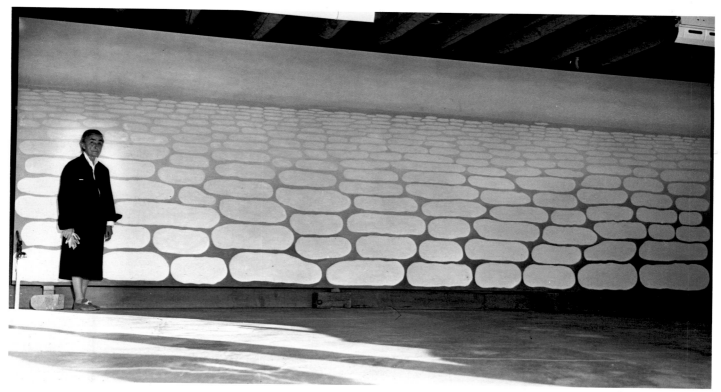

Georgia O'Keeffe with "Sky above Clouds," 1965. Ralph Looney. Copyright Ralph Looney.

1975

With Hamilton's encouragement, O'Keeffe resumed painting in water-
colors and, with assistance, in oils. APRIL 27 – MAY 23: An exhibition of
twelve of O'Keeffe's major New Mexican paintings – her second one-
person show in the state – was presented in the Governor's Gallery, at the
State Capitol in Santa Fe.

1976

JANUARY: O'Keeffe traveled to Antigua, and did some drawings based
on that trip. After years of her working on the design and layout, Viking
Press published *Georgia O'Keeffe,* a distinguished monograph with 108
fine reproductions and autobiographical text by the artist.

1977

JANUARY: O'Keeffe received the Medal of Freedom, the highest Ameri-
can civilian honor, from President Gerald Ford. NOVEMBER: The film
Portrait of an Artist, produced by Perry Miller Adato, was aired nationally
on public television. The artist attended her ninetieth birthday celebration
at the National Gallery of Art, Washington, D.C.; this event generated
increased public interest.

1978

NOVEMBER: "Georgia O'Keeffe: A Portrait by Alfred Stieglitz" opened
at the Metropolitan Museum of Art; O'Keeffe wrote the catalogue intro-
duction and selected the images, many of which had not been previously
exhibited.

1979

JUNE: O'Keeffe traveled to the Pacific coast of Costa Rica and Guatemala.

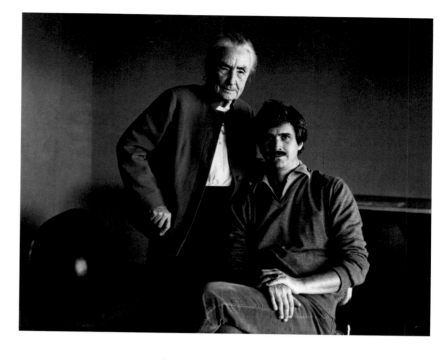

Georgia O'Keeffe, Juan Hamilton, 1983. William Clift. Copyright William Clift.

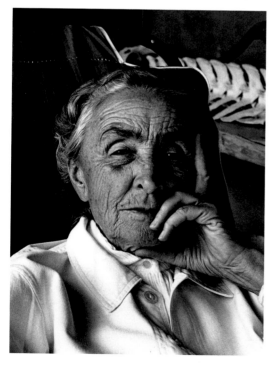

Georgia O'Keeffe at Ghost Ranch, 1963. Todd Webb. Copyright Todd Webb. Courtesy of Evans Gallery, Portland, Maine.

1980

Laurie Lisle published *Portrait of an Artist: A Biography of Georgia O'Keeffe,* the first full-length account of O'Keeffe's life.

1982

MAY: O'Keeffe traveled to Hawaii. SUMMER: She exhibited an eleven-foot-high abstract sculpture at the San Francisco Museum of Modern Art, in a show of twenty American sculptors. Her organic spiral form was an enlargement of a plaster maquette, which was originally modeled in 1945 and of which a limited edition had recently been cast in aluminum.

1983

JANUARY 30: O'Keeffe attended the opening of a retrospective exhibition of Stieglitz's photographs (on which she had worked extensively with curators Juan Hamilton and Sarah Greenough during the preceding five years) at the National Gallery of Art, Washington, D.C.; the exhibition was subsequently shown at the Metropolitan Museum of Art, New York. She visited New York City to attend the latter venue, and she and Hamilton were interviewed by Andy Warhol for his *Interview* magazine. The Stieglitz exhibition catalogue, on which the artist had also worked, won an American Book Award. After many years of not having seen Ansel Adams, O'Keeffe visited the photographer three times, staying with him twice, and doing some drawings based on the California redwoods. NOVEMBER: At ninety-six years of age, O'Keeffe made her final international trip, returning to the Pacific coast of Costa Rica.

1984

SPRING: In failing health, O'Keeffe moved to Santa Fe, where she lived with Juan Hamilton and his family.

Georgia O'Keeffe and James Johnson Sweeney at the American Academy, New York, 1963. Budd Waintrob. Copyright Budd Waintrob.

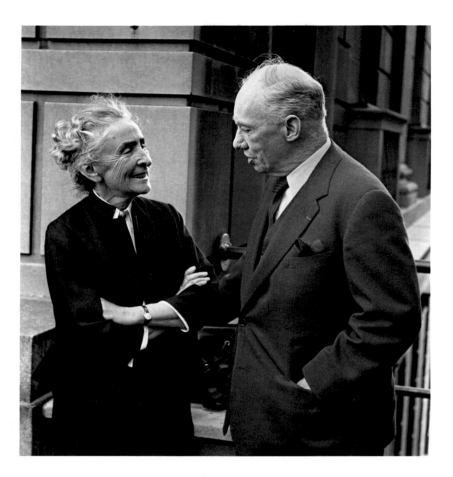

Olga and Joseph Hirshhorn, Georgia O'Keeffe, and Ira Lowe at the Hirshhorn Museum, 1977. Courtesy of the Hirshhorn Museum and Sculpture Garden, Smithsonian Institution.

*In the Bedroom at Abiquiu, late 1960s. John Loengard (*Life* magazine). Copyright Time/Warner Inc.*

*A Sunset Walk over Red Hills, late 1960s. John Loengard (*Life* magazine). Copyright Time/Warner Inc.*

1985

APRIL: O'Keeffe was awarded the National Medal of Arts by President Ronald Reagan.

1986

MARCH 6: O'Keeffe died in Santa Fe. At her request, no funeral or memorial service was held; her ashes were scattered over her beloved landscape of northern New Mexico.

1987

NOVEMBER: The artist's centennial was celebrated by a major retrospective at the National Gallery of Art, Washington, D.C., with Jack Cowart and Juan Hamilton as cocurators. Subsequently, the show toured to the Art Institute of Chicago; the Dallas Museum of Art; the Metropolitan Museum of Art, New York; and the Los Angeles County Museum of Art.

1989

JULY: Following the distribution of designated paintings by bequest, the Georgia O'Keeffe Foundation was established in order to perpetuate the memory of the artist and her work.

1991

OCTOBER: The Georgia O'Keeffe Foundation and the National Gallery of Art announced their plans to prepare a catalogue raisonné of the artist's works.

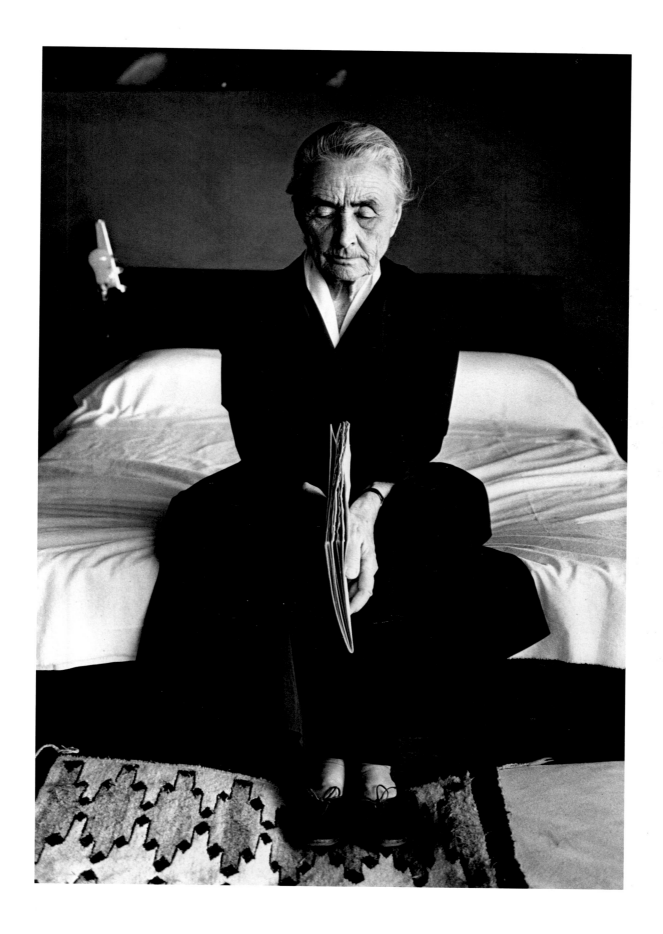

GEORGIA O'KEEFFE:

PAINTINGS AND DRAWINGS

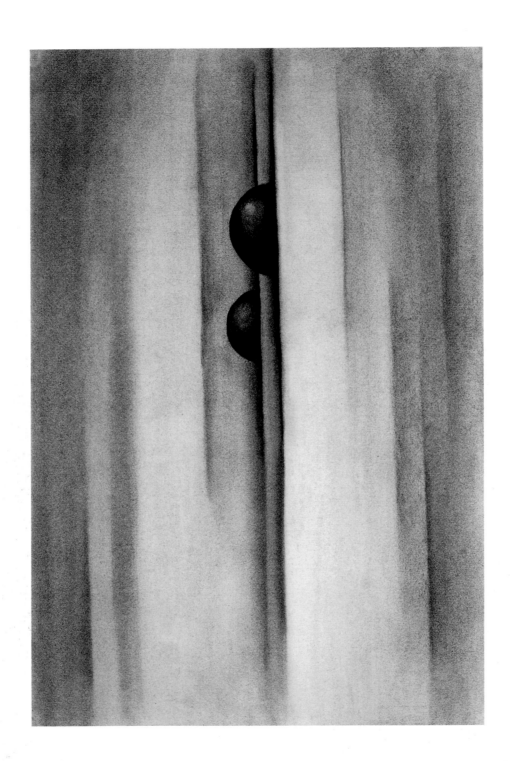

1. SPECIAL NO. 17, 1919

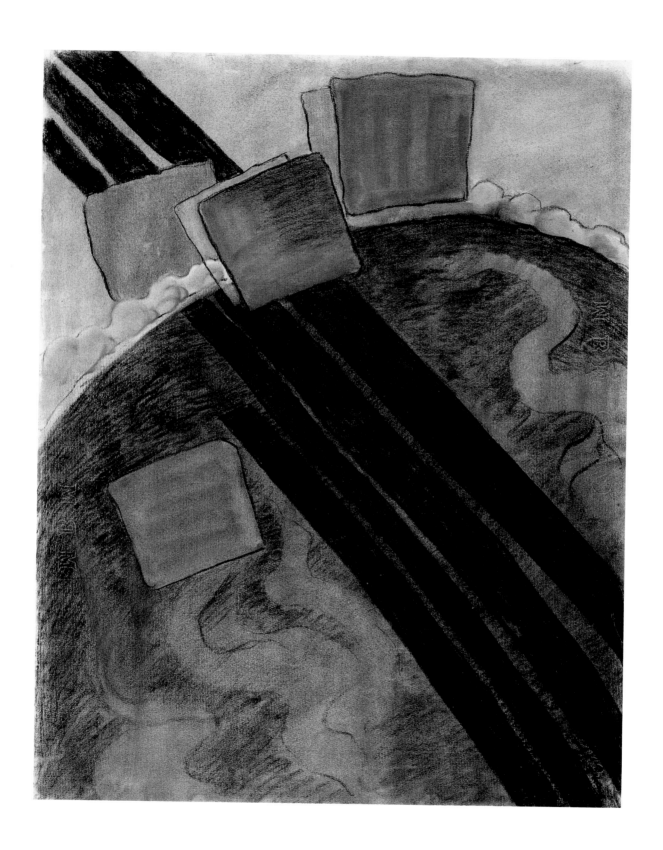

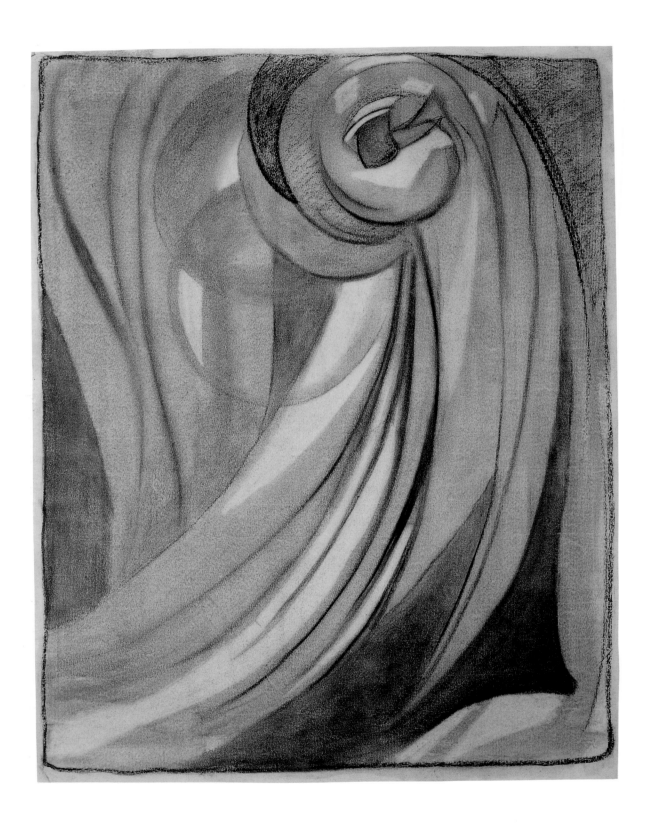

3. EARLY NO. 2, 1915

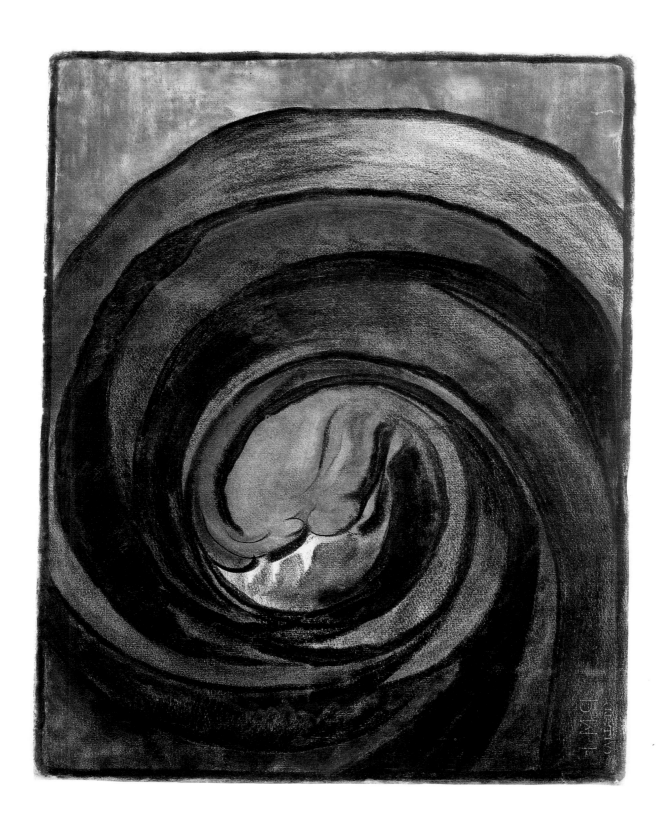

4. DRAWING NO. 8, 1915

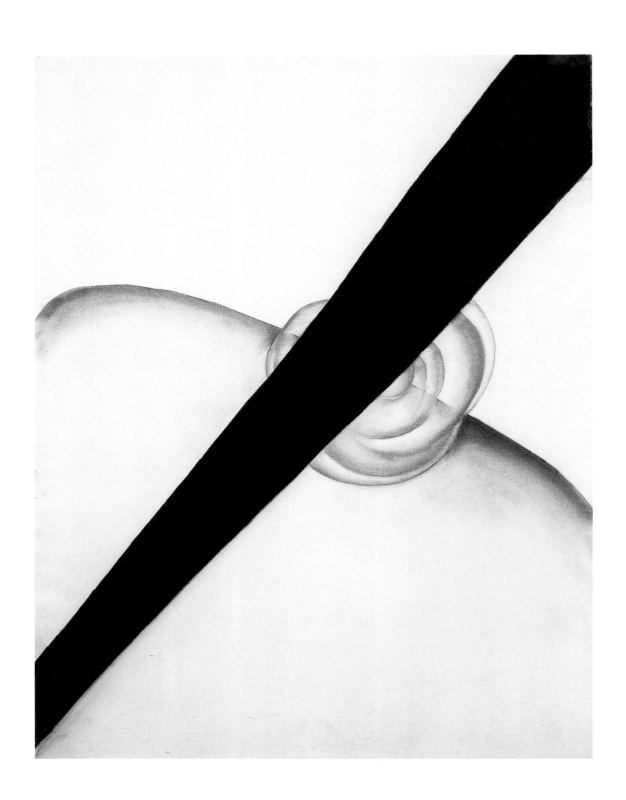

5. BLACK DIAGONAL, 1919

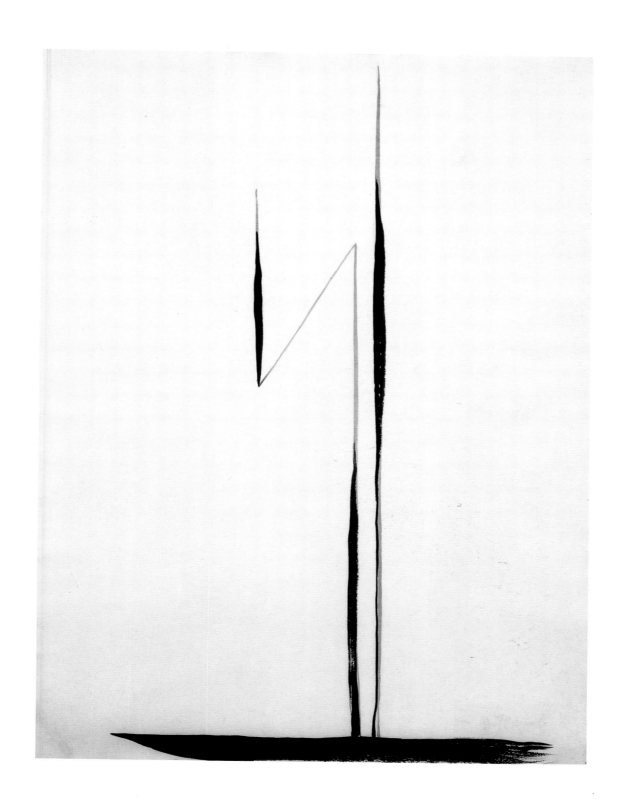

6. BLACK LINES, 1916

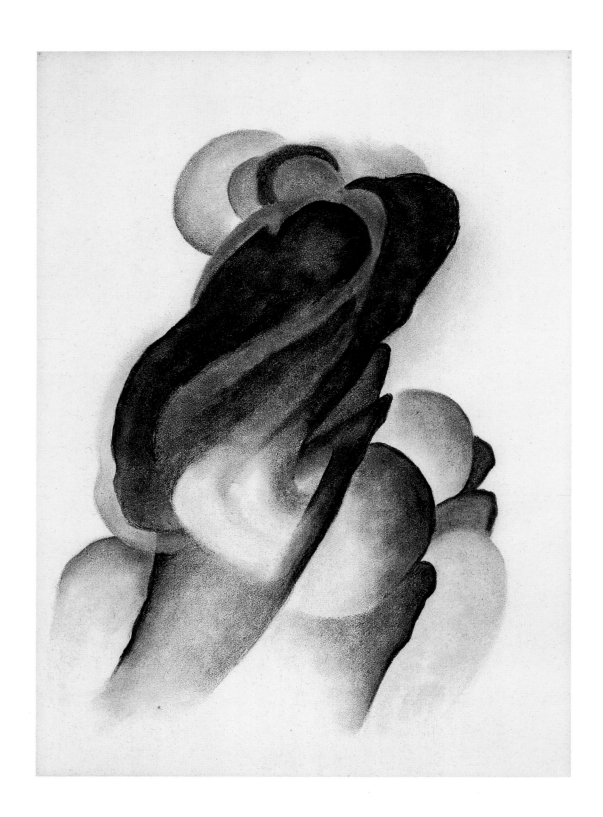

7. SPECIAL NO. 16, 1918

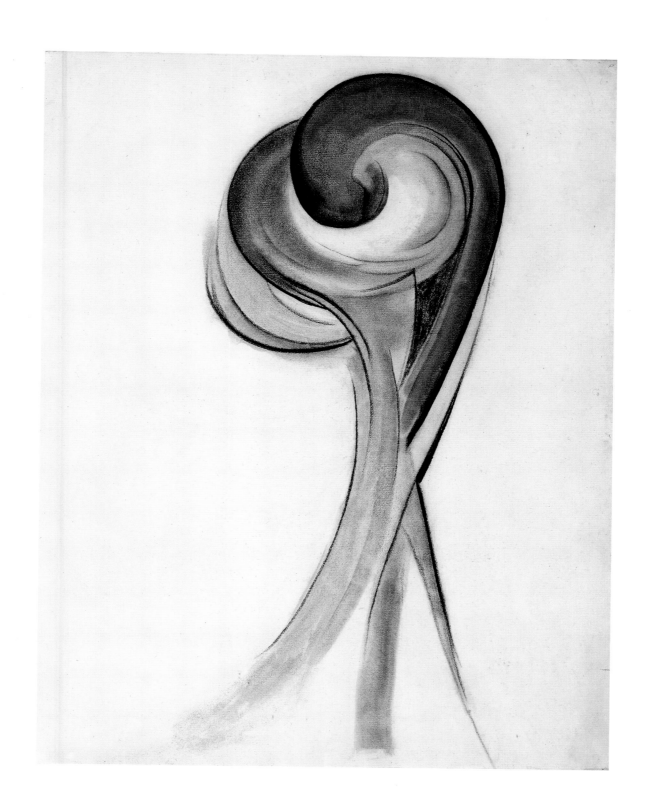

8. SPECIAL NO. 12, 1917

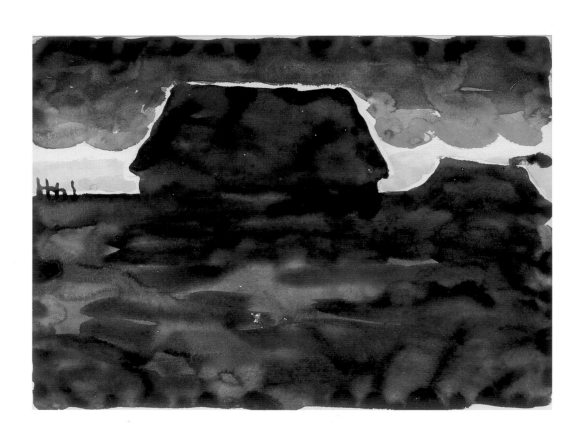

9. MORNING SKY WITH HOUSES NO. 2, 1916

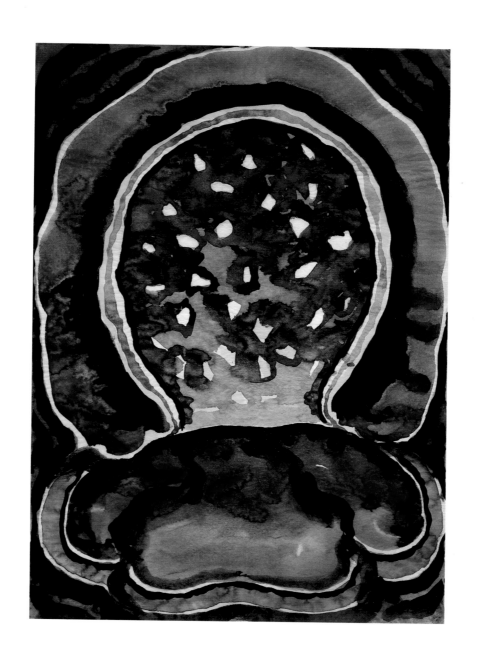

10. BLUE ABSTRACTION, 1917

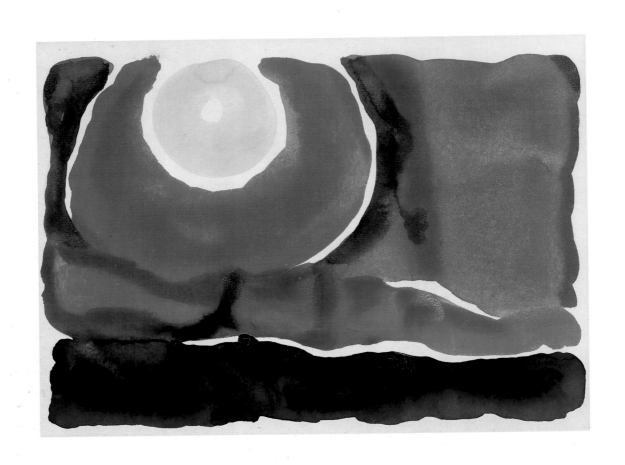

11. EVENING STAR VI, 1917

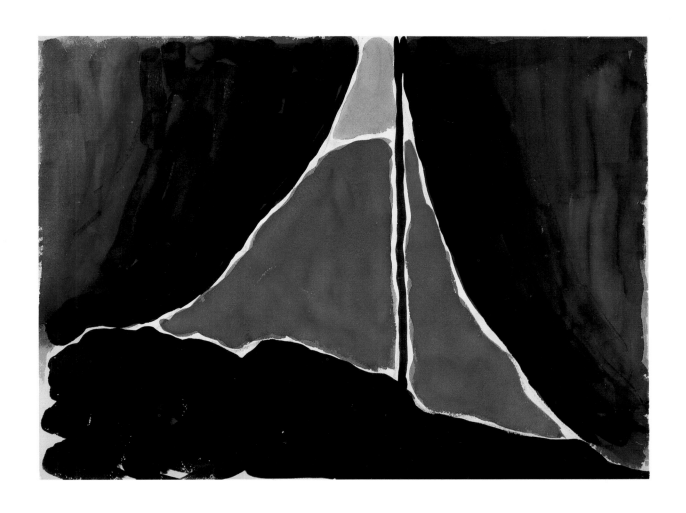

12. TENT DOOR AT NIGHT, C. 1915

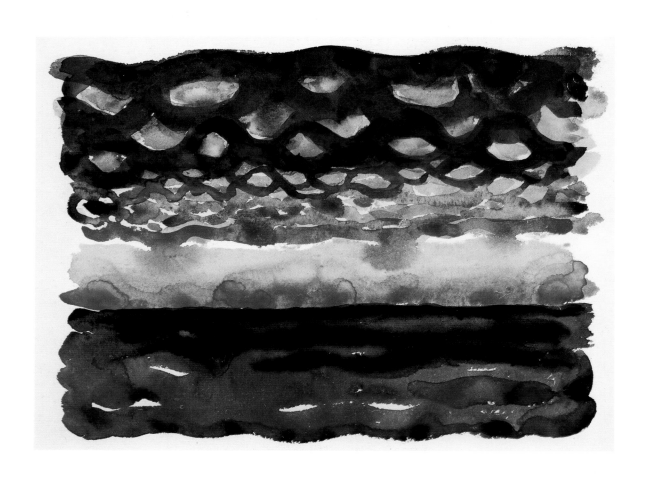

13. SUNRISE AND LITTLE CLOUDS NO. II, 1916

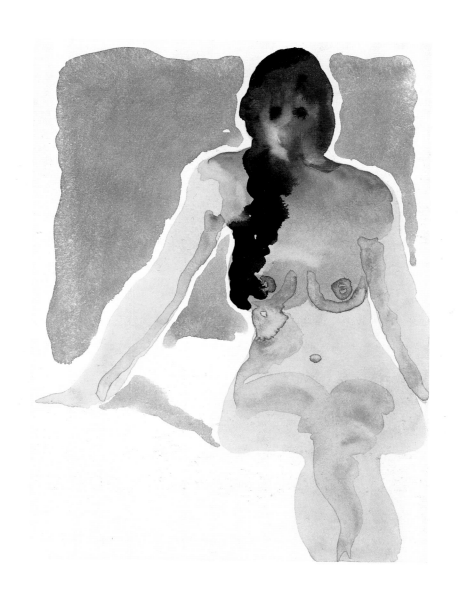

14. NUDE NO. IV, 1917

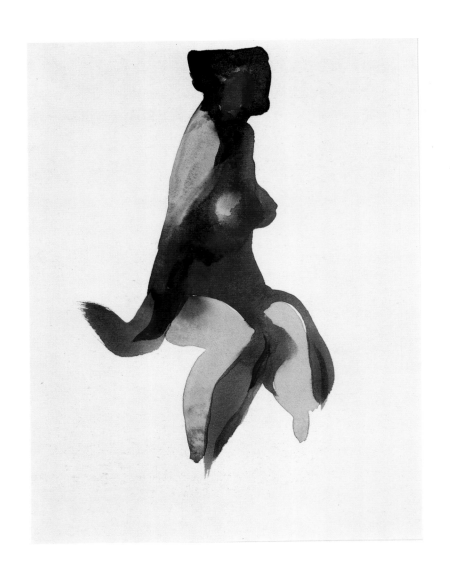

15. NUDE SERIES III, 1917

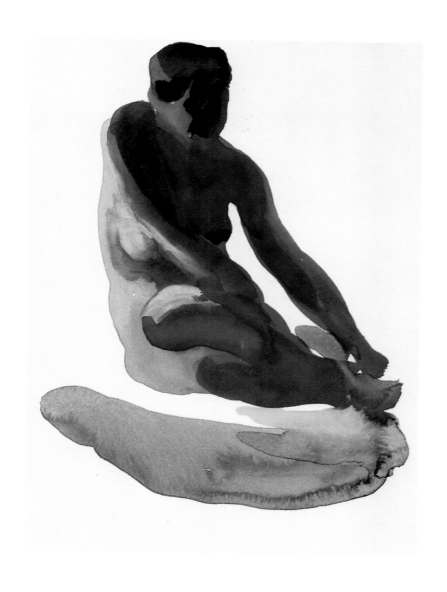

16. NUDE SERIES, SEATED RED, 1917

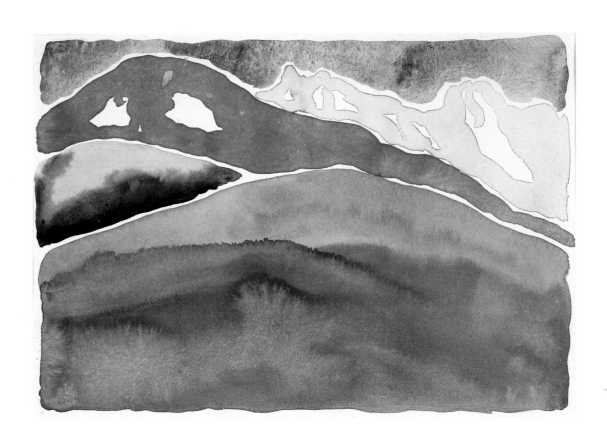

17. PINK AND GREEN MOUNTAINS NO. 1, 1917

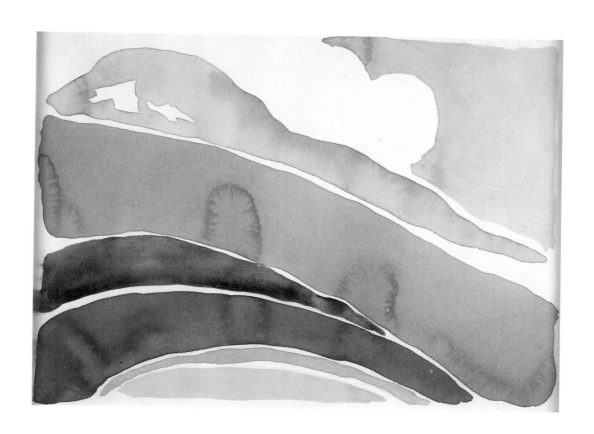

18. PINK AND GREEN MOUNTAINS NO. II, 1917

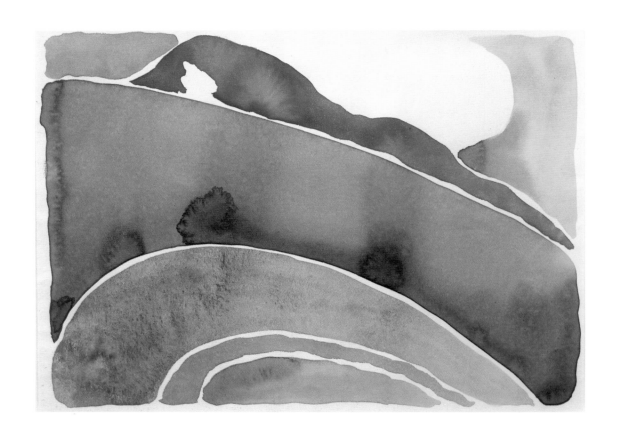

19. PINK AND GREEN MOUNTAINS NO. IV, 1917

20. PINK AND GREEN MOUNTAINS NO. V, 1917

21. BLUE AND GREEN MUSIC, 1919

22. LAKE GEORGE, COAT AND RED, 1919

23. FROM THE PLAINS, 1919

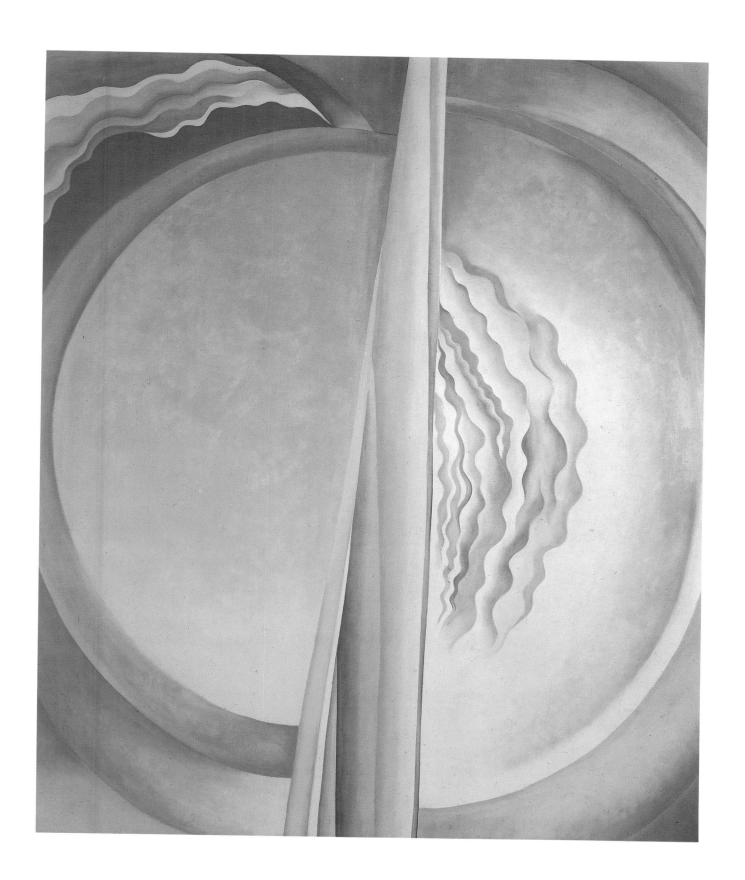

24. PINK ABSTRACTION, 1929

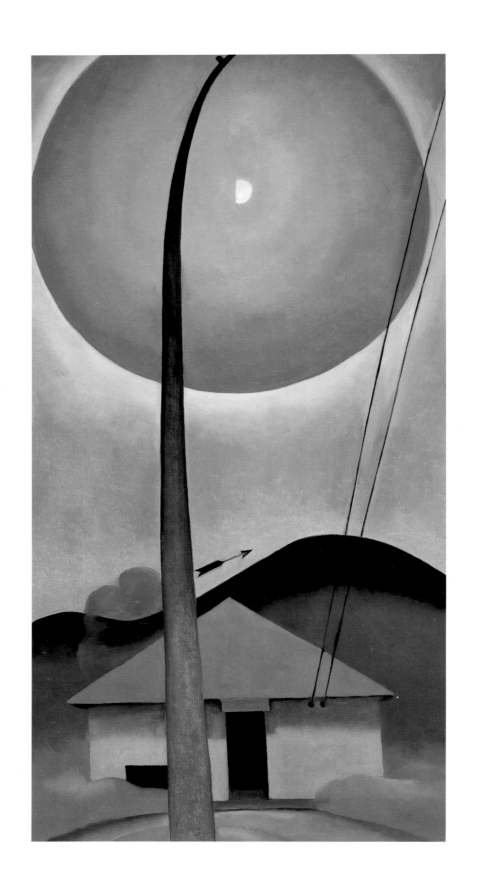

25. LITTLE HOUSE WITH FLAGPOLE, 1925

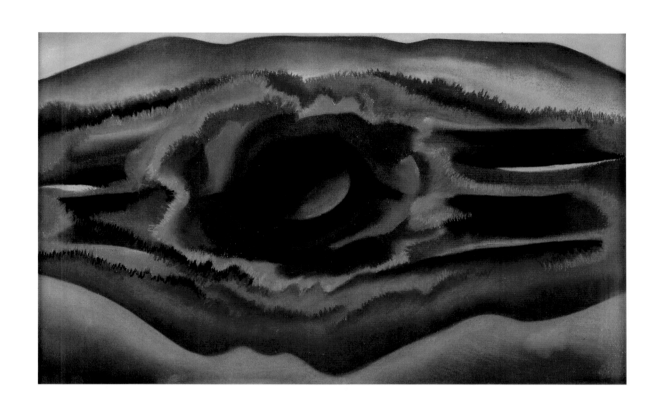

26. POOL IN THE WOODS, LAKE GEORGE, 1922

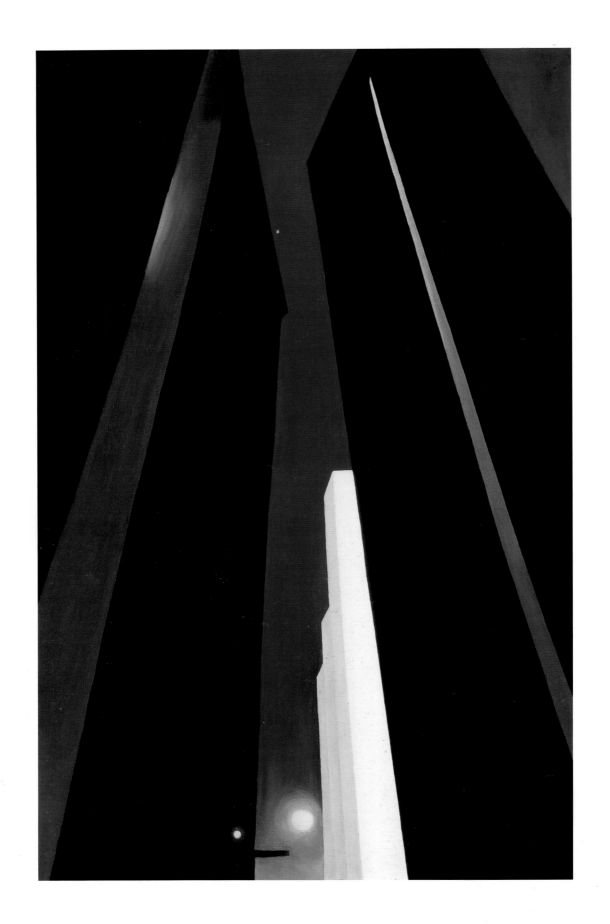

27. CITY NIGHT, 1926

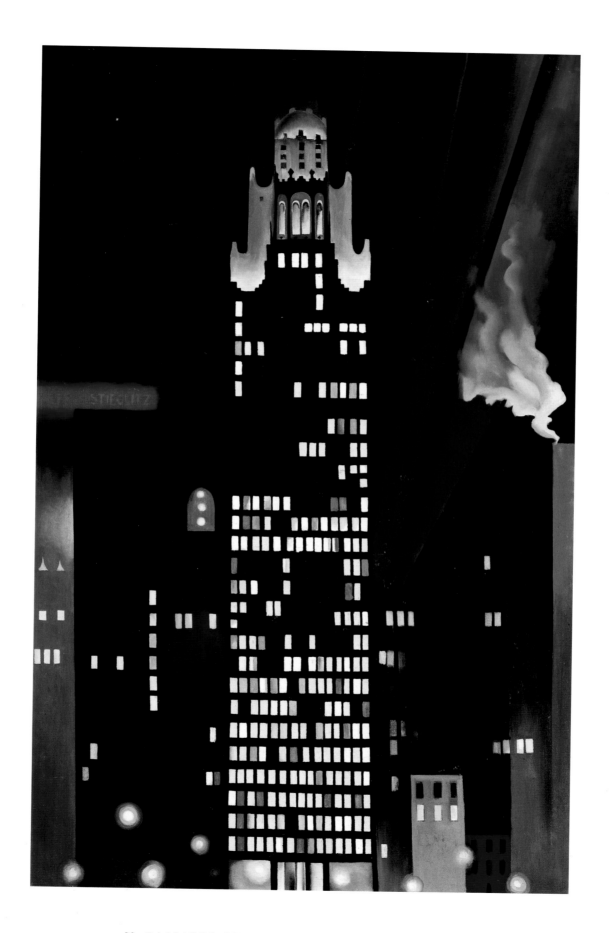

28. RADIATOR BUILDING, NIGHT, NEW YORK, 1927

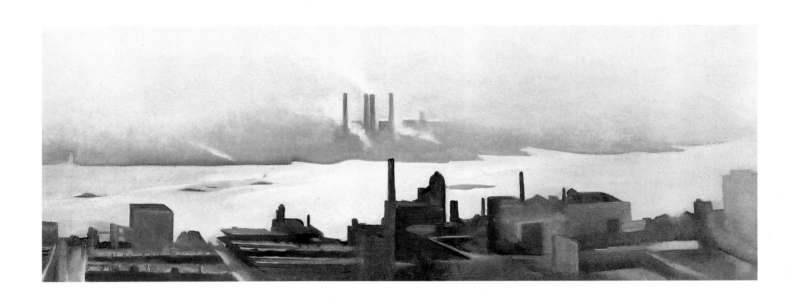

29. EAST RIVER NO. I, 1926

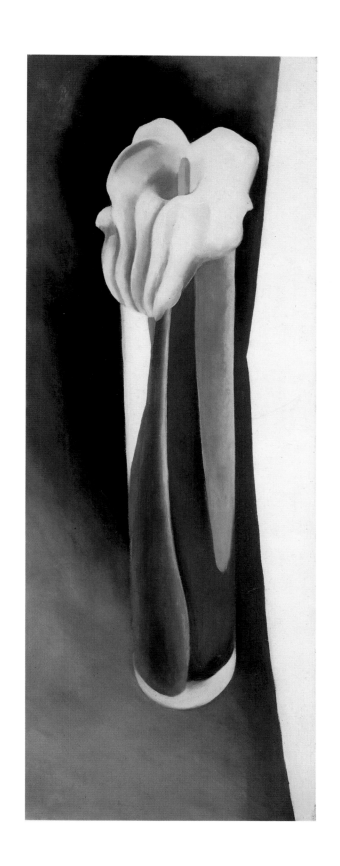

30. CALLA IN TALL GLASS NO. 2, 1923

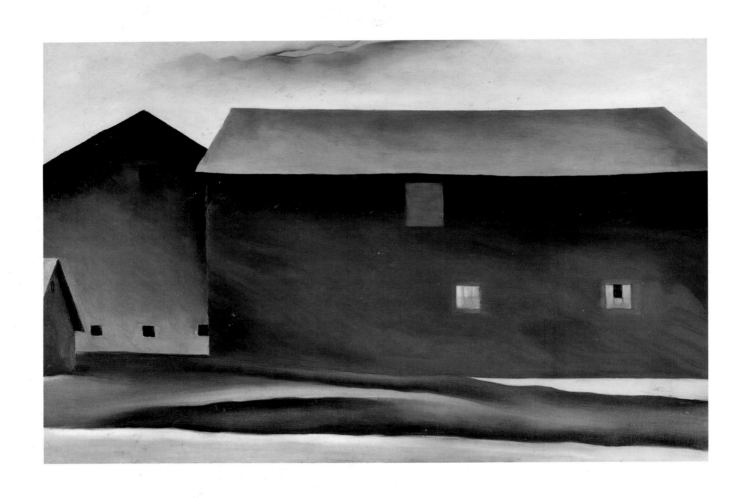

31. LAKE GEORGE BARNS, 1926

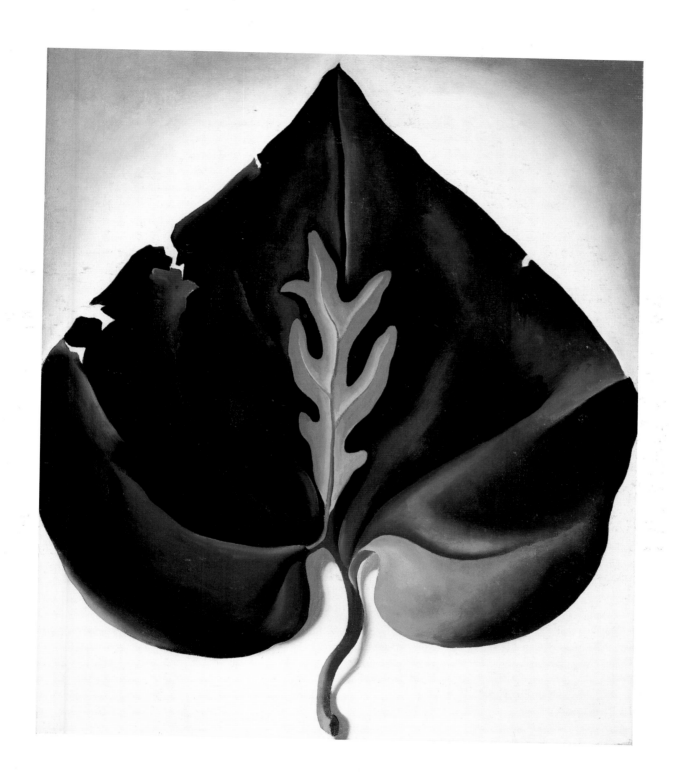

32. DARK AND LAVENDER LEAVES, 1931

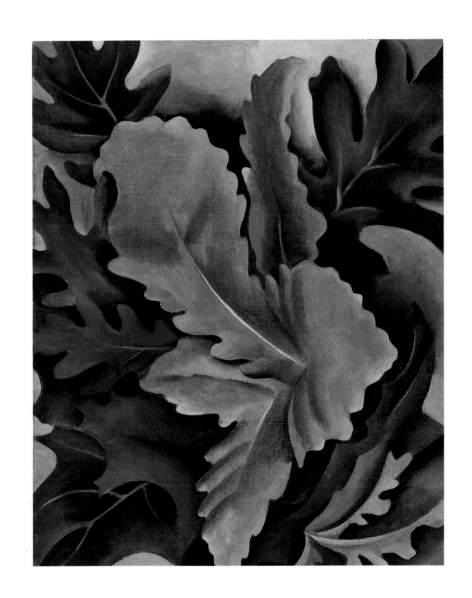

33. GREEN OAK LEAVES, C. 1923

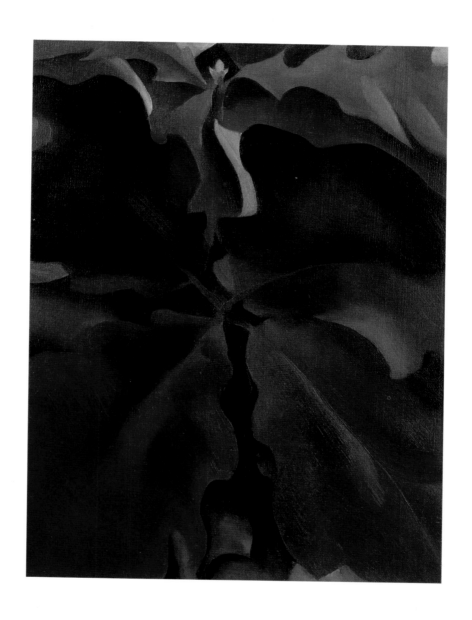

34. FOUR DARK RED OAK LEAVES, 1923

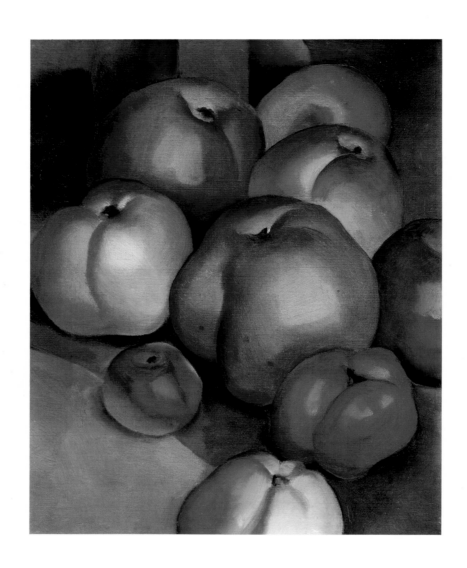

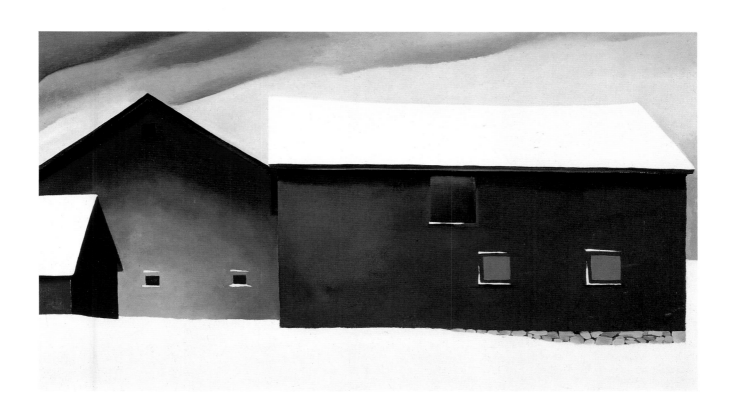

36. BARN WITH SNOW, 1934

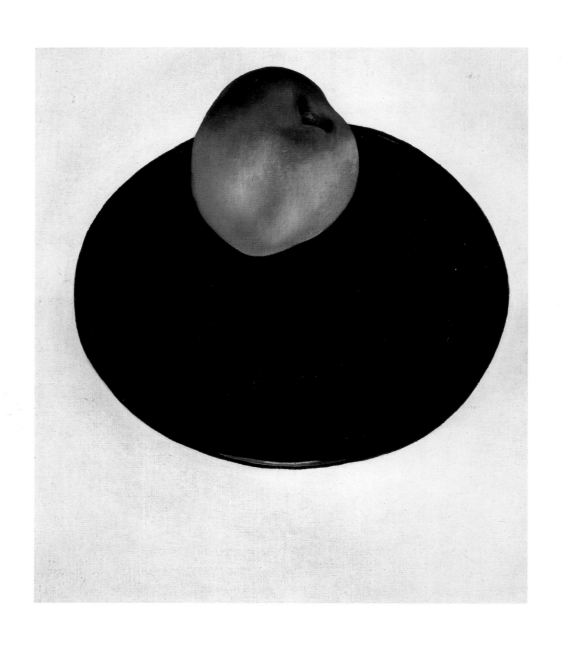

37. GREEN APPLE ON BLACK PLATE, C. 1921

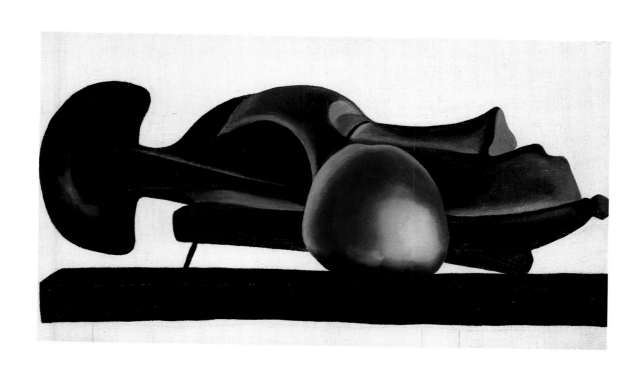

38. MASK WITH GOLDEN APPLE, 1924

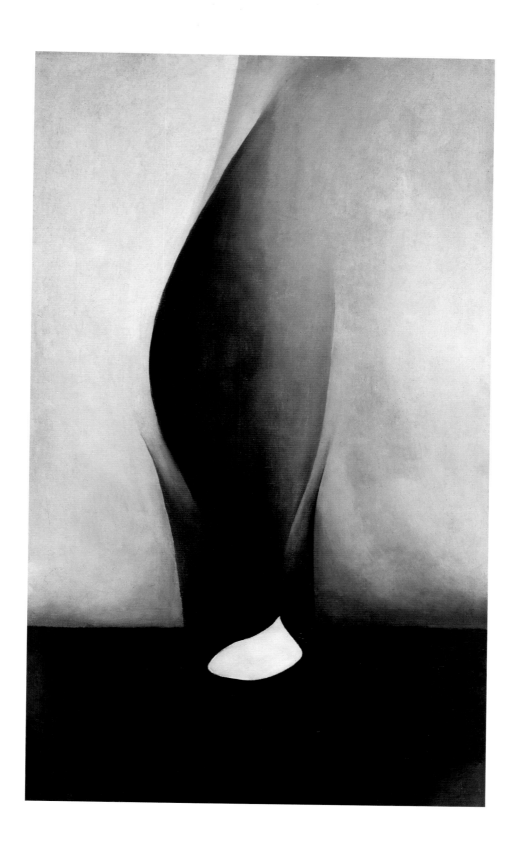

39. SHELL AND SHINGLE VI, 1926

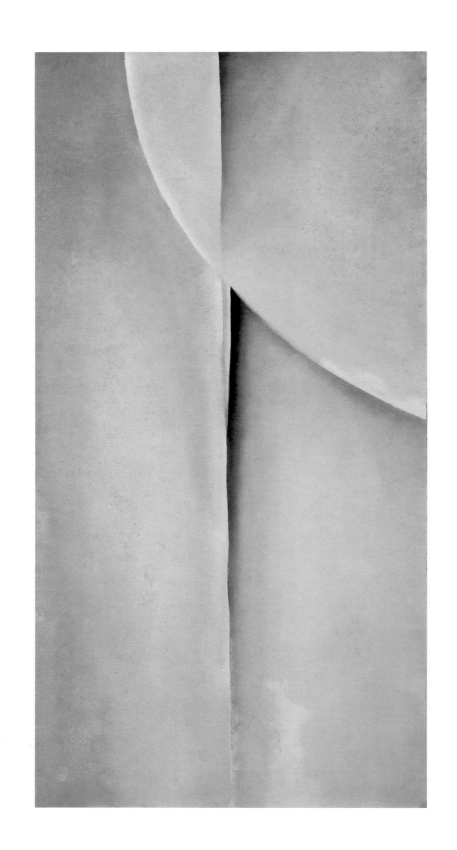

40. LINE AND CURVE, 1927

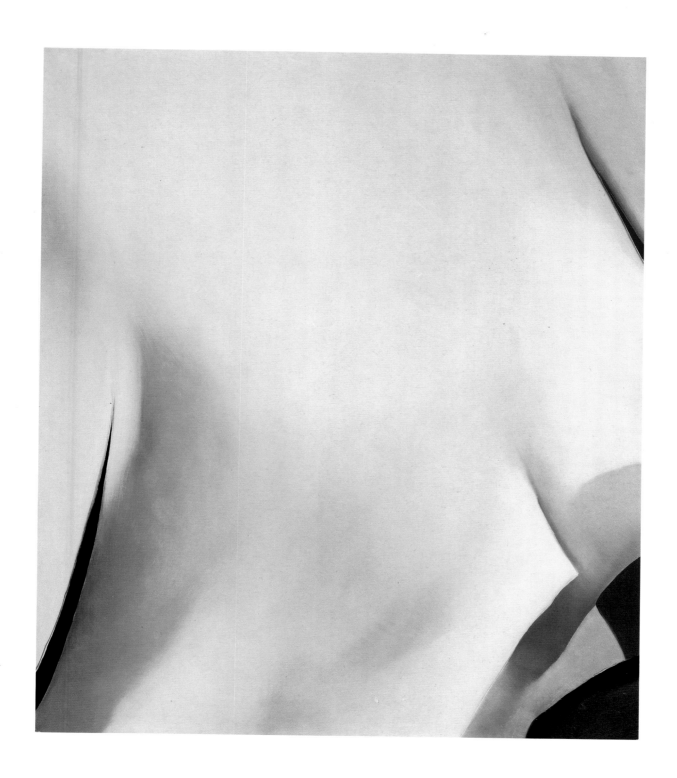

41. SERIES I NO. 12, 1920

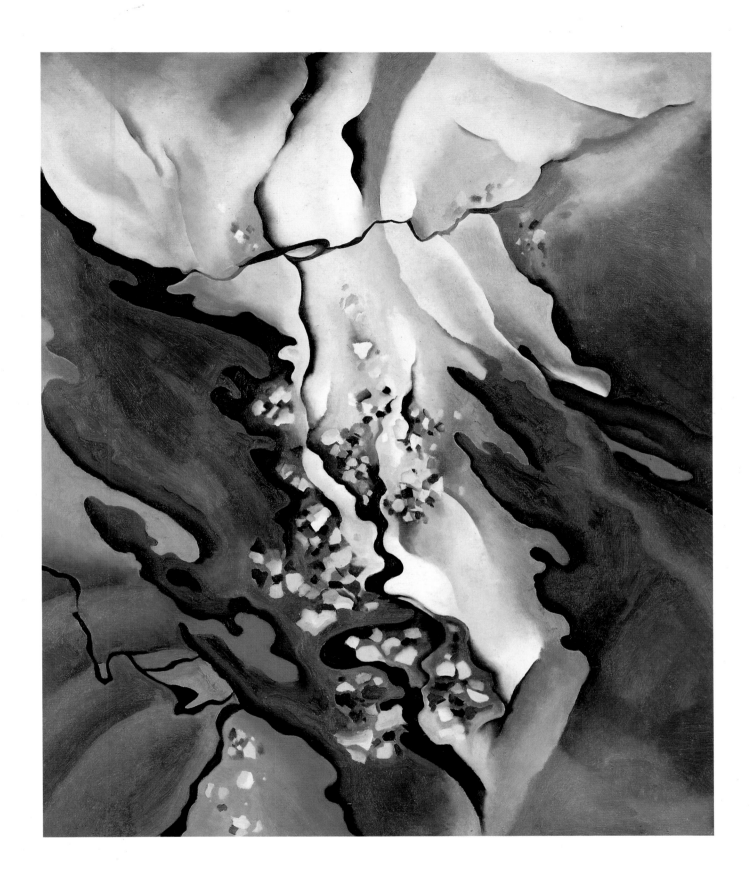

42. FROM THE LAKE NO. 3, 1924

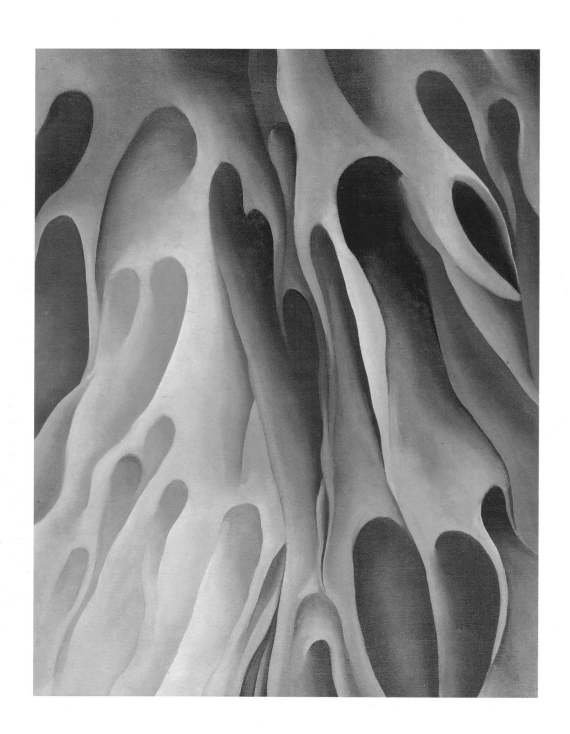

43. RED AND PINK, 1925

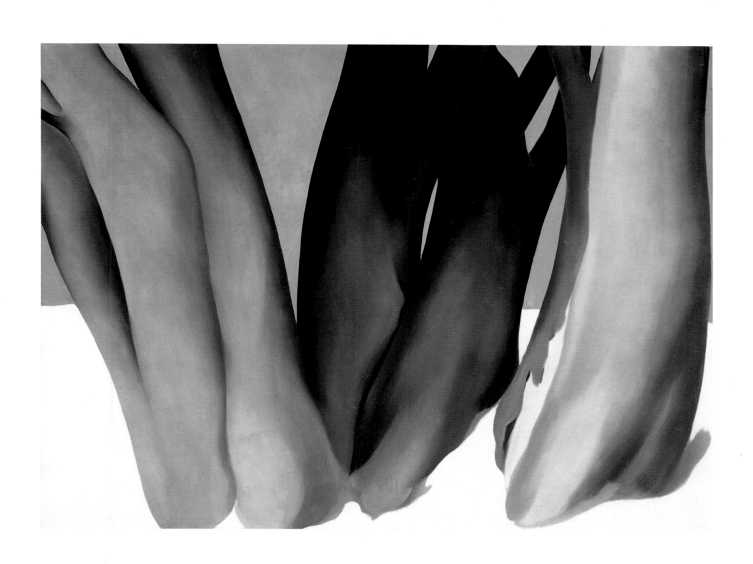

44. BARE TREE TRUNKS WITH SNOW, 1946

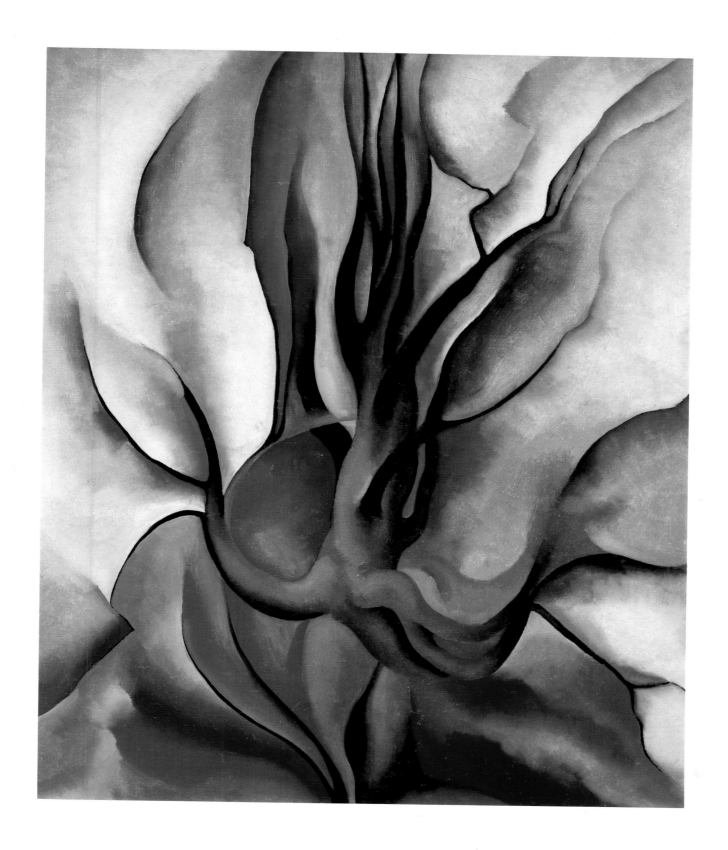

45. AUTUMN TREES — THE MAPLE, 1924

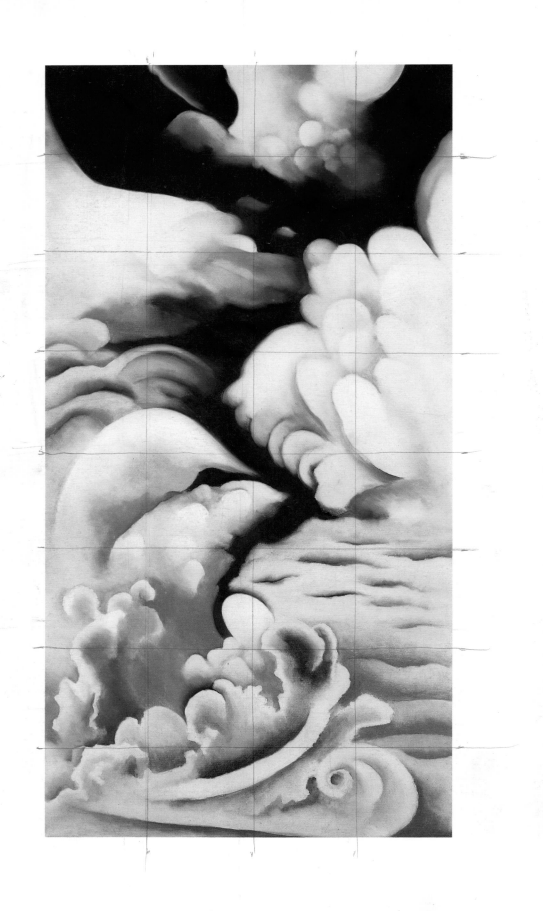

46. A CELEBRATION, 1924

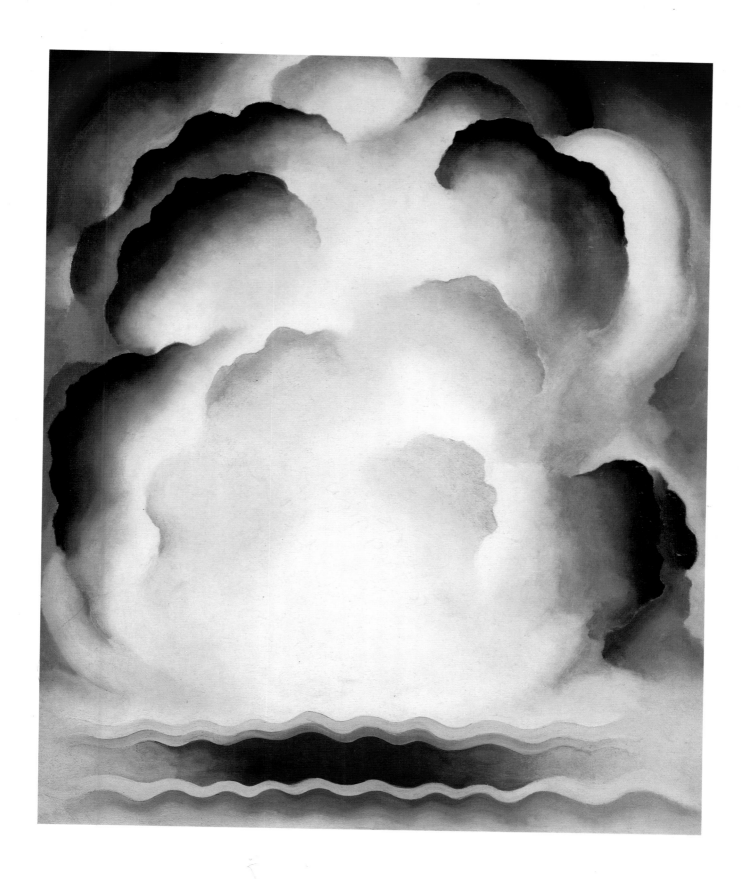

47. ABSTRACTION — ALEXIS, 1928

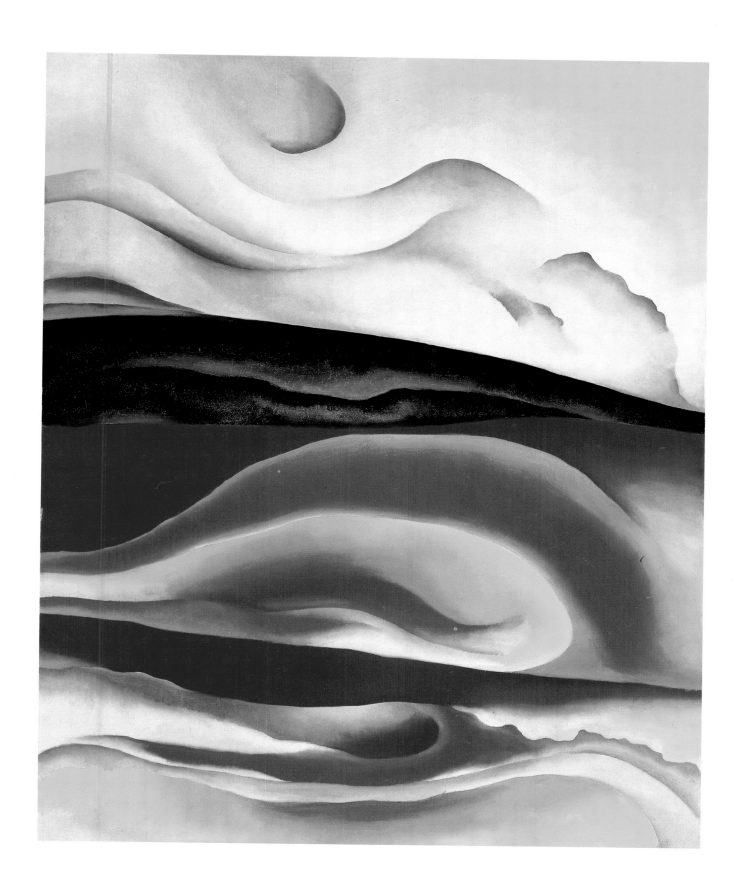

48. RED, YELLOW, AND BLACK STREAK, 1924

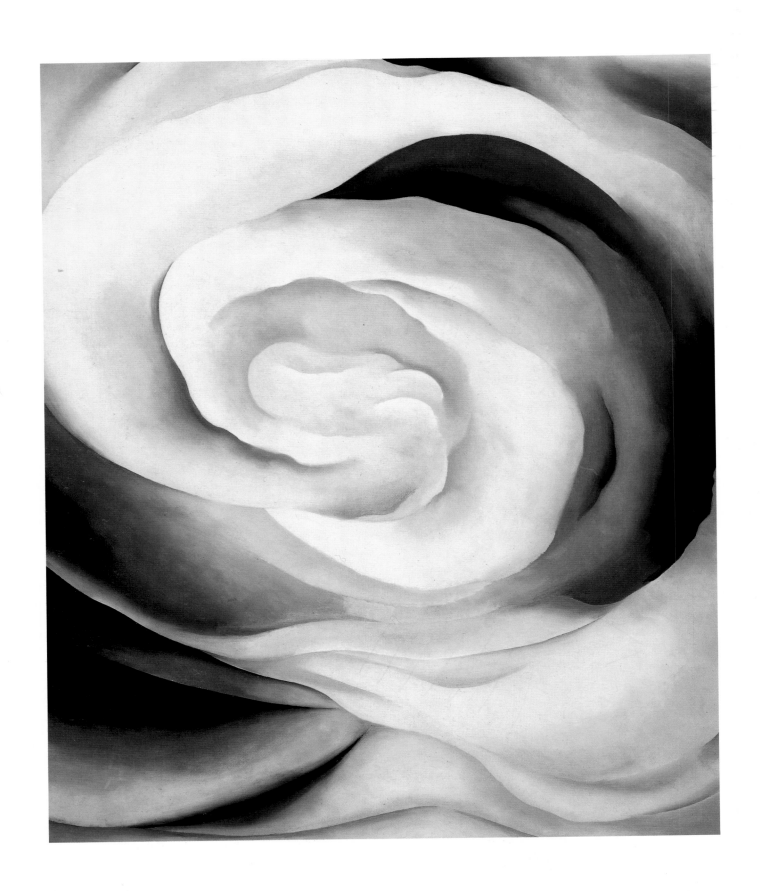

49. ABSTRACTION, WHITE ROSE II, 1927

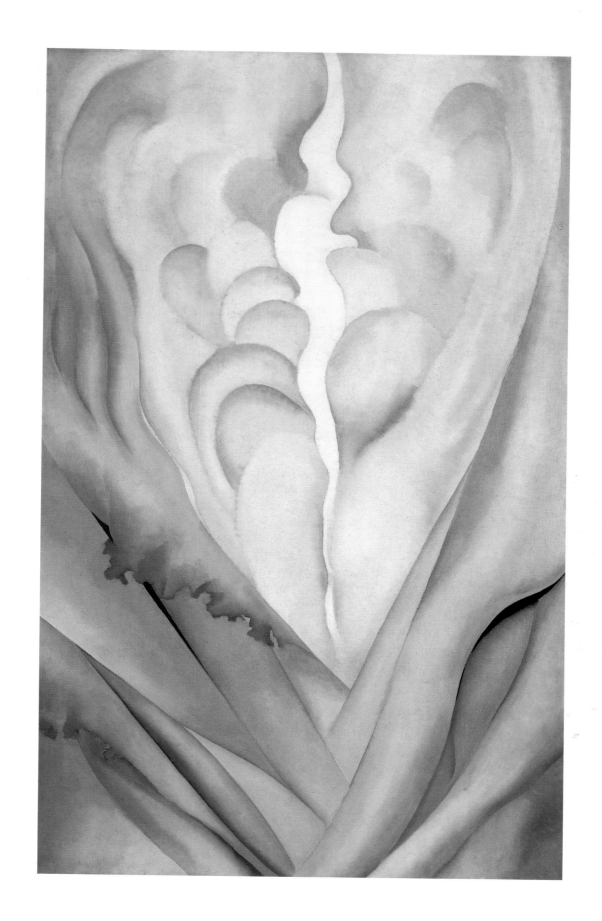

50. FLOWER ABSTRACTION, 1924

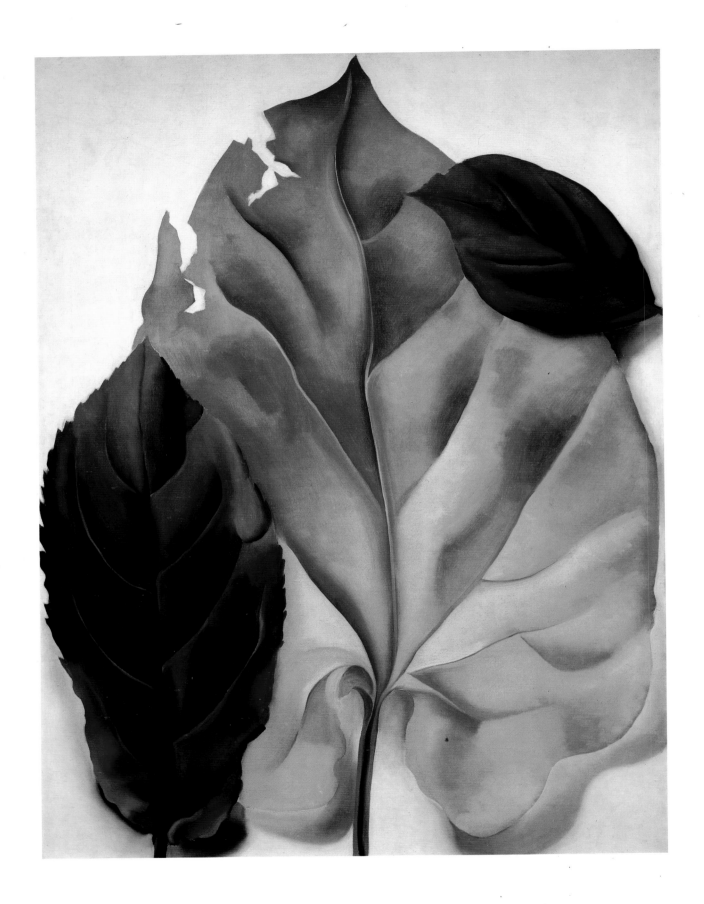

51. BROWN AND TAN LEAVES, 1928

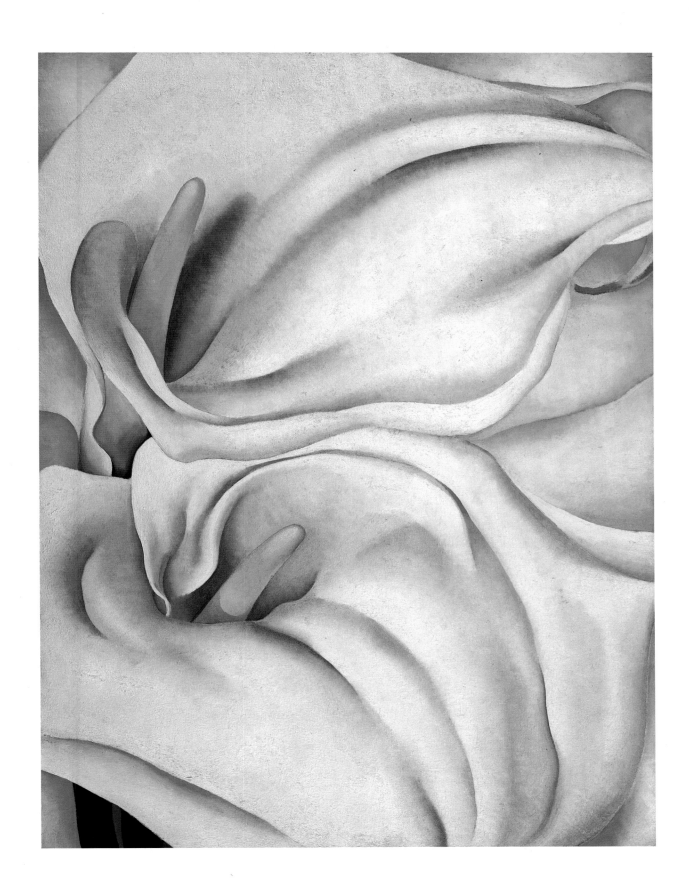

52. TWO CALLA LILIES ON PINK, 1928

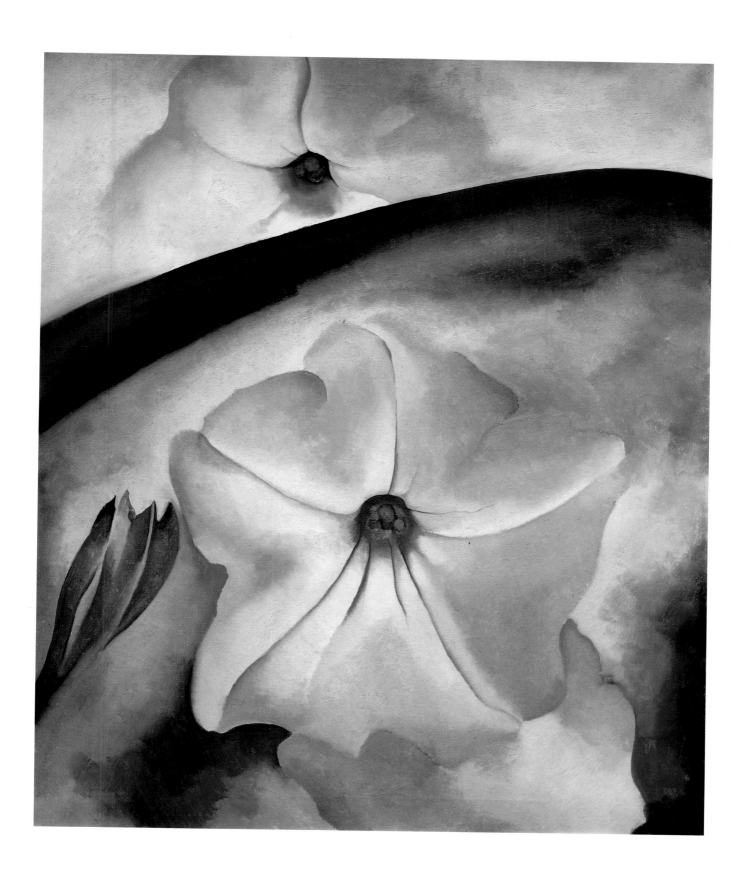

53. PETUNIA NO. 2, 1924

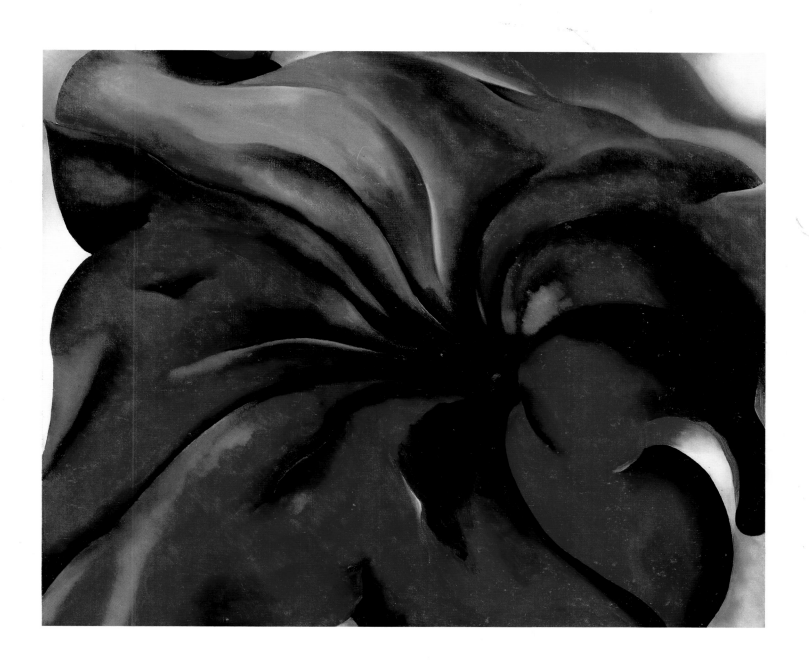

54. PURPLE PETUNIA, 1927

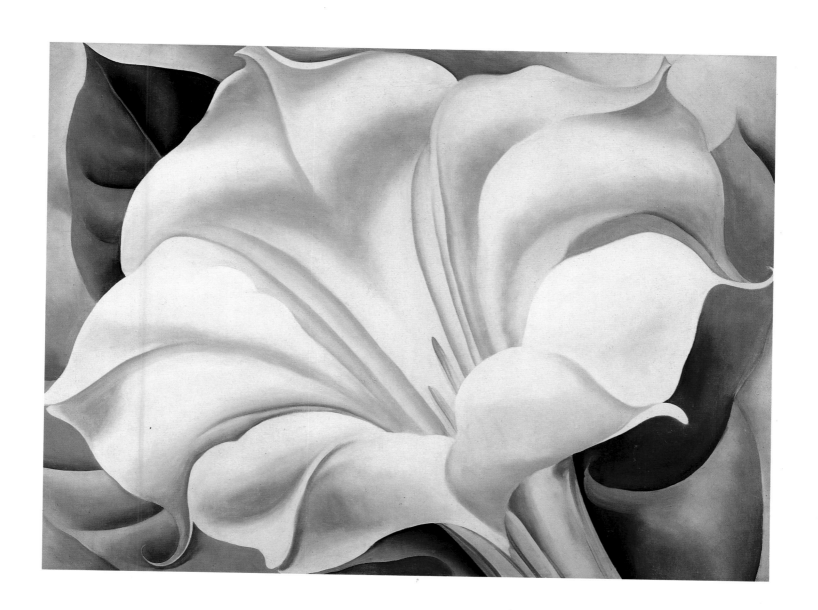

55. WHITE TRUMPET FLOWER, 1932

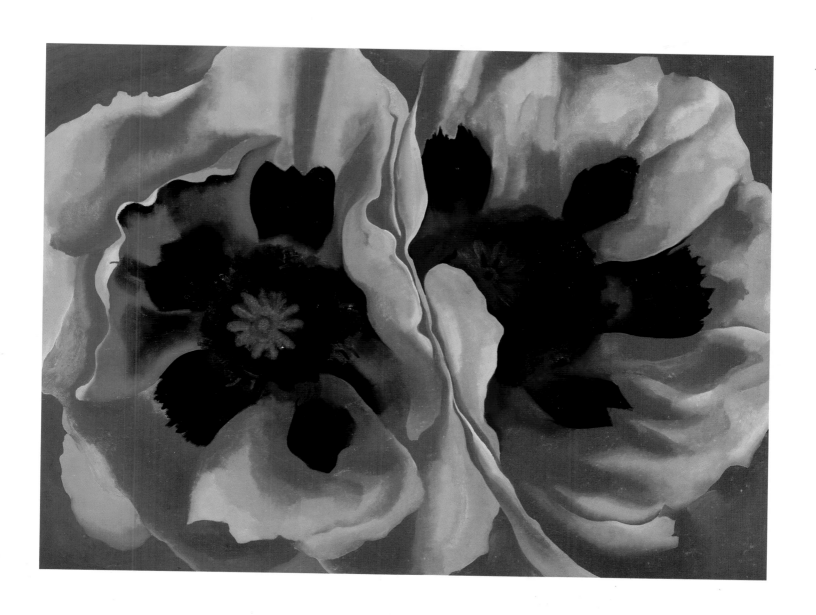

56. ORIENTAL POPPIES, 1928

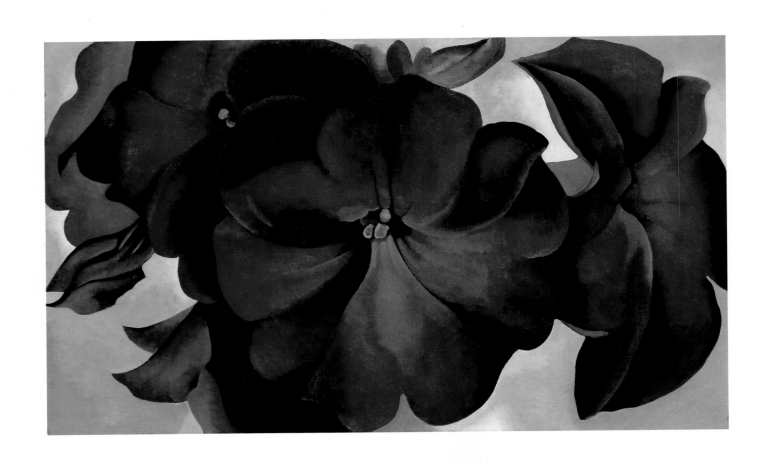

57. PETUNIAS, 1925

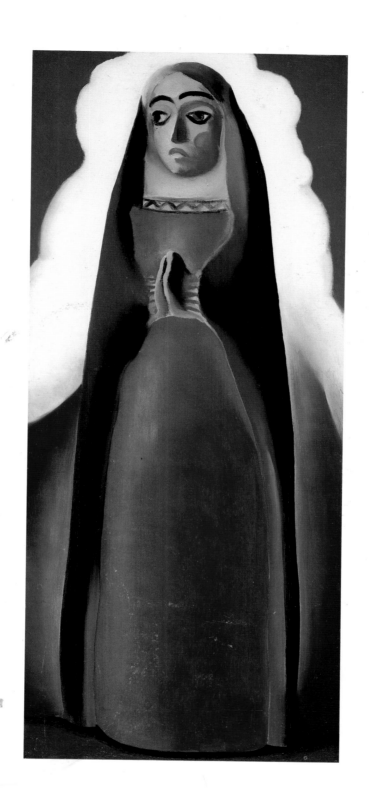

58. WOODEN VIRGIN, 1929

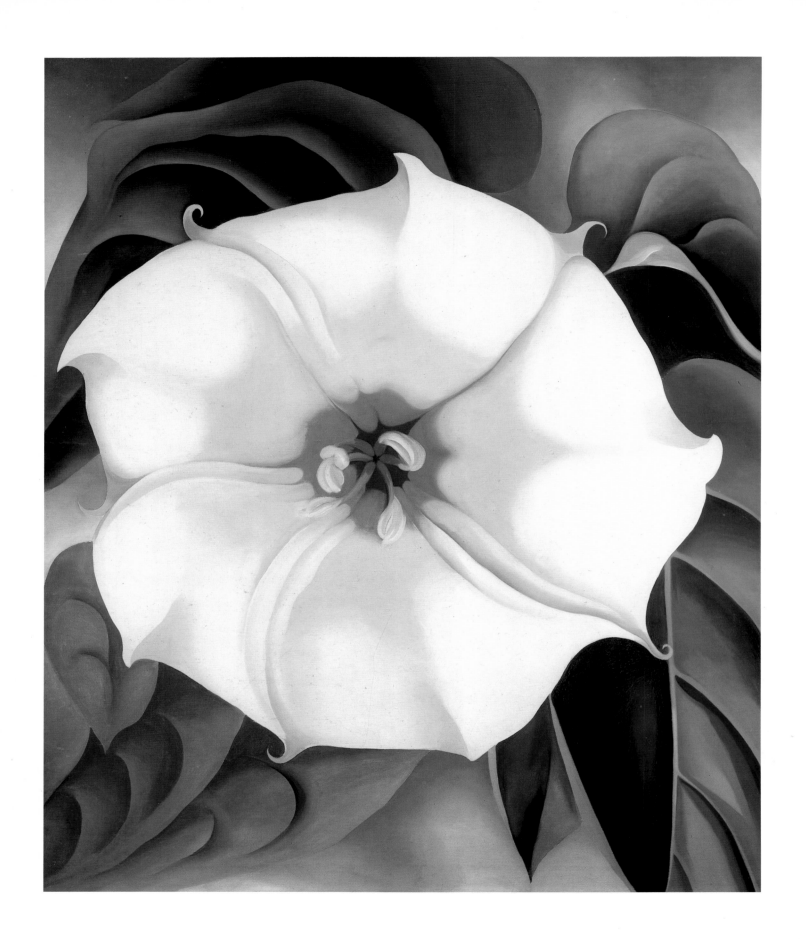

59. JIMSON WEED, 1932

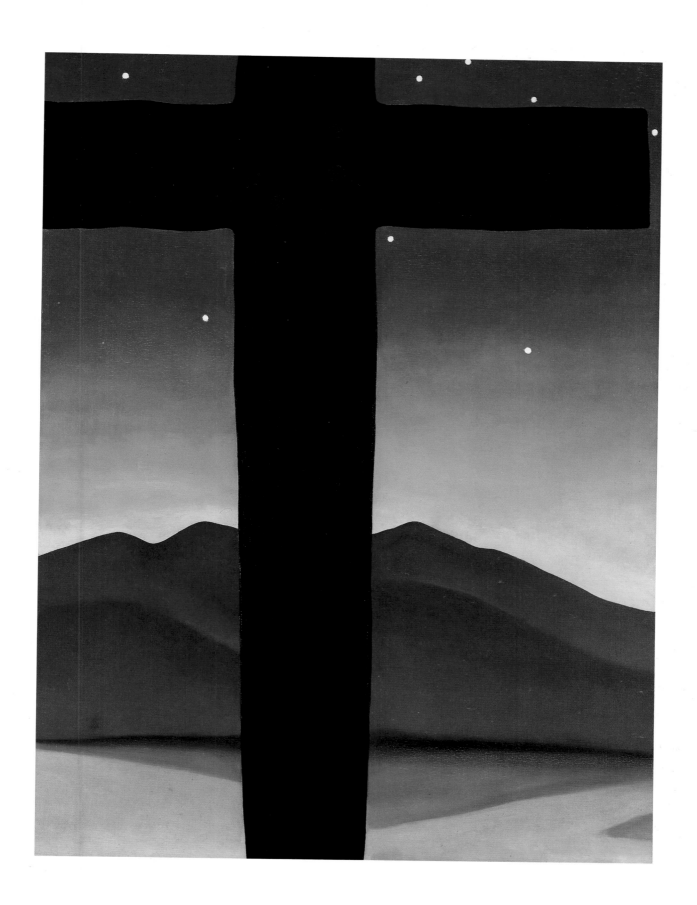

60. BLACK CROSS WITH STARS AND BLUE, 1929

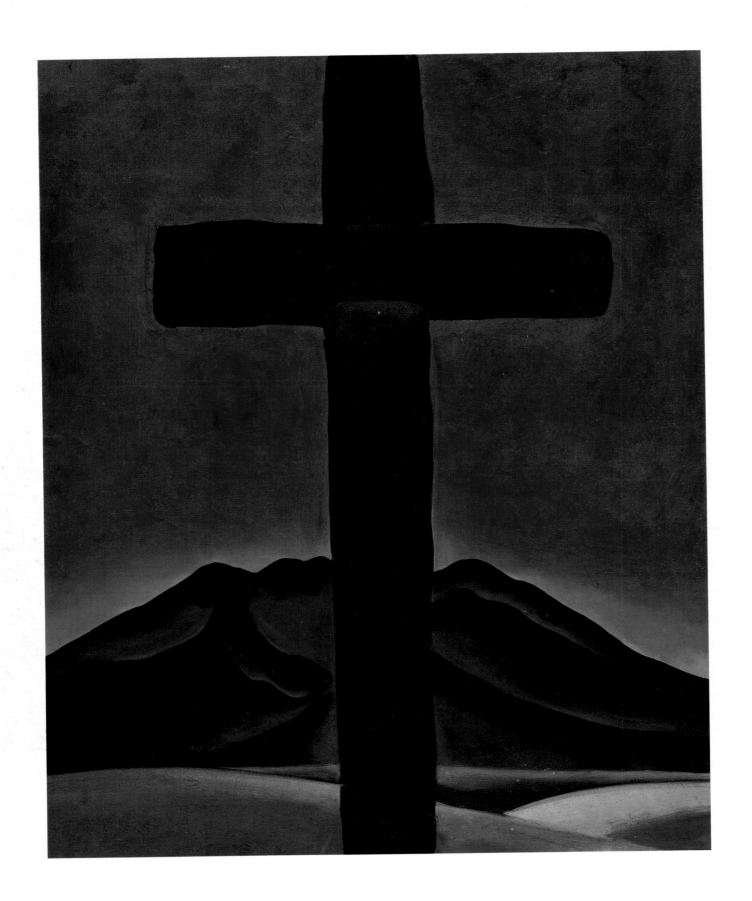

61. BLACK CROSS WITH RED SKY, 1929

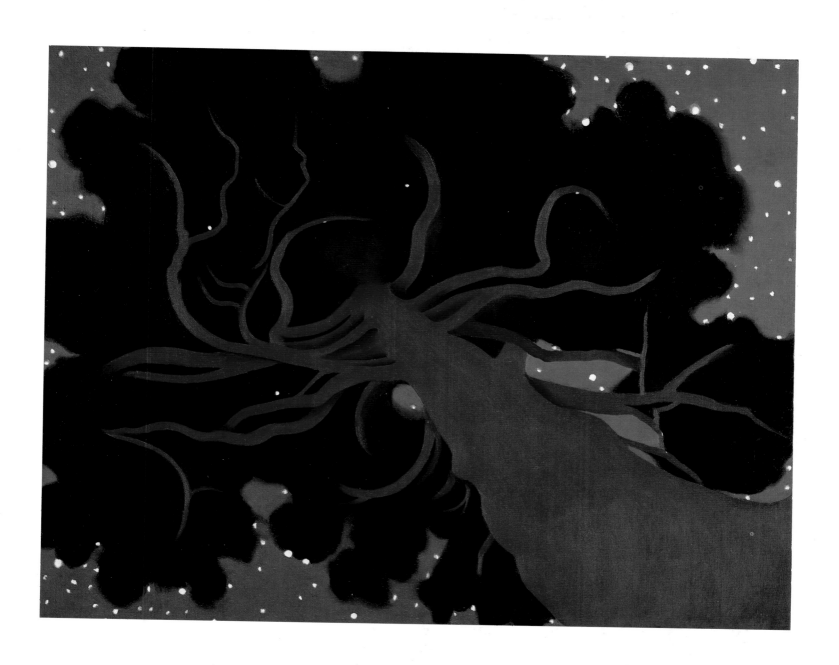

62. THE LAWRENCE TREE, 1929

63. DEAD TREE, BEAR LAKE, 1929

64. VIEW FROM MY STUDIO, NEW MEXICO, 1930

65. FROM THE FARAWAY NEARBY, 1937

66. PELVIS WITH PEDERNAL, 1943

67. RIB AND JAWBONE, 1935

68. SMALL PURPLE HILLS, 1934

69. CLIFFS BEYOND ABIQUIU, DRY WATERFALL, 1943

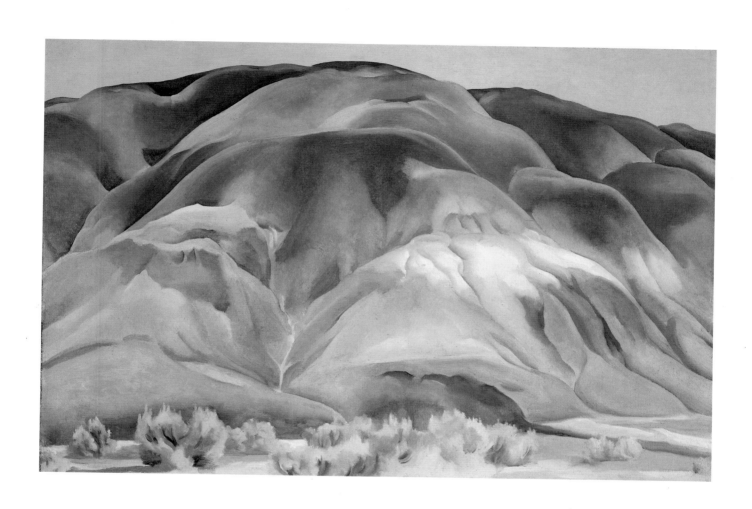

71. GRAY HILL FORMS, 1936

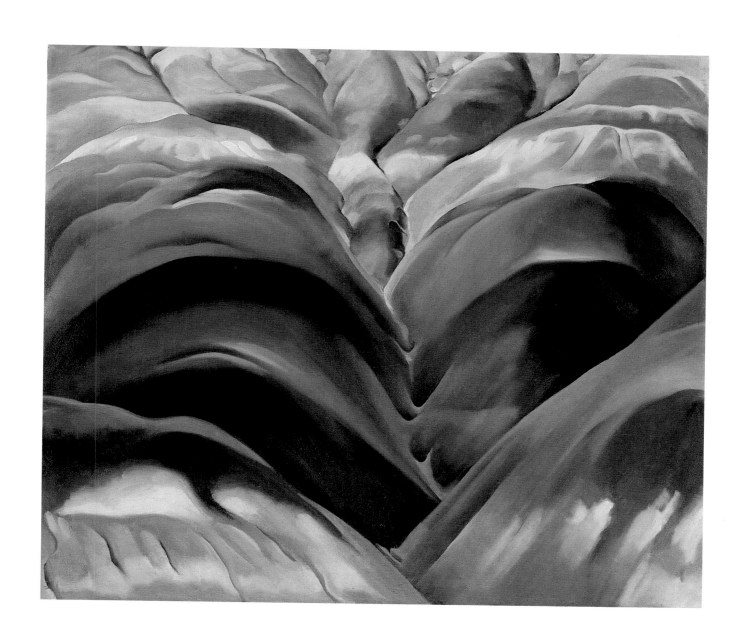

72. BLACK PLACE NO. I, 1944

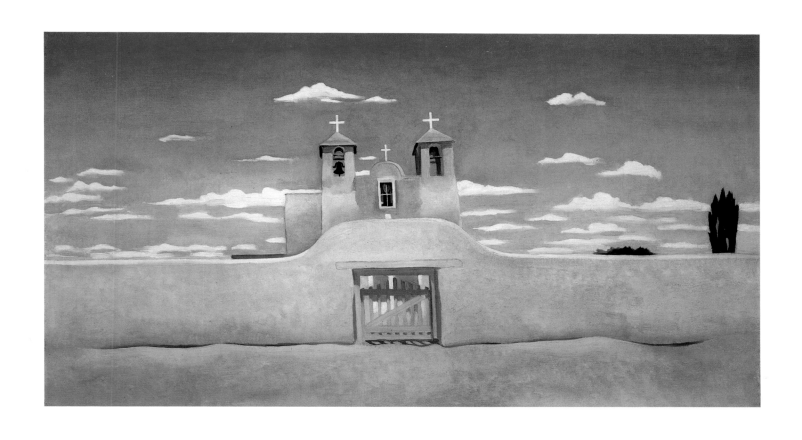

73. FRONT OF RANCHOS CHURCH, 1929

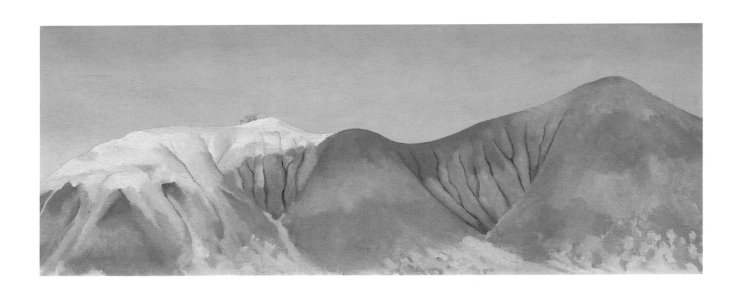

74. SERIES I: NEAR ABIQUIU, N.M. — HILLS TO THE LEFT, 1941

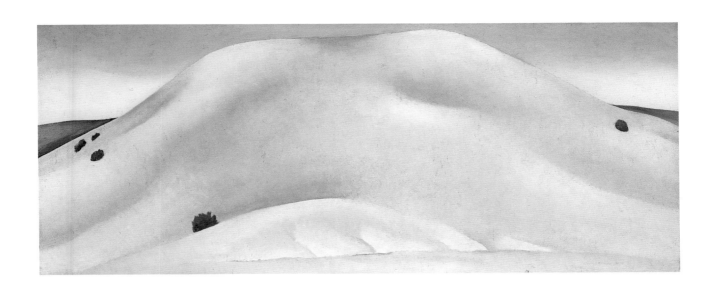

75. SOFT GRAY, ALCALDE HILL, 1929–1930

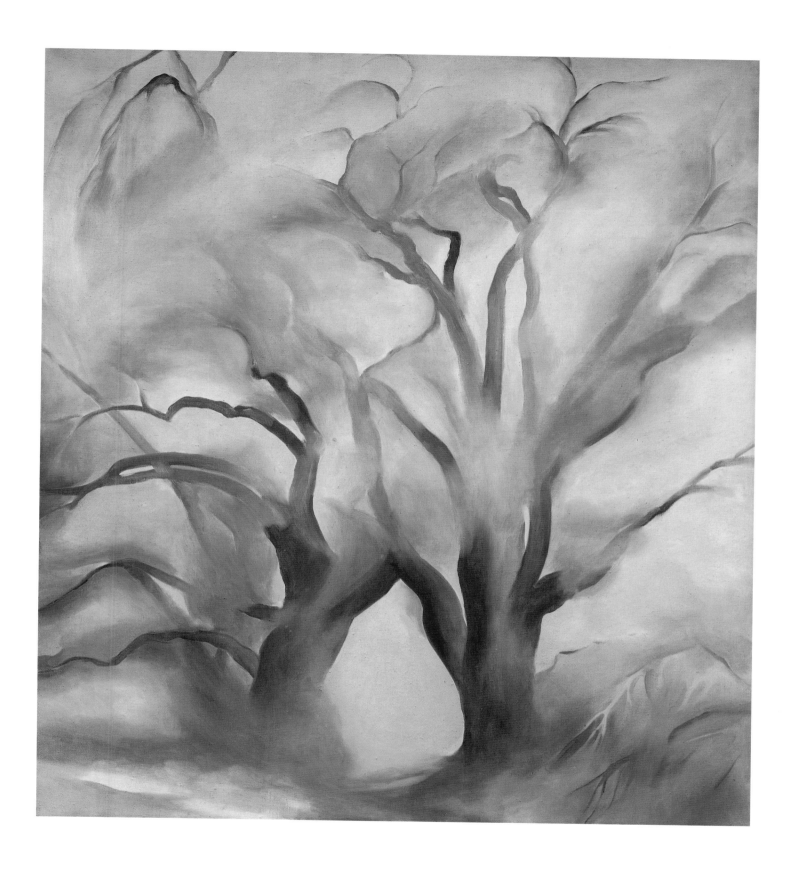

76. WINTER COTTONWOODS EAST NO. V, 1954

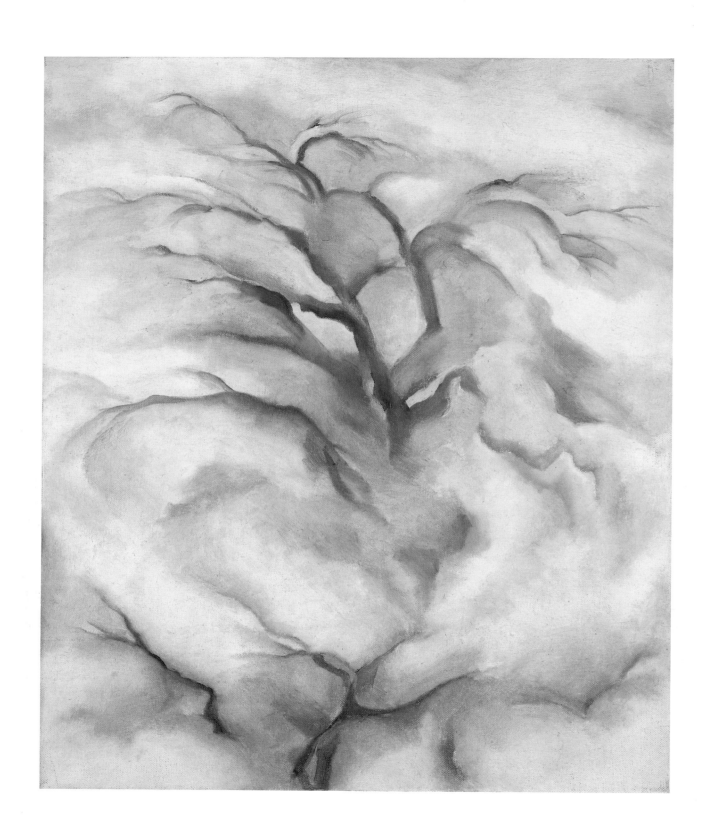

77. WINTER TREES, ABIQUIU I, 1950

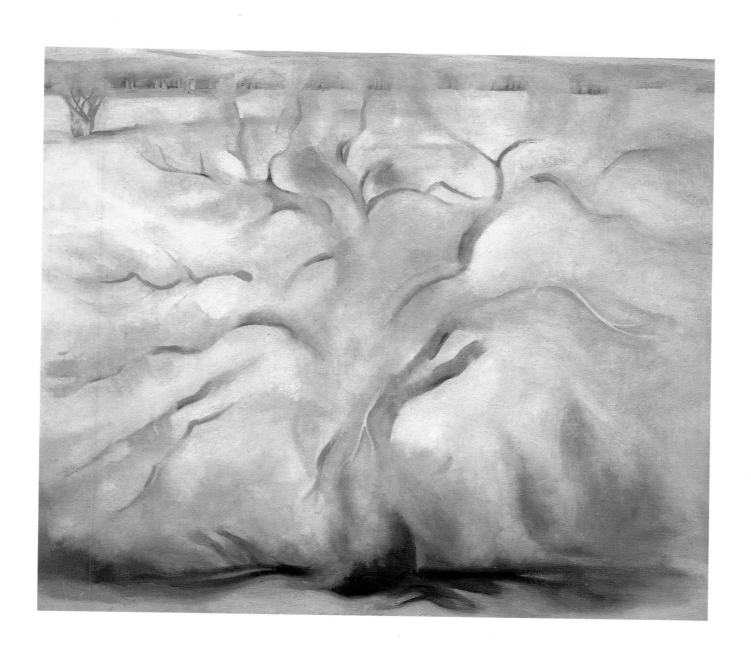

78. WINTER TREES, ABIQUIU NO. II, 1950

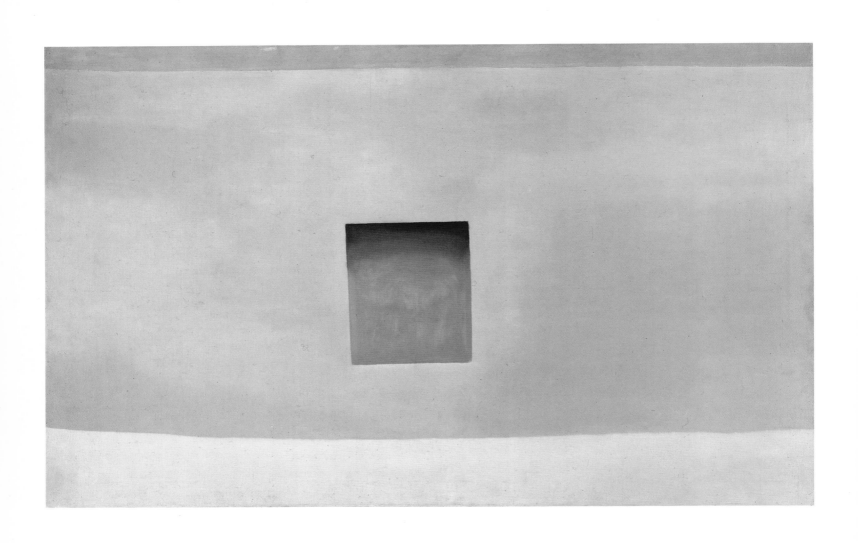

79. WALL WITH GREEN DOOR, 1952

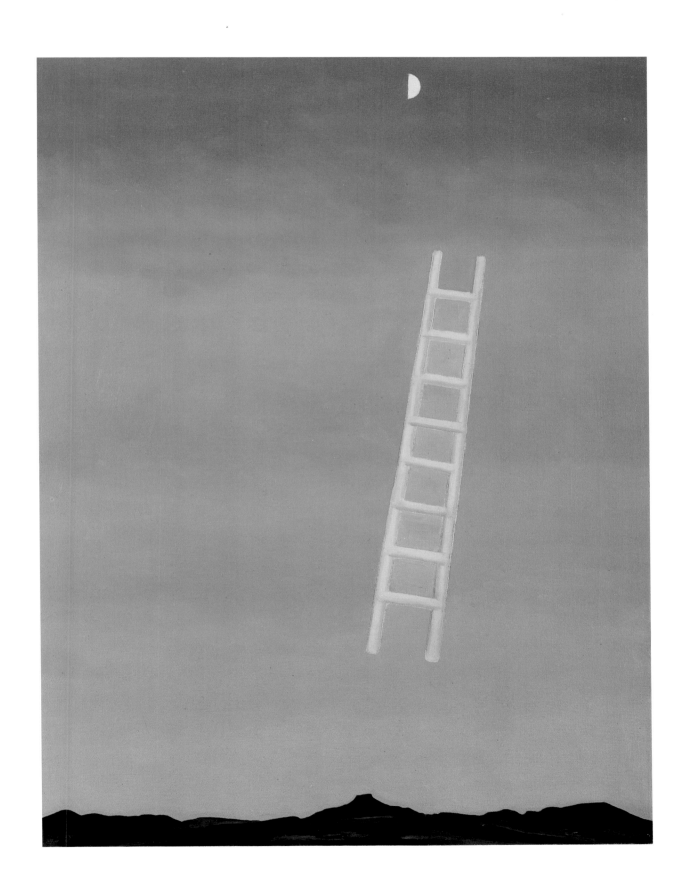

80. LADDER TO THE MOON, 1958

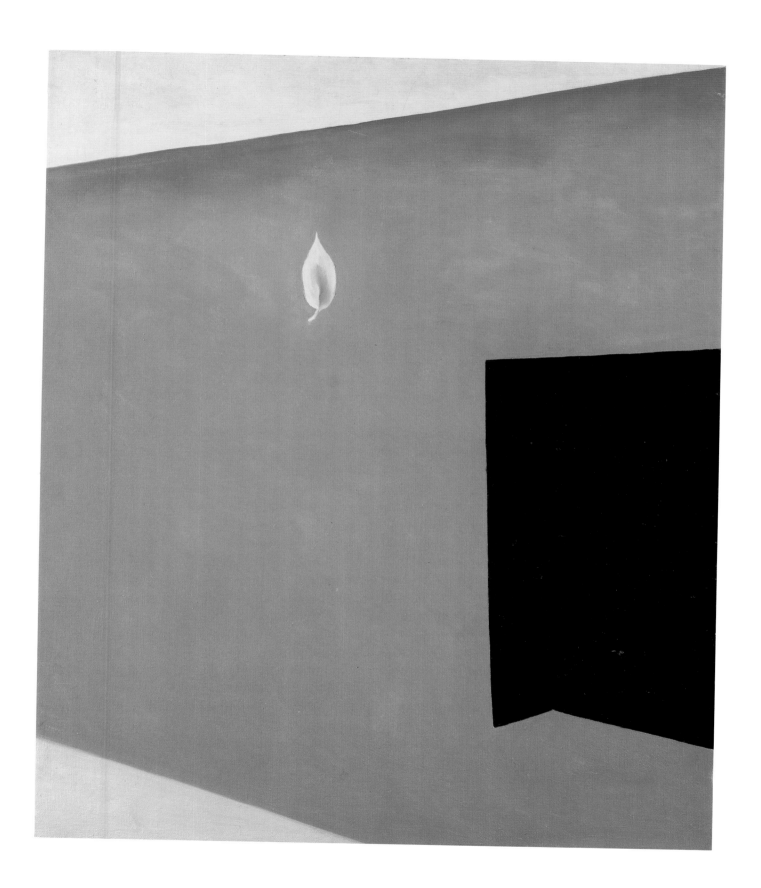

81. PATIO WITH GREEN LEAF, 1956

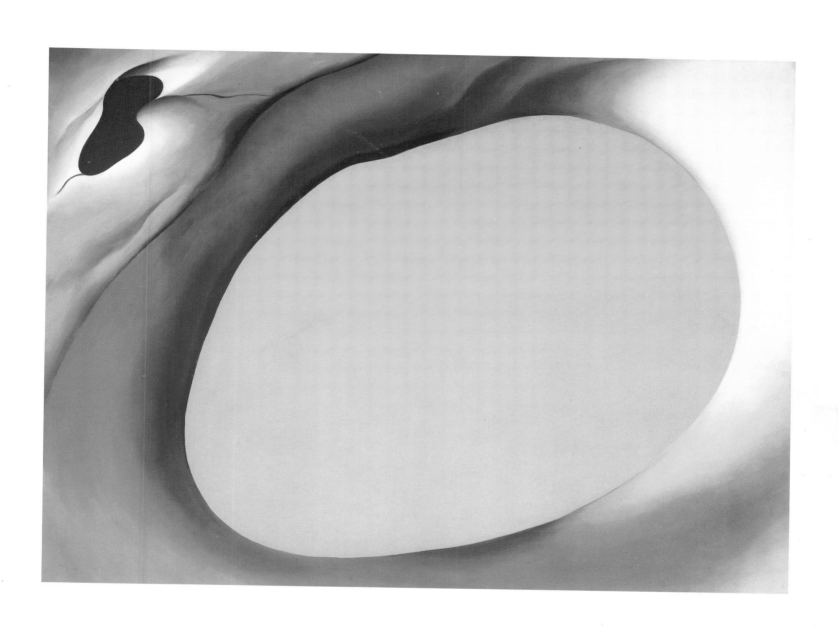

82. PELVIS SERIES — RED WITH YELLOW, 1945

83. WINTER ROAD I, 1963

84. BLUE B, 1959

85. SKY ABOVE WHITE CLOUDS I, 1962

86. IT WAS YELLOW AND PINK II, 1960

87. DRAWING III, 1959

88. DRAWING IX, 1959

89. DRAWING V, 1959

GEORGIA O'KEEFFE:

AMERICAN AND MODERN

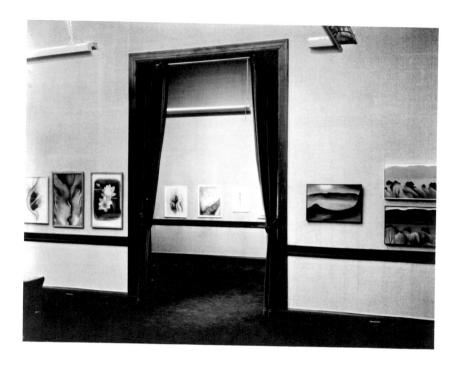

1. *O'Keeffe Exhibition (Side Gallery), Anderson Galleries, New York, 1923.* Alfred Stieglitz. National Gallery of Art, Alfred Stieglitz Collection.

EVEN BY the buoyant standards of its day, Georgia O'Keeffe's exhibition of 1923 was a remarkable affair. The show was her third organized by Alfred Stieglitz, the artist-impresario who had introduced her avant-garde work to the public seven years earlier. But not since 1917, when Stieglitz had marked the closing of his own gallery with O'Keeffe's first one-person show, had her work been seen by an avid New York audience.

O'Keeffe's new show was presented from January 29 through February 10 at the Anderson Galleries, whose fashionable midtown Manhattan address (Park Avenue and Fifty-ninth Street) provided a convenient destination for the many collectors, critics, artists, and other admirers who regularly flocked to Stieglitz's memorable exhibitions of modern art. Its high-ceilinged, skylighted main gallery (fig. 2) housed most of O'Keeffe's recent paintings and pastels, which were artfully arranged above the dark wainscoting, sometimes in double or treble tiers; through the portiere to an adjacent smaller room, visitors could see her early charcoal drawings simply installed "on the line" (fig. 1).

Between the demise of his 291 gallery (so-called for its Fifth Avenue address) and the opening of his Intimate Gallery in 1925, Alfred Stieglitz — master photographer, proselytizer for the avant-garde, and showman

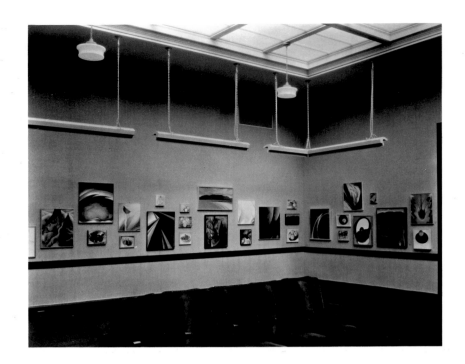

2. *O'Keeffe Exhibition (Main Gallery), Anderson Galleries, New York, 1923.* Alfred Stieglitz. National Gallery of Art, Alfred Stieglitz Collection.

extraordinaire – continued the advocacy of "his" modern artists with occasional exhibitions presented on others' premises. Under his aegis, John Marin, for instance, exhibited at the Montross and Daniel galleries in New York in the early 1920s. With Stieglitz's help, Arthur Dove and Marsden Hartley sold their paintings at the Anderson Galleries, and the impresario showed his own work there several times. Hence, the showing of Georgia O'Keeffe's pictures in 1923 conformed to a pattern of enterprises during Stieglitz's galleryless years of the early 1920s.

Amid the general acclamation of O'Keeffe's paintings and drawings, the curious titling of the exhibition went generally unremarked. The cover of the brochure for the show portentously read:

<div align="center">

ALFRED STIEGLITZ

PRESENTS

ONE HUNDRED PICTURES

OILS, WATER-COLORS

PASTELS, DRAWINGS

BY

GEORGIA O'KEEFFE

AMERICAN[1]

</div>

Stieglitz's typically distinctive layout and eccentric punctuation called attention to GEORGIA O'KEEFFE AMERICAN, a typographical equation of name and nation. Yet rare was the critic who, like Elizabeth Luther Cary, wondered "just why Alfred Stieglitz . . . should insist upon Miss O'Keeffe's Americanism."[2] Stieglitz's acolyte and amanuensis, Herbert J. Seligmann, noted that O'Keeffe's painting was "entirely and locally American, with a proud and unaccustomed mastery"; however, although he was encouraged that "American aspects are identified and made per-

sonal" in her work, Seligmann failed to explain what those aspects were or how they were identified.[3]

Shortly before her exhibition at the Anderson Galleries, the artist had suggested her own priorities and had hinted at the significance of Stieglitz's designation of her as American. In a letter to the editor of the avant-garde journal *MSS.*, she explained her professional development:

> *I studied art at the Art Institute of Chicago, at the Art Students League of New York, at Teachers College, Columbia University, at the University of Virginia.*
>
> *I even studied with [William Merritt] Chase and [George] Bellows and Professor [Arthur Wesley] Dow. I am sorry that I missed [Robert] Henri.*
>
> *I am guilty of having tried to teach Art for four summers in a university summer school and for two years in a state normal [school] but I don't know what Art is. No one has ever been able to give me a satisfactory definition.*
>
> *I have not been in Europe.*[4]

Her laconic record of training and travel, ironic in tone, ends on a telling note. Whereas most of her generation had been pilgrims *to* Europe, O'Keeffe had not even been *in* Europe, thereby avoiding both immersion and obeisance. Her independence rested in her innocence: she was "guilty" of not knowing what Art is, of not having been in Europe. O'Keeffe herself helped to advance the impression of the native innocent, untainted by foreign culture; for instance, recalling aesthetic debates within the Stieglitz circle ("long involved remarks about the 'plastic quality' of [Cézanne's] form and color"), she retained an almost defiant pride that "I was an outsider. My color and form were not acceptable. It had nothing to do with Cézanne or anyone else. I didn't understand what they were talking about."[5]

Paul Strand, the photographer and fellow intimate in Stieglitz's coterie, understood this distinction. "Just now," he explained, "it is the fashion to bow the head in wonder before everything European, even before a tenth rate example of a second rate worker backed by money and a list of names." Hence, the appearance of an artist who had not traveled to Europe, who had emerged from native studios and homegrown traditions, was "an event of the most profound significance," one that emboldened him and his fellow artists. "Things of the mind and of the spirit are being born here in and of America," he wrote, "as important to us and to the world as anything which is 'made in' France or Germany, in Russia, Czecho-Slovakia or anywhere else." Imitating the work neither of men nor of foreigners, Georgia O'Keeffe's art opened up "vast new horizons in the evolution of painting as incarnation of the human spirit." For Strand, the greatest wonder was that "here in America this amazing thing has happened."[6]

Stieglitz explained his sponsorship of O'Keeffe's work in a similar vein, but more bluntly. His ardent nationalist spirit was evident in correspondence with his admirer the young critic Paul Rosenfeld, to whom he worried: "Are we only a marked down bargain day remnant of Europe? — Haven't we any of our own courage in matters 'aesthetic'?" Stieglitz dreamed of an "America without that damned French flavor!" Finally, he

confessed: "That's why I'm really fighting for Georgia. She *is* American."[7]

Beginning then, and continuing to this day, many critics regarded the period from 1880 to 1940 as one "when French was synonymous with modern."[8] Stieglitz's contest with "that damned French flavor" was an effort to supplant the traditional equation, to explore the possibilities of being at once American *and* modern. It was not an easy campaign, but neither was it his alone. The struggle for a distinctive native expression gripped many creative Americans in the early decades of this century.

ABSTRACTIONS

GEORGIA O'KEEFFE'S first solo exhibition, at Stieglitz's 291 gallery in April 1917, marked the debut of her mature artistic vision. Over the previous decade, she had come into contact with a wide range of stimulating concepts and novel images. It was the absorption of these, and their transformation into her personal idiom, that was apparent in the remarkable works on view at 291.

O'Keeffe had studied with some of the most accomplished and influential tutors of the day, starting with John Vanderpoel and his drawing classes at the School of the Art Institute of Chicago in 1905. Subsequent instruction with the dashing William Merritt Chase at the Art Students League in New York City (1907–1908) helped develop O'Keeffe's special sensibility for still life. The time she spent with the prolific Chase imbued her with a great sense of industry and left an indelible impression of the seriousness of the painter's craft, but it also left her frustrated. "I'd been taught to paint like other people," she explained years later, "and I thought, what's the use? I couldn't do any better than they, or even as well. I was just adding to the brushpile. So I quit."[9]

It was the art theories of Arthur Wesley Dow that finally led her back to the studio. Unlike most American art instructors, who stressed practice in imitative drawing, Dow took his cue from the Japanese and emphasized principles of harmonious composition. "The Japanese know of no such divisions as Representative and Decorative," he taught. "They conceive of paintings as the art of two dimensions; an art in which roundness and nature-imitation are subordinate to the *flat* relationship. . . . [The Japanese artist] loves nature and goes to her for his subjects, but he does not imitate."[10] The Dow system was for O'Keeffe a novelty – and a liberation. Instructors at the Art Students League had emphasized representation and deplored the unregulated exploitation of individuality; the new method, by contrast, prized individual expression. "It is not the province of the landscape painter," Dow wrote, "merely to represent trees, hills and houses – so much topography – but to express an emotion, and this he must do by art."[11]

She had first encountered Dow's orientalizing principles via his disciple, Alon Bement, at the University of Virginia in 1912. Finally, she had the opportunity to study directly with Dow, at Columbia University Teachers College in New York from the autumn of 1914 to the following spring, and again in the spring of 1916. A year later, Professor Dow loyally visited his former student's show at 291 and warmly praised "the simplici-

ty of your designs and the harmonious rhythm that you had expressed so well" – lessons she had learned from him.[12]

Other formative influences came from outside the classroom and studio. O'Keeffe's correspondence is studded with references to her extensive readings on feminism, politics, and current events, as well as on art and aesthetic theory; doubtless the most influential of these was Alfred Stieglitz's avant-garde journal, *Camera Work.* Another challenging and rewarding encounter was with Wassily Kandinsky's important treatise *Concerning the Spiritual in Art;* O'Keeffe reported that by 1915 she was testing herself on his sophisticated aesthetic theory for the *second* time. By her own admission, however, "it was some time before I really began to use the ideas. I didn't start until I was down in Carolina – alone – thinking things out for myself."[13]

Late in 1915, while teaching art in South Carolina, O'Keeffe had made the bold decision to reshape her career. After examining her accumulated work of the previous decade, she determined to purge the mannerisms acquired from her mentors; rather than trying to fulfill the expectations of others, she would "think things out for myself."[14] As she later explained:

I grew up pretty much as everybody else grows up and one day seven years ago found myself saying to myself – I can't live where I want to – I can't go where I want to – I can't do what I want to – I can't even say what I want to. School and things that painters have taught me even keep me from painting as I want to. I decided I was a very stupid fool not to at least paint as I wanted to and say what I wanted to when I painted as that seemed to be the only thing I could do that didn't concern anybody but myself – that was nobody's business by my own.[15]

She began by drawing the "things in my head that are not like what anyone has taught me – shapes and ideas so near to me – so natural to my way of being and thinking that it hasn't occurred to me to put them down."[16] These unexpected, abstract forms she drew in charcoal, for the moment banishing color as well as recognizable subject matter from her repertoire.

Although suggestions of the figure and of natural forms appeared in some of the drawings, it was their tendency toward simplified abstraction that was most pronounced. To his students and to readers of his treatise *Composition,* one of the most widely distributed art texts of the early twentieth century, Professor Dow had emphasized the importance of the Japanese concept of *notan,* the balanced values of darks and lights, as the basis of his compositional system. It was this decorative approach that led to O'Keeffe's lifelong effort "to fill a space in a beautiful way,"[17] as first evinced in the drawings whose particular importance she emphasized with the series title *Special.*

The *Special* drawings early revealed a dichotomy in O'Keeffe's vision between the geometric and the organic; the abstract works incorporated both rhythmically rounded forms and crisp angular shapes, which were sometimes combined in a single image. In short order, the forms developed in these works provided the basis for some of O'Keeffe's most hermetic abstract paintings of about 1919 to 1920, works that are arguably

3. *Falls in January,* about 1895, oil on canvas. John Twachtman. The Roland P. Murdock Collection, Wichita Art Museum, Wichita, Kansas.

4. *"Modern Art" (Poster),* 1895, color lithograph. Arthur Wesley Dow. Spencer Museum of Art, The University of Kansas. Letha Churchill Walker Fund.

the most sophisticated ones produced by any American artist of her generation. Some of them represent the fullest expression of an aspect of her vision first developed in the *Special* drawings: the interest in angular geometric patterns, which was to resurface in abstractions of the late 1920s and in various architectural themes of later years. They were, however, but one part of the complicated formal vocabulary the artist invented in those crucial works.

Among the drawings unveiled at 291 were others of a very different character, featuring organic patterns that provided the morphological counterpoint to the geometric designs. These swelling, undulant forms related to the flowing patterns of Art Nouveau, which was the aesthetic birthright of turn-of-the-century children such as O'Keeffe. Parallels may also be drawn with the decorative shapes employed by compatriots such as Albert Pinkham Ryder, in his simplified moonlit marines, or John Twachtman, in his snowbound scenes of the 1880s and 1890s (fig. 3). Further, O'Keeffe's flowing curves and countercurves may also reflect the sinuous forms found in the 1890s in American poster design, a graphic renaissance to which Dow made significant contributions (fig. 4); the forms could even reflect the architectural decoration of Louis Sullivan, whose Chicago-based influence was echoed in buildings throughout the region, including southern Wisconsin, O'Keeffe's childhood home. In fact, Art Nouveau's formal vocabulary was nearly ubiquitous in American art and design at the turn of the century, and it provides one obvious foundation for O'Keeffe's organic inventions.

The curvilinear *Specials* evoke affinities across cultures as well as across time. Their dynamic rhythms suggest the organic vitality possible in abstractions from nature, such as the innovative vegetal designs of Henri van de Velde, master of the Belgian fin de siècle. Alternatively,

O'Keeffe's flowing curves are curiously reminiscent of southern Song landscape painting, such as Ma Yuan's river views, a model Dow would most likely have endorsed. As with the geometric abstractions, O'Keeffe's organic shapes of the mid-1910s are pivotal, looking Janus-like to the Art Nouveau past or more distant sources, while containing the germ of modern expression.

Her experiments of the mid-1910s provided a formal vocabulary, the basis for later compositional experiments. For example, in 1924 Stieglitz reported that, in the midst of an especially productive autumn at Lake George, "Georgia has done some amazing canvases. Intimately related to the early drawings which so overwhelmed me when brought to me the first time back in 1916."[18] The early works continued for decades to provide her with inspiration. In 1969, when O'Keeffe was reviewing these bold works on paper in preparation for her retrospective at the Whitney Museum of American Art, she remarked to the curator: "We don't really need to have the show, I never did any better."[19]

TO THE reviewers of O'Keeffe's first exhibitions, her work seemed innovative, unburdened by convention, refreshingly direct in statement – in short, modern. Their reactions anticipated and shaped the tone of subsequent critical response. When they were displayed at 291, her abstract designs in charcoal earned acclaim from critics and artists alike. They drew the attention of William Murrell Fisher, whose thoughts, published in *Camera Work,* bore the implicit approval of Stieglitz, its editor. Fisher's reveries suggest the pervasive subjectivity of criticism at that time. He found in the drawings evidence of a "consciousness . . . that one's self is other than oneself, is something larger, something almost tangibly universal, since it is *en* rapport with a wholeness in which one's separateness is, for the time, lost." In other words, Fisher was moved by the transcendence, an Emersonian merging of the self and the universal, that was suggested by the drawings. He characterized the works as "mystical and musical," and therein suggested two traits that have been of continuing interest to reviewers ever since.[20]

Henry Tyrrell, to whom went the honor of being the first to publish commentary on O'Keeffe's art, likewise found a revelation in these drawings "alleged to be of thoughts, not things." Using language and concepts that others would perpetuate for generations, Tyrrell concluded that the abstractions presented "the innermost unfolding of a girl's being, like the germinating of a flower."[21] The judgment, tinged with Freudian overtones, was echoed and amplified by Stieglitz, who "had never before seen woman express herself so frankly on paper." He found the drawings "of intense interest from a psycho-analytical point of view," perhaps because through the subconscious one might appreciate an art that, as Fisher observed, lay "beyond the grasp of reason."[22]

Tyrrell reiterated his position in 1917. O'Keeffe, he thought, had in the new drawings, watercolors, and oil paintings "found expression . . . for 'what every women knows,' but what women heretofore have kept to themselves." He considered the drawings "purely symbolistic, a sort of allegory in sensitized line," and as an example interpreted a design of

paired verticals as "a man's and a woman's [lives], distinct yet visibly joined together by mutual attraction, grow[ing] out of the earth like two graceful saplings."[23] The human inferences, freighted with sexual innuendo, came to typify much of the commentary on the artist, particularly in the 1920s. Additionally, in the reiterated references to nature – germinating flowers, graceful saplings – Tyrrell provided the basis for ongoing discussions of the artist's organic imagery, which also became a significant leitmotif in the literature on O'Keeffe.

Thus, within a year of the artist's debut, critics had already sketched many of the major themes that would occupy their attention over the balance of her long life. They continue to do so today.

DISCUSSION of formal elements – color, line, composition – was, however, minimal in the early reviews, which concentrated instead on subjective, emotional issues. In lieu of formal explications, critics were moved to rhapsodies over O'Keeffe's "emotional forms quite beyond the reach of conscious design, beyond the grasp of reason."[24] This neglect seems particularly strange in light of her own faith in pictorial form, which she often expressed: "Colors & line & shapes seem for me a more definite statement than words –."[25] Henry Tyrrell did marvel at her "technical abilities quite out of the common," a finesse that left other artists "wonder[ing] at [her] technical resourcefulness."[26] But more specific discussion was scant.

The charcoal designs predictably elicited no commentary on O'Keeffe's color; even its striking absence from the monochromatic drawings went unremarked. The few oil paintings that were included in her show of 1917 suggest her hesitancy in reopening the spectrum; they warranted but a single notice for their "lovely but singularly disquieting color tonality."[27] O'Keeffe suggested her own concurrence with this judgment when, at about this time, she worried privately to a friend that "the colors I seem to want to use absolutely nauseate me."[28]

After the series of rigorous inventions in charcoal, color returned to O'Keeffe's palette late in the spring of 1916. Initially, and perhaps somewhat tentatively, she opted for monochromes, generally selecting evocative hues whose symbolic connotations were familiar from her reading of Wassily Kandinsky. Beyond its purely physical effect on the retina, Kandinsky claimed that "color directly influences the soul," an effect that can, in a "more sensitive soul . . . produce a correspondent spiritual vibration." In yellow, for instance, he found "a disturbing influence" with an "irresponsible appeal"; comparing colors to states of mind, he likened yellow to "the manic aspect of madness." Red, by contrast, was "determined and powerful. It glows in itself, maturely." For Kandinsky, blue was restful, the "typical heavenly color." In it he felt "a call to the infinite, a desire for purity and transcendence."

In their varied intensities, colors could evoke different responses. In its lighter tones, for instance, blue grows "indifferent and affects us in a remote and neutral fashion, like a high cerulean sky," ultimately reaching complete quiescence in white. In the darker range, however, a very different effect results. "When it sinks almost to black," Kandinsky noted, "it echoes a grief that is hardly human. It becomes an infinite engrossment

in solemn moods."[29]

O'Keeffe readily warmed to Kandinsky's theories, as did many of her generation in the United States and abroad.[30] When in 1916 she again felt the need for color, her initial choice was blue, most likely inspired by the special significance Kandinsky assigned to it.[31] She used that "spiritual" hue in a group of watercolor abstractions of 1916 and 1917 (pl. 10), and it long remained a favorite. Nearly three decades later, she suggested its symbolic significance in her designs based on pelvic bones profiled against illimitable western skies (pl. 66): "They were most wonderful against the Blue – that Blue that will always be there as it is now after all man's destruction is finished."[32]

By 1918 the full spectrum had reappeared in O'Keeffe's palette, and the artist quickly showed her uncommon gifts in handling sometimes difficult colors. From the late 1910s onward, her decorative compositions made striking use of clean, forceful hues: cherry reds warming to oranges and acid yellows, a blue range from cold near-whites to inky blue-blacks, and a gamut of greens surpassing Nature's own palette. These tones were rarely found in the drabber paintings of her contemporaries, and she earned critical kudos for her "strong and unrestrained fondness for color."[33] On occasion, O'Keeffe agonized over her own finesse with color. As late as the 1940s, when she was intensifying her southwestern palette more than usual (pl. 82), she still fretted to an appreciative correspondent: "I look at what I've done and fear for myself – in an odd way – because it's mine and isn't quite like other things – Always a feeling of walking too near the edge of something."[34] Viewers, however, did not share her anxiety, and generally reacted with delight to this novel modern sensibility. The painter Charles Demuth memorably exclaimed of O'Keeffe's skill: "Each color almost regains the fun it must have felt within itself on forming the first rainbow."[35]

The foil to O'Keeffe's bravura chromatics was her finesse with whites (pl. 49), which seemed to capture what the poet Amy Lowell called "the whiteness of intolerable beauty."[36] It carried strong personal associations, as well as the conventional ones of purity and light. Stieglitz often referred to her as the embodiment of that tone, suggesting her special aura: "Georgia is a Wonder. – Truly an artist. If ever there was a Whiteness she is that. – She *is*."[37] The metaphor was adapted by others of Stieglitz's circle, such as Rebecca Strand, who thought her artist friend "a white and steady light burning in a wilderness of dull sparks and crazy skyrockets."[38] Most notable perhaps was Marsden Hartley's fevered discussion of O'Keeffe's paintings as "living and shameless private documents" that startle by their "actual experience in life . . . in all its huge abstraction of pain and misery." Resorting to Stieglitz's chromatic language, Hartley summarized O'Keeffe's persona as "impaled with a white consciousness." Ultimately, he valued the artist's "expositions of psychism in color and movement" as proof that she was "modern by instinct and therefore cannot avoid modernity of expression. It is not willed, it is inevitable."[39]

Just as her colors came to be perceived as inevitably modern, so did her compositions; but here, too, the first critics were largely silent on the issue. It was doubtless difficult to explicate the designs whose genesis

O'Keeffe explained simply as "things I see in my head."[40] Her early compositions in watercolor or charcoal included a rich variety of patterns and forms, from bold vortices and compact budlike shapes to elegantly spare traceries and rhymed linear patterns. Her handling of this inventive vocabulary, however, initially earned only one passing reference, which praised the designs' obedience to "an inner law of harmony."[41]

Neither did the critics remark on her inclination to work in series, another trait attributable to the modernist attitude. At least since Claude Monet's influential examples (the famous *Grainstacks* or *Rouen Cathedrals*, for instance), serialism had been an important aspect of modernist practice. Monet realized, as one historian has written, that "the joint exhibition of a single series of studies, successively and comparatively developed before a limited range of motifs and perhaps further related one to the other in the course of termination in the studio," could provide "a programmatic alternative to the single, large-scale painting" (which was often the basis for mid-nineteenth-century exhibitions). The resulting "cumulative monumentality" of the series seems an apt description not only of Monet's suites of paintings[42] but also of O'Keeffe's seminal, and very modern, abstractions.

CANYON AND MOUNTAINS

IN THE ISOLATION of Canyon, Texas, to which O'Keeffe moved for a teaching job in September 1916, she was able to work as she pleased. Just as seclusion in South Carolina had been fruitful the preceding year, when she began the charcoal abstractions, the privacy in Texas proved stimulating and liberating. Many years later, she recalled somewhat wistfully that in Canyon "I was alone and free – *so very free*."[43] In the Texas panhandle, O'Keeffe was newly inspired by the landscape and by subjects from nature, which provided motifs to supplement the shapes she saw only in her mind. The artist, who had been raised in the gently rolling country of southern Wisconsin and the wooded hills of Virginia, was enthralled by the vastness of the northern Texas plains. To her friend Anita Pollitzer, who was back in the bustling metropolis of Manhattan, O'Keeffe exclaimed: "It is absurd the way I love this country. . . . I am loving the plains more than ever it seems – and the SKY – Anita you have never seen SKY – it is wonderful – "[44]

In contrast to the abstractions of the South Carolina works, the forms of nature and landscape were given new primacy in the Texas works. The shift of focus outward, to the world observed around her, prompted work in series, featuring the female nude or, more often, landscape effects. In the *Pink and Green Mountains* series of 1917 (fig. 6 and pls. 17–20), for example, O'Keeffe demonstrated the technical skills and compositional boldness typical of her watercolor technique. This group of paintings derived from a visit to the Rocky Mountains in 1917, during which she sketched in the Indian Peaks area, near Ward, Colorado. In the case of *Pink and Green Moutains,* the survival of her original sketchbook, with its first impressions of the landscape around Long Lake, helps viewers appreciate the reductive evolution of her image.

5. *Rocky Mountain Landscape with Indian*, about 1870s, oil on paper mounted on canvas. Albert Bierstadt. Gift of Mrs. Earle E. Partridge, Mrs. Marshall Sprague, and Mrs. John Wolcott Stewart. Collection of the Taylor Museum for Southwestern Studies of the Colorado Springs Fine Arts Center.

6. *Pink and Green Mountains No. III,* 1917, watercolor on paper. Georgia O'Keeffe. Milwaukee Art Museum. Gift of Mrs. Harry Lynde Bailey.

7. *Sketch of Long Lake, Colorado,* 1917, watercolor on paper. Georgia O'Keeffe. The Georgia O'Keeffe Foundation.

8. *Sketch of Long Lake, Colorado,* 1917, watercolor on paper. Georgia O'Keeffe. The Georgia O'Keeffe Foundation.

The rugged country that O'Keeffe painted had long attracted the attention of visitors.[45] Its scenic grandeur had challenged the brushes of Albert Bierstadt and a host of lesser landscapists from the mid-nineteenth century onward; but Bierstadt's dramatic alpine panoramas, and the oil sketches on which they were based (fig. 5), differ dramatically from the loose watercolor washes of O'Keeffe's mountain series. Her initial sketches of Long Lake (figs. 7, 8) are relatively descriptive of the site, showing the fir-covered slopes that flank the lake, with higher, barren summits in the distance and, towering above them, billowing cumuli characteristic of the place and season. O'Keeffe's landscape sketches, while appearing freely tinted, were nevertheless loosely based on the dark green-blacks of pine and the gray-mauves of steep rocky peaks. In transforming her impressions into a series of watercolors, O'Keeffe reversed the role of the sketch as traditionally employed by Bierstadt. Whereas his small works completed at the site were generalized notations of color, form, or composition to be given more finish and detail later, in the studio, her sketches were relatively more detailed than the dramatically simplified designs that followed. Ultimately, the *Pink and Green Mountains* series tells more about art than about topography. In the progression from sketchbook to finished design, O'Keeffe gave her colors greater emphasis, accentuating each hue by carefully separating the heavy washes with unpainted margins of white; she had used this technique earlier, in both abstract and figurative compositions, but it reached its most intense effect in *Pink and Green Mountains* and in the *Evening Star* series of the same year (pls. 17–20, 11). In such motifs, O'Keeffe discovered the perfect wedding, of formal language and subjects drawn from nature; it was a combination that inspired her profoundly, sustaining her inventive interest through the multiple sheets or canvases of the resultant series.

EQUIVALENCE

O'KEEFFE'S serial imagery usually came from her observations of the world – Colorado mountains, Texas skies, flowers, buildings, bones – or

from shapes seen in the mind's eye, the things in her head. But it could also come from things heard in her ear, or in her mind.

The fascination with synesthesia, the subjective experience of a sense other than the one being stimulated, was a legacy of the turn of the century, when many artists discovered inspiration in such sensory translations. The synesthetic impulse was basic to the "sight" of Aleksandr Scriabin's color music, to the "taste" of des Esseinte's liquor organ (in J.-K. Huysmans's *A rebours*), and to various painters' translations of aural inspiration into visual form. Many agreed with the philosopher William James, that "there is a certain border of the mind where all sound becomes visible," and critics applauded "the artist who can seize and hold on canvas the fleeting moment of melody."[46]

It was with just such a "seizure" that Alfred Stieglitz first expanded the purview of the 291 gallery beyond photography; in 1907 he introduced the synesthetic drawings and watercolors of Pamela Colman Smith (fig. 9), images that the young Anglo-American painter described as "not pictures of the music theme . . . but just what I see when I hear music. Thought loosened and set free by the spell of sound."[47] In these musical pictures critics discovered the "natural expression of . . . thought and feeling" rendered in "symbolic forms rather than into tones or words."[48]

In light of his predilection for the subjectivity of symbolist art and his emotional response to the music of Wagner and other late-nineteenth-century composers, it seems no surprise that Stieglitz was captivated by Smith's work. "Music is a passion with me. But I have so many passions I dare not humor them all. At least not at the same time," he quipped.[49] This waggish self-portrait was written in 1915, long after Smith's debut at 291, but only a year before the drawings of Georgia O'Keeffe — quickly to become Stieglitz's greatest passion — entered his gallery and his life. O'Keeffe shared Stieglitz's musical interests — she had once dreamt of a career as a concert violinist — although not with the same sophistication and commitment — and she joked about being reborn as a blonde soprano.[50] Of their early years together, after her move to New York in 1918 to be with him, O'Keeffe recalled: "I had a kind of belief in Alfred that made those days especially fine. I had a need of him that I had never seemed to feel for anyone else before. His feeling for music, concerts, books and the outdoors was wonderful. He would notice shapes and colors different from those I had seen and so delicate that I began to notice more."[51]

Among O'Keeffe's ambitious abstractions of 1919 — a remarkably fruitful year made possible by Stieglitz's encouragement and support — was a group of paintings inspired by music or, more precisely, by aural impressions. *Red and Orange Streak* (Philadelphia Museum of Art) recalls the dark emptiness of night on the Texas plains, with only the scarlet line of daybreak suggesting the distant, flat horizon. O'Keeffe later explained that the design was inspired by the sounds of the panhandle; the jagged arc across this nocturnal landscape was inspired by the sounds of cattle country, where the lowing of animals was always in the air. O'Keeffe's painted song of the cattle was accompanied by another musical invocation of her beloved panhandle, *From the Plains* (pl. 23). The ratcheted form across its upper region echoes the jagged orange streak of the Texas nocturne, like it

9. *Chromatic Fantasy – Bach*, about 1907. Pamela Colman Smith. Collection unknown; reproduced from *Strand Magazine*, June 1908.

10. *Songs of the Sky* or *Equivalent,* 1924. Alfred Stieglitz. National Gallery of Art, Alfred Stieglitz Collection.

providing a visual abstraction of cattle calls; reinforcing the suggestion of auditory stimulus is O'Keeffe's inscription on the verso of her photograph of this work, in which it was titled *A Song.*[52] The title and the motif of clouds and space high over a landscape suggest a provocative parallel with – and possible inspiration for – Stieglitz's well-known photographs of similar subjects, especially his *Music: A Sequence of Ten Cloud Photographs* (1922) and *Songs of the Sky* (fig. 10).

Although O'Keeffe's synesthetic evocation of place was distinctive – and her bovine inspiration most likely unique – a number of artists associated with the 291 gallery – among them Marsden Hartley, Max Weber, and Arthur Dove, as well as Stieglitz himself – dealt with depictions of musical themes. Like them, O'Keeffe also drew inspiration from more conventional musical sources, as had Pamela Colman Smith before her. The artist remembered vividly the moment when her interest in the subject was first aroused, while she was studying with Dow in 1916:

Walking down the hall of Columbia University Art Department, I heard music. Being curious, I opened the door and went in. The instructor was playing a low-toned record, asking the class to make a charcoal drawing from it. So I sat down and made a drawing too. Then he played a very different kind of record – a sort of high soprano sounding piece for another quick drawing. The two pieces were so different that you had to make two quite different drawings.

One of the works from that initial exercise, *Special No. 14* (pl. 2), "gave me an idea that I was very interested to follow – the idea of lines like sounds."[53]

In 1919 O'Keeffe painted two versions of *Music – Pink and Blue* (collections of Barney A. Ebsworth, Emily Fisher Landau); composed about central blue apertures surrounded by pale organic folds, the design suggests a similarity of intent, if not of appearance, to Smith's work. Smith's

11. *Special No. 9,* 1915, charcoal on paper. Georgia O'Keeffe. The Menil Collection, Houston.

imaginative designs bring to mind an effort akin to those of her friends Claude Debussy and Maurice Maeterlinck "to pierce the veil that hid the subjective world."[54] In describing her aspirations, O'Keeffe invoked similar language; her synesthetic designs of 1919 suggest a painted corollary to her wish for "real things . . . Music that makes holes in the sky."[55]

O'Keeffe's *Blue and Green Music* (1919; pl. 21), the mate to her pink-and-blue paintings of the same year, echoed the synesthetic inspiration but reverted to the morphology of certain charcoal drawings from several years earlier, combining flamelike swirls of flickering whites and rhymed pale waves with hard, dark diagonals intersecting in an angular V shape. The wavy pattern, which in *Blue and Green Music* was used to convey the harmonic pulsations of music or sound waves, had first appeared in one of O'Keeffe's abstract drawings of 1915 (fig. 11), where it carried the suggestion not of sound waves but of landscape – a furrowed field, or perhaps a flowing stream. The artist's inventive reuse of formal language led to many such reprises. The rhymed wave motif, like other inventions of the 1910s, provided the foundation for decorative compositions in the coming

decades. The pattern was echoed, for instance, in her acclaimed designs based on close study of floral interiors (pl. 50); as her close focus dissolves the blossom in decorative abstract patterns, the genesis of the art in Nature is recalled in the pulsing wavy lines, implying the organic vitality of the original subject. The wave motif also appeared in landscape guise, suggesting the patterns of ripples on the surface of Lake George, and it was used as well in abstract designs.

The reemergence of distinctive patterns was typical of O'Keeffe's morphology, and it revealed both the artist's compositional methods and her personal affections. For example, the curious ratcheted design of *From the Plains* (1919) was reflected decades later in *From the Plains No. I* (1953; McNay Museum, San Antonio, Texas), documenting formal continuities over a long career as well as her enduring affection for the sights and sounds of the American West.

IN 1937 O'Keeffe made a rare exception to her rule never to comment on the critiques of others, and drafted a letter correcting assumptions and conclusions that the recipient had made about her work. In the course of this fragmentary self-portrait, she declared: "Even if I could put down accurately certain things that I saw & enjoyed it would not give the observer the kind of feeling the object gave me. – I had to create an equivalent for what I felt about what I was looking at – not copy it."[56]

Equivalents was the collective title Stieglitz had chosen for his photographs of clouds, a series he had begun in the early 1920s (see fig. 10). These small images, which he described as "Songs of the Sky – Secrets of the Skies as revealed by my Camera," could provide "direct revelations of a man's world in the sky – documents of eternal relations – perhaps even a philosophy."[57] The philosophies and relations revealed in the *Equivalents* have varied with the individuals observing them over the years. Paul Strand discovered in them suggestions of an array of emotions, "feelings of grandeur, of conflict, of struggle and release, of ecstasy and despair, life and the blotting out of life." Ultimately, however, because of their remote subjects and abstract quality, Strand decided that the *Equivalents*' "intensity is on a very personal level, their meaning is never quite specific."[58] The sympathetic but perennially prolix Waldo Frank settled for a reference to Stieglitz's photographs as "a true *Divina Commedia*," ranging from the inferno of his early urban imagery, through the purgatory of portraiture, to "the Paradise – the latest set of studies of clouds, sun, mist, ethereal space that holds a divinity and an infinity of vision."[59] Others found equally vague or subjective meaning in the cloud series, which was surely Stieglitz's most abstract and metaphysical achievement.

Not surprisingly for one who shared in so many aspects of Stieglitz's aesthetic faith, O'Keeffe also found inspiration overhead. Her cloud painting *A Celebration* (pl. 46) was most likely prompted by Stieglitz's celestial studies. But she also engaged in the pursuit of equivalency in other motifs, working both on the material plane and with more subtly nuanced depictions. A scavenger by nature, O'Keeffe throughout her life gathered physical objects, natural souvenirs of place: river-washed stones, shells from Atlantic beaches, feathers and leaves from all over, and, most fa-

mously, bleached bones from the New Mexican desert. To Henry McBride she once forecast: "When I leave the landscape it seems I am going to work with these funny things that I now think feel so much like it –."[60] Elsewhere, she explained that her natural souvenirs provided equivalents for the experience of place: "I have used these things to say what is to me the wideness and wonder of the world as I live in it."[61]

People as well as places could be revealed through surrogate objects or designs. With *Lake George, Coat and Red* (pl. 22), she honored both. The title specifically refers to the Stieglitz homestead, to which she was, in 1919, still a newcomer; the startling spectral array behind the dark central vertical may allude to the sparkling effects of the wooded landscape in autumn, which, for O'Keeffe and Stieglitz, was a season of new intensity. The vertical, "human" form dominating the center of the composition seems an evocation of Stieglitz, who had brought O'Keeffe from the plains of Texas to a northern autumn woodland. The shape, like so many others in O'Keeffe's repertoire, has a kinship with those in her early charcoal abstractions, its sweeping lines and gathered energy paralleling her *Special No. 16* (pl. 7). The gray-black tones of the painting are reminiscent of Stieglitz's dark loden cape, his favorite outdoor wear, which he was rarely without except in the warmest summer weather; he had, for instance, worn it on a memorable outing to Coney Island with O'Keeffe and Paul Strand during her introduction to the 291 circle in 1917. Both the event and the garb were evidently important to him. On another gray and foggy day, he recalled that earlier trip, during which he had first wrapped O'Keeffe in his black cape to keep her warm.[62] And it was in such dress that he posed her in 1920 (fig. 12), for a photograph in which she dominated the sky and the composition just as the dark form in her painting had. In *Lake George, Coat and Red,* the bright burst at the point where the "cape" is gathered at the figure's "shoulder" most likely refers to Stieglitz's color preferences: "Other than black and white, Stieglitz loves red, a touch of red," remembered one friend.[63] His black cape was lined with red, and beneath it he often wore a bright red vest. In Kandinsky's symbolic palette, the color red evoked determination, power, and maturity, all attributes appropriate to Stieglitz. The burst of color might also have been an allusion to O'Keeffe herself, who, according to Marsden Hartley, was then using "more red in her pictures than any other color."[64] Ultimately, O'Keeffe's curiously titled *Lake George, Coat and Red* reveals itself as a portrait, an evocation through abstract means of Alfred Stieglitz looming large before the sparkling autumnal landscape of Lake George country.

The interest in abstract portraiture was shared by many of the avant-garde, in the United States and elsewhere, in the years during and after World War I. It was especially evident among various artists who were at one time or another associated with Alfred Stieglitz. Marsden Hartley's designs inspired by a painting of German officers and Charles Demuth's "poster portraits" (fig. 13) are the most familiar of these, but scarcely the only contributions in this vein. In 1928 O'Keeffe's favorite brother became the subject of the most overt of her portrait evocations, *Abstraction – Alexis* (pl. 47), being represented by a gray cloud billowing ominously above a

12. *Georgia O'Keeffe: A Portrait,* 1920. Alfred Stieglitz.

13. *Poster Portrait: O'Keeffe,* 1923, poster paint on panel. Charles Demuth. Courtesy of the Beinecke Rare Book and Manuscript Library, Collection of American Literature, Yale University, New Haven.

vibrating horizon line. The composition, which at first appears as a complete abstraction of oriental grace, is an apt homage to Alexis, who had been the wartime victim of a gas cloud in the horrendous trench struggles on the western front.

When properly read or deciphered, a number of O'Keeffe's abstractions from about 1919 to 1929, as well as some still lifes and nature studies from that time, rank in the company of modern abstract portraits. The artist admitted as much when she wrote: "There are people who have made me see shapes. . . . I have painted portraits [of them] that to me are almost photographic. I remember hesitating to show the paintings, they looked so real to me. But they have passed into the world as abstractions – no one seeing what they are."[65]

THE SUCCESS of a portrait, abstract or otherwise, lies in the artist's ability to convey physical and emotional likeness through telling details, to distill character or appearance. This challenge of portraiture pertains to other genres as well – landscape, for instance, or still life – and it led to the early modernists' preoccupation with describing the "essence" of a subject. References to "essence," to "distilling" a subject to its "essentials," color

the rhetoric of the early modernist period. Neith Boyce expressed a typical notion when she wrote to her friends O'Keeffe and Stieglitz that "people like us live in the elemental, the essential, only – it is something that cuts deep under the surface of life, something pure, intense & direct – from this springs all creative activity, art and joy –."[66] In O'Keeffe's later years, friends likewise often described her as having "reduced her life to fundamental essentials."[67]

The subject that artists in Stieglitz's circle were most frequently trying to distill was nature itself. In her effort to discover a formal vocabulary with which to realize its "essence," O'Keeffe early discovered the power of the sweeping, budlike organic form. Her choice conformed to the general appreciation of the primordial spiral design by which natural forms and forces had long been described. The great spiral – the Ur-form – was widely understood by metaphysicians as the symbol of primordial matter before it evolved into separate male and female principles. Both its occult guise and O'Keeffe's abstract use of the motif suggest a concern with the generative principle. This interest in generation, in the vitalist impulse – in what one of the Stieglitz circle's favorite philosophers, Henri Bergson, called "élan vital" – suggests a quest for the most primary of essences, for creation made manifest.

O'Keeffe's search for the formal essence of life or nature was as modern as Kandinsky's efforts to reveal "manifestations of life" through occult patterns. And her familiar vibratory design, which energized her homage to Alexis and sounded a chord in *Blue and Green Music,* recalls the synesthetic equation proposed by Kandinsky. "Words, musical tones and colors possess the psychical power of calling forth soul vibrations," wrote the influential Russian. "They create identical vibrations, ultimately bringing about the attainment of knowledge. . . . In Theosophy," he continued, "vibration is the formative agent behind all material shapes, which is but the manifestation of life concealed by matter."[68] Although the American's approach was neither narrowly theosophical nor doctrinaire, her reliance on repeated patterns suggests comparable concerns for getting at rhythms beyond the visible.

O'Keeffe was compelled by the ability to reveal yet disguise this essence through abstract designs. Her grand abstractions of about 1919 to 1920 were but the earliest in an ongoing, periodic series of ambitious oil paintings along such lines. With a largeness of vision, she took to global subjects and universal themes as sources of inspiration. She had to invent a new language in order to describe pictorially that which she was unable to address verbally. As she explained: "It is lines and colors put together so that they may say something. For me, that is the very basis of painting. The abstraction is often the most definite form for the intangible thing in myself that I can only clarify in paint."[69]

O'KEEFFE'S compositions elicited both feverishly enthusiastic prose and head-scratching mystification from critics, and from a number of artists, too. Yet sometimes the lay viewer managed to grasp their significance without the excesses of critical rhetoric. One such admirer discovered in O'Keeffe's floral paintings "the essential truth . . . the drama of life work-

ing itself out there among the petals. . . . It is the universe we are looking at, isn't it, whatever the object may be that catches our eye, if we look into things rather than at them. . . . You take a seed . . . and unroll the Cosmos out of it."[70]

Her approach was as traditional, and as radical, as William Blake's famed observation of "a World in a Grain of Sand."[71] This attitude was underscored by O'Keeffe's friend Jean Toomer, who regarded the artist's pelvic compositions as "the universe through the portal of a bone."[72] But it was also as modern as the microscope, the magnifying camera, and other scientific tools of vision. In the concern for the particular – bone, flower, seed – some contemporary historians see a prime trait of the modern spirit; in lieu of the broad tendencies of the nineteenth century, the new era "placed its focus on the microcosmic dimension. . . . Modernist thought adhered to the notion that the small was more and beautiful. . . . Focus on the minute particle – of human experience or art as well as nature – conditioned all of Modernist culture."[73]

Artist-filmmaker Fernand Léger delivered advice in a similar vein in 1926, in an article translated in the American journal *Little Review*. Léger argued the importance of close camera focus and the formal possibilities it provides. "Enormous enlargement of an object or fragment gives it a personality it never had before," he advised, "and in this way it can become a vehicle of entirely new lyric and plastic power."[74] O'Keeffe understood this, as suggested by her enlargements of flowers, leaves, and other natural forms or fragments thereof, which had preceded Léger's article. "I often painted fragments of things because it seemed to make my statement as well as or better than the whole could," she explained.[75] Although O'Keeffe was not directly dependent on Léger's article, both artists were clearly exploiting modern focus in their close examinations of objects and fragments. Through that approach one might discover form – and essence, the cosmos in a seed.

MODERN DISCOURSE

BEGINNING IN 1917, Stieglitz photographed the artist several times before one of her large charcoal drawings or watercolors (fig. 14). Stieglitz's arrangement of pose suggests that he equated the vitality of the art with that of its maker, as if O'Keeffe herself were a force of nature. About the same time as he made the portrait, he wrote in astonishment to his associate Arthur Dove: 'O'Keeffe is a constant source of wonder to me – like Nature itself. . . .'"[76]

Late-nineteenth-century symbolist artists – who were a particular favorite of Alfred Stieglitz – tended toward presenting types of women rather than portraying them as individuals. According to Carol Duncan, these types are, among other qualities, "occasionally more spiritual than man, but usually more instinctual. They are always closer to nature than man, more subject to its mysterious forces."[77] Stieglitz's comment about O'Keeffe's proximity to nature conforms perfectly to Duncan's description of the work of symbolist artists. Dove provided a seemingly antiphonal response, again corroborating Duncan's conclusions, when he

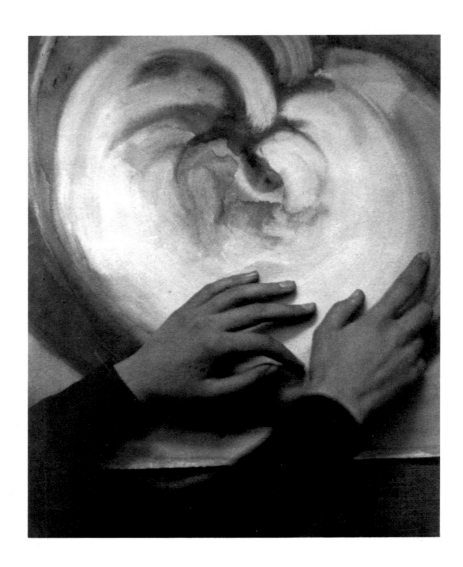

14. *Georgia O'Keeffe: A Portrait – Hands and Watercolor,*
1917. Alfred Stieglitz.

exclaimed on first viewing O'Keeffe's abstractions: "Stieglitz, this girl is
doing naturally what many of us fellows are trying to do, and failing."[78]

Rare was the male critic who, likes Giles Edgerton in 1908, would
take exception to this conventional typing of woman's instinctive nature.
Edgerton wondered if the phrase "intuitional art" – which at the time was
being used by critics to describe an exhibition of paintings by women –
was "silly or wise, kind or cruel, or just intended to be pleasantly mys-
terious." He finally decided it was "utter rubbish!"[79] Most reviewers,
however, resorted to the words "instinct," "intuition," and "nature"
when speaking about women. Even O'Keeffe reiterated the prevailing
attitude. Describing her working method, she referred to her "so-called
brain" and suggested that her approach was unconscious rather than
rational.[80]

Shaped by Freudian psychology, this critical perspective is of interest
more for what it divulges about the writers and their time than, perhaps,
for what it reveals about the art. O'Keeffe's arrival on the exhibition scene
in the late 1910s coincided with the burgeoning American interest in the
novel theories of personality and consciousness being advanced in Vienna.

Psychological investigation – and its popularization – had received a major boost in 1909, when Sigmund Freud visited the United States in order to deliver an address at Clark University in Worcester, Massachusetts. By the postwar years, the news of Dr. Freud's theories was widely disseminated, if not well understood.

Among those contributing to the growing interest in psychology was Abraham A. Brill, in Vienna a student of Freud and his English translator (most notably of *Three Contributions to a Sexual Theory*), as well as a fixture among avant-garde circles in New York. Brill reigned in 1913 at the salon of Mabel Dodge (not yet Luhan); the journalist Lincoln Steffens recalled that "there were no warmer, quieter, more intensely thoughtful conversations" than those led by Brill on Freudian issues.[81] Brill was also welcomed into the debates that swirled around Stieglitz at 291. He was one of the "Twenty Men and Women Famous in Our Day" (along with Stieglitz and O'Keeffe) to whom Waldo Frank dedicated individual essays in his illuminating study *Time-Exposures*. In the United States – "the psychopathic land – the Neurotic States" – the message of Freud, via Brill, was "craved," wrote Frank. "Freud was destined to be king in our city. Brill was his viceroy." But, although he may have been the most notable catalyst, the ensuring "saturnalia of sex talk" was scarcely limited to Brill and his associates.[82]

Havelock Ellis's tomes on human sexuality were avidly consumed by many American readers. Stieglitz, for one, found them "an extraordinary achievement," and recommended the author to Dorothy Brett.[83] Writers such as D. H. Lawrence found the new ideas liberating, and earned salacious reputations for their creative use of sexual themes in volumes that were favorites of the cognoscenti.[84] Less lofty but equally enthusiastic were the pursuits of American youths, who "met in club, in salon, in bed – and 'psyched' each other."[85] So great was the vogue that Dorothy Brett felt compelled to warn O'Keeffe about the perils of psychoanalysis, based on the experiences of a mutual friend: "Georgia – for the love of heaven don't you ever go and get psycho-analyzed. Its a nasty trap & once in its devilish hard to get out – [psychoanalysts] are just like vampires – they suck and they suck –."[86]

Critics, like nearly everyone else, fell under the spell of the Freudians, and used the concepts and language of the profession, albeit often without clinical precision. To be discussed in such terms was a sign of the subject's note, and of the critic's currency with cultural fashion. Henry Tyrrell was typical of many reviewers in describing O'Keeffe's exhibition of 1923 as "an extraordinary manifestation of . . . feminine self-revelation."[87] It was a manifestation to which each writer responded in an individual manner. The painter-critic Alexander Brook spoke for the more timid or conventional, lamenting O'Keeffe's proclivity "to take objects, thoughts and emotions that most people would rather ignore, and glorify them" in works that "seem to be painted with her very body."[88] Henry McBride, by contrast, after labeling O'Keeffe "a B. F." (one who had lost her inhibitions *Before Freud*), praised her as a "modern Margaret Fuller," likening the painter to the nonconformist mid-nineteenth-century author, who was once dismissed as a libertine but subsequently became the

object of much admiration.[89] In such a climate and with such terms, O'Keeffe's paintings became the most discussed and analyzed of those by modern artists.

A NASCENT NATIVISM

WHEN prospects for the League of Nations expired in March 1920 for want of approval by the United States Congress, it marked more than the end of Woodrow Wilson's dream of a new, international order for the postwar generation. "Here was a new generation," wrote F. Scott Fitzgerald that same year, "grown up to find all Gods dead, all wars fought, all faiths in man shaken."[90] Among other things, the collapse of Wilson's ideal coincided with a resurgent nationalism, as if combatants of the world war had had enough of internationalism and were newly content to cultivate their respective gardens. Across a broad cultural and political landscape, this new spirit was expressed in diverse ways – and rarely without fervor. There were, of course, those Americans of the fabled "Lost Generation" for whom nothing short of Montmartre or Montparnasse would suffice; yet, recalled Malcolm Cowley, himself part of the exodus, once "in Paris or Pamplone [sic], writing, drinking, watching bullfights or making love, they continued to desire a Kentucky hill cabin, a farmhouse in Iowa or Wisconsin, the Michigan woods, the blue Juniata."[91] Moreover, for every expatriate intellectual escaping to a Parisian café, there were many more, such as Van Wyck Brooks, at home debating new theories of America and dreaming of a new national culture "as we sat under the apple-tree."[92]

In the years between the two world wars, the familiar and the local were widely celebrated around the world, from Ben Nicholson's coastal scenes of Cornwall and Ludwig Kirchner's Bavarian landscapes to Margaret Preston's studies of Australian bush and blossom, from the works of Mexican muralists to those of the Canadian Group of Seven. Canadian artists were typical in being urged to "find a true racial expression" that could result only from "a complete break with European traditions." Nationalists sought a Canadian mood "through a love of landscape, soil and air."[93] This emphasis on the particulars of physical or geographical environs was echoed in many locales during the decades between the world wars, an era of homecoming on a global scale.

THE NATIVIST element could be revealed by the manner in which the artist worked, as well as by what was depicted. On the occasion of Georgia O'Keeffe's exhibition at the Anderson Galleries in 1924, the critic Virgil Barker drew an often-quoted comparison between her and the painter-photographer Charles Sheeler, whose work was also shown in New York that season. Though admitting the "likeness . . . in the surface aspect of the art," Barker also found "unlikeness . . . beneath the surface in the temperaments that produce the art." He concluded with the memorable estimation: "Miss O'Keeffe's pictures are the clean-cut result of an intensely passionate apprehension of things; Mr. Sheeler's, the clean-cut result of an apprehension that is intensely intellectual." Readers continue

to quarrel with the implications of Barker's gendered exegesis of "woman's . . . abandonment" and "man's austerity," of O'Keeffe's "intelligent passionateness" and Sheeler's "passionate intelligence."[94] But his characterization of their individual techniques, however different, as being based on an "intense . . . apprehension" remains undisputed. Indeed, in such terms, notable efforts have been made to define a peculiar national expression, an American vision.

In the 1960s, Barbara Novak constructed one of the most influential definitions of a national art, tracing "the unique relation of object to idea that characterizes so much American realism from colonial times to the present." At the root of this tradition she cited the early paintings of John Singleton Copley as exemplifying a "specific kind of ideal or conceptual realism – idea is amplified to become form. To say it differently, abstract knowledge is fortified by the *stuff* of empiricism." Novak concluded that the development of Copley's early realism – and of its numerous American progeny and permutations – is ultimately "a problem in the history of vision."[95] (That O'Keeffe shared aspects of that vision is suggested by the artist's own description of her working method, which conforms to Novak's conceptual realism: "You paint *from* your subject, not what you see . . . I rarely paint anything I don't know very well."[96]) It was, however, a "problem" older than Copley and broader than the visual arts, an issue that ultimately encompassed "the cultural history of the object, or thing, within the American experience."[97]

Objects were not without their delineators in the United States. From the prolific Peale family in eighteenth- and nineteenth-century Philadelphia to the photorealists of recent decades, still-life painting, the portrayal of things, has had numerous proponents; yet its history in America has been largely episodic rather than sustained over generations, the latter being the case with landscape painting and abstraction, for example. In part this is due to the traditionally inferior status of the still-life genre among academicians, for whom the ennobling subjects of history, which were rich in allegorical possibilities, ranked highest; for them, even the pedestrian representation of faces and real estate, portraits and landscape, surpassed still life in significance. This devaluing of still life led to a general critical neglect of the genre, which has persisted until relatively recently. Today, however, historians such as John Wilmerding have begun to discover "clarifications about neglected connoisseurship in this field, provocative correlations with other contemporary currents in American culture, and ultimately the meanings intimated by ordinary and familiar objects chosen for aesthetic attention."[98]

COLONIAL portraitists and nineteenth-century still-life painters were not alone in their concern for things. Even before Copley, the Reverend Jonathan Edwards of Massachusetts, who was one of the most influential and intellectual preachers of his time, urged that "a rational way of teaching" include a role for material objects. Specifically, Edwards, relying on John Locke's theory that words were separable from reality, argued that "the child should be taught to understand *things,* as well as *words,*" in order to comprehend better the logical progression from language to

concept.[99] In such intellectual growth, things give material form to, and provide the essential bridge between, word and idea. Edwards's educational precepts (if not his theology) echoed over the generations, even down to the modern era. In the 1920s the principle was reiterated by the prominent educational reformer and theorist John Dewey, who recognized the instructive value of particulars, of "detail mean[ing] things in concrete existence." "All concepts, theories, general ideas are thin, meager and ineffectual," wrote Dewey, unless they are related to, reflective of "things which specifically enter into our lives and which we steadily deal with."[100]

The value of the tangible within human experience was felt profoundly by artists as well as by pedagogues. Stieglitz's sharpened, modern focus on the objects of his physical environment helped to revolutionize not only the photographic art in America but painters' aesthetics, too. Charles Sheeler's "intense" vision and precise delineation of the painted form were shaped by his simultaneous practice as a photographer (he was importantly indebted to Stieglitz in his formative years). Charles Demuth's work also owes much of its power to his sponsor, Stieglitz; Demuth's sparkling watercolors of fruits and flowers were praised for showing "nature perceived in its fullest visual intensity," just as Stieglitz's photographs did.[101] John Marin, another Stieglitz intimate, likewise honored the material presences of his world and his art – rock and tree, boat and building, views of city, sea, and land. "If you have an intense love and feeling toward these things," he said, "you'll try your damnedest to put on paper, on canvas, that thing." Marin would tolerate an artist's expressive play with motifs, but only if in the end the works "have the roots of that thing in it and no other thing."[102]

Such materiality, such reverence for the power of the object, affected others in the creative community around Stieglitz. Most notable among them was the young poet William Carlos Williams, for whom the example of photographers and painters became the basis for his poetics of particulars. Many commentators have noted a peculiar American penchant for details and concreteness, and a "sensibility which attempts to rescue spiritual values from the most banal and material objects of everyday life."[103] Williams summarized and immortalized this national attitude in his terse aphorism: "No Ideas but in Things."[104]

Stieglitz's assistant, Herbert J. Seligmann, once described O'Keeffe's "purity and aloofness" as similar to the Native American's character, "at home in the realm of Manitou, of nature. Something of the aboriginal Indian soul . . . seems to have descended upon O'Keeffe." Ultimately, he regarded O'Keeffe as one "in touch with the spirit of things rather than people."[105] By examining some of the things that Georgia O'Keeffe depicted with her "intense" vision, the viewer might discover aspects of spirit and vision both personal and national.

STILL LIFE WITH APPLES

THE ORCHARDS of upstate New York blossomed with unusual exuberance in the spring of 1919, almost as if the apples were celebrating the new peace following the armistice of the preceding November. American apple

blossomings and harvests in the dismal wartime years were unremarkable; but in April 1919 the trees in the Lake George area of New York began a notable series of productive seasons that gained the attention even of longtime observers.

The harvests of 1920 through 1922 were particularly bounteous. In November 1920 Alfred Stieglitz wrote from his family's vacation home at Lake George that there were "more than many apples this year."[106] By 1922, with "Apples everywhere," he was relating anecdotes of the zealous harvest by the family's two German nurses who "go out & gather from ground & tree – & one hears 'Oppulls,' 'Oppulls,' all day."[107] Inspired by the bounty of the harvest, Stieglitz, during those three years, produced sixteen photographs that prominently featured the apple. Some focused on the ripe fruit hanging weightily on the bough. In a number of them he paired the fruit with Georgia O'Keeffe, as part of the ongoing composite portrait of his companion and protégé.

While Stieglitz was photographing the trees in bloom and heavy with fruit, it was natural for his model, mate, and muse also to succumb to what he called "the apple fever."[108] O'Keeffe's record books for the year 1921 include a group of thirteen apple motifs, a treatment of the subject in series, as was her custom. Clearly, the painter fully shared Stieglitz's fascination, indeed obsession, with the subject.

They were, of course, not the first western artists to be drawn to the apple. The fruit has appeared in various guises in literature and the visual arts since the ancients and even in prehistory. As Henry David Thoreau wrote: "It is remarkable how closely the history of the apple tree is connected with that of man. . . . It has been longer cultivated than any other, and so is more humanized."[109] Depictions of the original sin generally represent the forbidden fruit as the apple, an identification likely inspired by Greek mythology and pagan legend that associated the apple with the erotic; in the context of western Christianity, this equation was reinforced by the Latin pun: *malum* = apple, evil.[110] Eve's apple appears in numerous European works; it figures as well in American art, even among painters not conventionally known for religious subject matter.

In numerous depictions of the Madonna and Child from the Renaissance onward, the Child embraces an apple, a reference to the original sin that he was sent into the world to redeem through his sacrifice. In the late nineteenth century, Mary Cassatt repeated the basic motif (fig. 15), secularizing it yet retaining the ambivalent mood of the Christian symbol; the intimate scene of a woman passing the fruit to her child is enriched by the equation of the apple and the tree of knowledge. Cassatt treated the apple-harvest theme on several occasions, most notably in mural decorations (now lost) for the Woman's Building at the World's Columbian Exposition in Chicago in 1893; in these works the apparently simple genre subject of women gathering fruit is complicated by the precedent of Eve's sorrowful harvest.

It is unlikely that O'Keeffe had any conventional Christian symbol in mind when she painted her apples, despite her early education in traditional Roman Catholic schools. There is, however, something of apparent human significance about her fruits, a lifelikeness that Thoreau understood

15. *Baby Reaching for an Apple,* 1893, oil on canvas. Mary Cassatt. Virginia Museum of Fine Arts, Richmond. Gift of an anonymous donor.

when he spoke of the apple being "more humanized" than other crops.[111] The human quality of O'Keeffe's apples was especially accentuated when she gathered them in compositions titled *Apple Family.*

Her friend Paul Rosenfeld, who spent part of these fruitful seasons at Lake George with the artist and Stieglitz, early recognized the implications of her subjects. The intense hues of the fruit, acidic greens and sharp reds, particularly captured his attention: "O'Keeffe does not play the obvious complements of hot and cold against each other," he wrote, but instead relies on "tart harmonies" to give the "curious, biting, pungent savor" characteristic of her work.[112] He wrote of O'Keeffe's "gnarled apples" (pl. 35) as "small intense volumes [that] take on the bulk of cosmical protagonists."[113]

The sentient quality of O'Keeffe's still-life subjects gives her work its distinctive allure; like Stieglitz's prints, her paintings are (as Jean Toomer described the photographs) "explicit in themselves, direct communicants with one's feelings."[114] Bram Dijkstra noted that Stieglitz's photographs used the "materials of objective reality" to represent "all the emotions of which man is capable." Similarly, O'Keeffe sought to express meaning, to convey something of pictorial and personal significance through inanimate objects. And, just as "Stieglitz was afraid of no aspect of reality," neither was she.[115]

A rich array of human emotions and associations is suggested by the material objects and natural forms reproduced in her paintings. They quickly caught the attention of discerning critics. Helen Read, for instance, writing sympathetically about O'Keeffe's exhibition of 1924, remarked on the works' "clear reflection of personality," which she thought their "most important" element. "Each picture," she concluded, "is in a way a portrait of herself."[116] The voluble Stieglitz, "presenter" of O'Keeffe's exhibitions, might have prompted that concept in the critic's mind. In any event, he certainly found it apt, and repeated it himself when he wrote of O'Keeffe as "self portrayed through flowers and fruits."[117]

Stieglitz's reference to floral self-portraits is telling. The analogy between the beauty of woman and that of the blossom is an ancient one, and feminine portrayals in floral guise have a long history in western art; they flourished particularly during O'Keeffe's formative years, in the fin de siècle. Hence, it is not surprising that O'Keeffe's floral subjects early captured popular attention and critical praise. Her fruit still lifes, which shortly preceded the flowers, have not, however, been so thoroughly examined. Only recently has Sarah Peters followed Stieglitz's suggestion, surmising that O'Keeffe's "consequential" series of *Apple Family* paintings might be "among the very earliest of her newly abstract–objective self–portraits."[118]

The familial fruit of O'Keeffe's compositions suggests "portrait" associations of various types. They might be a surrogate for the garrulous and numerous Stieglitz clan, the "protagonists" who gathered seasonally at the family homestead at Lake George, much to the consternation of the very private O'Keeffe. The acid tones of her apples, crowded and jostled in their small, confined space, provide an apt metaphor for the artist's reactions to the unwelcomed company of Alfred Stieglitz's siblings, in-

laws, nieces and nephews, and various family retainers. Their presence was an irritant to which O'Keeffe never adjusted; even after several summers at the lake, Stieglitz reported that "she still feels like a visitor here."[119]

On another level, the choice of still-life subjects from the harvest reflected O'Keeffe's new happiness with domestic life with Stieglitz, particularly in the autumns, when family and guests had departed. Then, O'Keeffe could rejoice in the simple pleasures of work amid the splendors of autumn in the Adirondacks, when "the colour season would be underway both in and out of doors."[120] Stieglitz explained their routine to one correspondent: "Our days consist of 15 hours. . . . We eat in the kitchen – And we feel like masters of the world. For we can cook on the stove without having to beg permission. . . . Georgia [is] cooking – and cooking well."[121] Before joining Stieglitz in New York in 1918, O'Keeffe had always occupied quarters that were temporary and generally Spartan, rented rooms without kitchen or hearth; the city quarters they shared at his brother's home and subsequently in the Shelton Hotel were also kitchenless. Hence, for O'Keeffe, the simple domestic chores at Lake George were a novel source of contentment, and her pleasure with the new circumstances is suggested by her still lifes. As Roxana Robinson has aptly explained:

In choosing these purely domestic subjects for her still lifes, O'Keeffe was commenting on the importance of daily life, domestic gestures. She was expressing the wholeness that lay at the center of things: the apples she pressed for cider were also the objects of her aesthetic attention, equally important facets of her life. The apples were a source of nourishment on every level.[122]

Despite – or perhaps because of – the imposing Parisian precedents of still lifes by Cézanne, Picasso, Braque, and others, American modernist painters infrequently depicted the humble objects of the household. Photographers, their medium being less burdened by artistic traditions and hierarchies of value, were quicker to exploit such subjects; see, for instance, Paul Strand's arrangement of fruit and vessels (fig. 16) or his famous *Bowls* (1915), a work that Stieglitz exhibited at 291 and reproduced in *Camera Work*. The capacity of the camera to depict closely focused details yielded surprisingly abstract patterns, which at once disguised the ordinariness of the subject and freed it from traditional domestic connotations. When O'Keeffe met Strand in 1917, she was greatly impressed by the photographer and his work. She later confided to him the impact he had made on her: "I believe Ive been looking at things and seeing them as I thought you might photograph them – Isn't that funny – making Strand photographs for myself in my head."[123] The results of this internalized vision quickly became apparent in her still-life paintings.

Green Apple on Black Plate (pl. 37) is at once a triumph of artful design, almost oriental in its grace, and a paean to the daily pleasures of the kitchen. O'Keeffe freed the fruit and container from gravity and from the confines of the tabletop, examining their silhouette against an ambiguous white ground. By isolating the motif and emphasizing its formal properties – the asymmetrical composition, the rhymed curves, the chromatic play of acid green against glossy black – she appears to have given primacy

16. *Ceramic and Fruit, Twin Lakes, Connecticut*, 1916, platinum print. Paul Strand. Copyright 1980 Aperture Foundation, Inc., Paul Strand Archive.

to considerations of design and abstraction, just as Strand did with his studies. Yet O'Keeffe's reiteration of her apple motif in many canvases simultaneously implies a level of involvement beyond the formal.

Other writers have speculated on the service of the fruit as an even more personal symbol. From O'Keeffe's earliest exhibitions, some critics had focused on the perceived sexual aspects of her imagery, one even declaring that her abstractions said: "I want to have a baby."[124] Whatever the intent of the abstract designs, her desire for a child did grow during the happy, initial years with Stieglitz; in the early 1920s, O'Keeffe spoke openly of her wish with close friends and family, before Stieglitz finally and firmly ended the discussions and the prospect of parenthood in the summer of 1923. For an aspiring mother, the female image of the apple – the fruit, ripe with seed – provided an obvious and apt metaphor. It was one adopted by earlier artists, such as Copley, who had portrayed the matriarch *Mrs. Ezekiel Goldthwait* (fig. 17) making a benedictory gesture above an ample plate of apples and peaches. O'Keeffe's *Apple Family* paintings might, like the portrait of Mrs. Goldthwait, have provided a symbol of domestic happiness, and of the hoped-for fruits of her womb.

The fruits functioned significantly on yet another symbolic level, as a reference to Paul Cézanne, who was widely hailed as one of the titans of modern art, especially in the years following his death in 1906. The first exposure in the United States to Cézanne's work came at Stieglitz's 291 gallery in 1910, although American artists in Paris had discovered and revered the painter's work long before then. His figure paintings and landscapes were hugely admired and avidly collected by Americans, but he was perhaps best known for his still lifes; this genre had been a constant interest to him during his long career. Of particular importance among his still-life motifs were human skulls and fruits, especially apples. So prominent were these last that in 1927 the critic C. J. Bulliett began his influential

treatise on modern art with the assertion: "An apple by Paul Cézanne is of more consequence artistically than the head of a Madonna by Raphael."[125]

That Georgia O'Keeffe adopted skulls (albeit animal, not human) and apples as signature motifs seems scarcely accidental, her choice of subjects signaling her allegiance to the modernist tradition of which Cézanne was a primary source. His apples became a sort of modernist talisman for legions of younger painters, who through subject sought to ally themselves with his consequential example. In 1919 the British painter Wyndham Lewis made the classic observation on this enthusiasm: "More apples have been painted during the last fifteen years than have been eaten by painters in as many centuries."[126] In the United States too, artists succumbed to the vogue, so much so that the conservative critic Thomas Craven fretted: "America was suddenly pestilent with bastard Cézannes. . . . The still-life became a curse."[127]

O'Keeffe made a curious contribution to the genre when in 1925 she exhibited *Mask with Golden Apple* (pl. 38), which paired the upended fruit with an African carving laid on its back side. Beyond the formal analogy between rhymed arcs of profiled mask and apple, initially there seems little to link these incongruous and disparate objects: one manufactured, the other natural; one with African associations, the other of indeterminate origin. Does the fruit relate to the legendary judgment of Paris, who honored Venus's fairness with the bestowal of another golden apple? Or was it plucked from the mythic garden of the Hesperides, whose tree with golden apples was guarded by a serpent that eventually was slain by Hercules? Or might it simply be the harvest from the orchards of Stieglitz? Whatever O'Keeffe's intention, the unexpected grouping raises multiple associations. It suggests the judgment of Parisian modernists, for whom the powerful influence of African art was already legendary. It also recalls the two African masks from Stieglitz's collection which O'Keeffe displayed on her walls in New Mexico; they were among the very few artworks by others which she tolerated having in her home (see p. 40). Surprisingly, O'Keeffe's mask is among the rare visual references by any of the Stieglitz artists to the arts of sub-Saharan Africa, this despite Stieglitz's own early recognition of the force of that tradition.[128] O'Keeffe's unique incorporation of the mask may have been intended as a mirror of Stieglitz's pioneering role in the recognition of African arts, particularly the sculptural tradition that O'Keeffe equated with the force of classical art through the symbol of the golden apple. By virtue of its importance to the genesis and iconography of cubism, the mask may also provide an indirect allusion to Picasso; among Stieglitz's herculean labors on behalf of modern art was the presentation of the first solo show anywhere of the works of this most celebrated of contemporary artists.

The golden apple might have had other, even more personal, associations for O'Keeffe, a Wisconsin woman who, like the mythic Hesperides, was the daughter of a western garden. Sarah Peters suggested this equation when noting that the juxtaposition of apple and mask "seems to embody a sort of visual argument made up of two of Stieglitz's favorite, and most enlightened, pronouncements: that the root of European modern art lies in 'the statuary in wood by African savages' and that the apple is an

17. *Mrs. Ezekiel Goldthwait,* 1770–1771, oil on canvas. John Singleton Copley. Courtesy Museum of Fine Arts, Boston.

appropriate metaphor for the native American artist's spirit."[129]

The association of apples with America was long-standing. It was early acclaimed by Ralph Waldo Emerson as "our national fruit," and national connotations abounded in literature, folklore, and the arts.[130] "Johnny Appleseed" (né John Chapman, 1774–1845), for example, became a folk hero for planting orchards in the wilderness of Ohio and Indiana in advance of the settlers' arrival. Beginning about the time of World War I and continuing into the 1930s, this ascetic horticulturist enjoyed a revival of note; like many other national heroes of legend and history, his life was newly celebrated by the public and its poets (including Vachel Lindsay and Stephen Vincent Benét) as part of a generational search for what Van Wyck Brooks called a "usable past."[131]

The virtues of country life and cultivation embodied by Johnny Appleseed were cited by some as the antidote to the increasing complexities of modern urban life, an alternative to the city that was considered "a coffin for living and thinking."[132] "The national drift from these simple habits of living is one of the dangers now confronting the country," warned one speaker in 1910. As a panacea to modern metropolitan ills he prescribed the cultivation of rural orchards: "The industry of raising apples will act as a check . . . to this drift to the cities, and . . . will furnish a healthful and profitable occupation."[133] If, as the American adage goes, "an apple a day keeps the doctor away," an orchardful might keep the health of the nation, improve its treasury – and hold the dreaded demons of modern life at bay.

Among members of the Stieglitz circle, imagery of the apple flourished in the 1920s, often relating the symbolic fruit to the favored American land. Paul Rosenfeld, for instance, described Columbus's pursuit of "man's immemorial dream of a divine land . . . a golden-aired, apple-laden place."[134] Later, he used the metaphor to describe American art, characterizing Stieglitz's protégé John Marin as "fast in American life like a tough and fibrous apple tree," a painter whose watercolors, "the fresh, firm, savorsome pulp of his art," came as naturally to him as did fruits to the tree.[135] Marin's specialty was landscape, and still life rarely held his attention; there were, however, in addition to O'Keeffe, other Stieglitz exhibitors, most notably Charles Demuth and Marsden Hartley, for whom the apple played an important and frequent role in still-life compositions. And, during the 1920s, Stieglitz continued his composite photographic portrait of O'Keeffe, on several occasions pairing his favorite sitter with the fruits (frontispiece).

Stieglitz's friend Van Wyck Brooks was fond of citing Henrik Ibsen's saying "culture is unthinkable apart from national life," an aphorism with which the photographer doubtless agreed. To Brooks, as to Stieglitz, "only through the group, by means of ties and loyalties, could one apprehend primary things; and consequently men were better citizens of the world if they were also, and first, citizens of their country."[136] For Stieglitz and his contemporaries, allegiance to country was most frequently and fervently expressed through the metaphors of nature, particularly agrarian images of the soil and the harvest. Of this American tradition, he made O'Keeffe his exemplar. Stieglitz, the eldest child of immigrant German

Jews, prided himself on his New World origins. "I was born in Hoboken. I am an American," he exclaimed in his most famous biographical statement.[137] Yet, as he later admitted to a friend, his and O'Keeffe's "lives were basically different – she from Wisconsin and he from Hoboken, Europe and New York."[138] When, in December 1924, he and O'Keeffe were finally wed, it was, in the words of one historian, as if "he married America."[139]

For one apparently so tied to her native land, the symbol of fruited plains made geographic, horticultural, and metaphoric sense. "The apples in these [Stieglitz] portraits," concluded Sarah Greenough, "refer symbolically to the sources of O'Keeffe's art, suggesting that she draws not only her subjects but her very artistic being from the American soil."[140] The associations of the composite portrait were equally apposite for Stieglitz's other apple subjects, and for O'Keeffe's *Apple Families*. Even as O'Keeffe was painting the latter during a creative burst in 1921, the poet Vachel Lindsay was celebrating the national fruit:

> *An angel in each apple . . . ,*
> *A ballot-box in each apple,*
> *A state capital in each apple,*
> *.*
> *All America in each apple . . .*[141]

For painter, as for poet, the rich and multivalent meanings of the apple made it an apt symbol for creations whose tone and implications were at once intensely personal and universal. In O'Keeffe's pictorial repertoire, it became the fruit of nation and of procreation, the paradoxical sign of innovation and tradition.

BARNS AND OTHER BUILDINGS

IN FEBRUARY 1924 Georgia O'Keeffe greeted the news of a niece's birth with a brief note to her sister, Catherine O'Keeffe Klenert, who, alone of the seven O'Keeffe siblings, was still living in their home state of Wisconsin. "The news of you and your baby – your way of living is nice to have," wrote the artist. "I like to feel that at least one member of the family lived what might be called a normal life – No one in New York can even approach being a normal human being. . . . You can be glad that you live in a little town where you can look out and see a tree."[142]

O'Keeffe's response to her sister was emotionally complicated. Close beneath the expressed pleasure for Catherine's domestic happiness was a hint of regret at the foreclosure of O'Keeffe's own maternal options. Additionally, reports of her professional progress in "abnormal" New York – "I've done well enough to be talked about and written about more and more"[143] – were shaded by nostalgia for a "little town" on the prairie, for the sisters' Wisconsin farm home and a family life now forever lost. Throughout her life, O'Keeffe treasured recollections of her Wisconsin childhood; in later years, she claimed that "what's important about painters is what part of the country they grow up in. . . . I was born and grew up in the Middle West . . . the normal, healthy part of America, [which]

had a great deal to do with my development as an artist."[144]

New York City, the quintessential modern metropolis, was far from her "normal" Wisconsin home; throughout her three decades in the city, O'Keeffe remained ambivalent about urban life, and was often sustained by memories of rural America. For her, the symbol of that favored place was the barn, the traditional landmark of the American farm and a reminder of her happy childhood. Even in old age, she received pleasure from recollections of her years on a Sun Prairie dairy farm: "I can still see the enormous loads of hay coming into the barns in the evening," she told one interviewer. "I've never seen loads of hay like that anywhere else."[145]

Paintings of architectural subjects, as Lisa Mintz Messinger has astutely observed, were often among O'Keeffe's first responses to new environments, which she encountered when she changed addresses in her early years and when she traveled later in her life.[146] Such was the case with her early watercolors from Virginia and Texas; these views sometimes focused on a fragment of a building – a dormer window, the profile of a gable – from which she extracted simplified, colorful patterns. This emphasis on details decoratively treated, and later often enlarged, eventually became a hallmark of the artist's work, and she used it in various still-life arrangements of the 1920s and in other architectural motifs, particularly the *Patio Door* series (pl. 79), which she began in 1946.

The banalities of architecture in the Texas panhandle generally offered but modest stimulation until O'Keeffe discovered a dramatic perspective on the motif, at daybreak and again at day's end, when "the ugly little buildings and windmills looked great against" the wide and blazing sky.[147] She captured the matinal effect in *Morning Sky with Houses No. 2* (pl. 9), emphasizing the simple silhouette of plain structures against the vast sky.

During the 1920s her favored Lake George subjects also included architecture, particularly the weathered barns on the Stieglitz family property. As with apples, barns were a subject she shared with Stieglitz. The photographer was generally jealous of his motifs and loath to share them with others; for instance, Stieglitz scolded Paul Strand who, while visiting at Lake George, happened to photograph "his" barns. Stieglitz related his affection for the landmarks to Sherwood Anderson, describing their effect on him: "I'll never forget the barns that I saw in the moonlight. Talk about the Sphinx and pyramids – there was that barn – nothing could be grander – The austere dignity of it. Flooded with light. . . ." In his nocturnal revery, the structure became animate: "It was as if it could have understood me if I had spoken to it."[148]

Beginning in 1922 and continuing for more than a decade, O'Keeffe also treated the rustic buildings, in an unusually protracted series that suggests she imputed special import to the subject (pls. 31, 36). Ultimately, though, O'Keeffe's barn paintings may reveal more about the artist than about the architecture. Such structures had been a familiar part of the artist's world from her earliest memories of her father's Wisconsin dairy farm; her gravitation to the subject in the 1920s suggests it had a claim on her imagination beyond the general interest of the time in Americana and "native ground." She admitted to one friend: "The barn is a very healthy part of me . . . it is my childhood." O'Keeffe then added the somewhat

cryptic lament: "There should be more of it."[149]

These simple structures provided shelter, for both her privacy and her creativity. In August 1920, when the Stieglitz family crowded into summer quarters at Lake George, O'Keeffe sought refuge in "The Shanty," a rustic outbuilding on the property which she had transformed into her private studio. It seems telling that, at a moment of personal stress, she turned for solace to such a simple and familiar farm building; throughout her life, barns would provide an architectural barometer of her mood.

In the spring of 1928, during a period of professional and marital tumult, O'Keeffe escaped for a visit with her sister Catherine in Portage, Wisconsin. Significantly, the primary product of that respite was a painting of a local barn; standing proudly erect and freshly clad in a coat of red paint, the subject inescapably evokes freshened memories of childhood and of a similar structure built by her father. With its steeply pitched gable crowding the upper margin of the canvas, her Wisconsin barn painting provided an architectural homage to her farmer father, who in 1918 had died after a fall from a steep roof on which he had been working.

During a trip in 1932 – another of O'Keeffe's periodic escapes from the tensions of life with Stieglitz at Lake George – to the rugged Gaspé country of Canada, her attention was captured by the "hideous houses and beautiful barns. The barns looked old, as if they belonged to the land, while the houses looked like bad accidents."[150] Not surprisingly, her Canadian paintings featured these barns. A final reprise on the Lake George subject (pl. 36) dates from 1934, when O'Keeffe was emerging from the most trying period of her life, including a nervous breakdown and a long hiatus from her art; instead of the greenery of summer or the brown tints of autumn in which she had previously situated her barns, she blanketed her motif with snow in this work, significantly bringing the seasonal cycle to closure.

INTERSPERSED with the periodic barn subjects were other architectural motifs, most notably the new monuments of Manhattan. If barns provided an emblem of agrarian shelter, the centerpiece of farm life and a symptom of its prosperity, their antithesis was skyscrapers, which in the 1920s were transforming the skyline and the streetscapes of New York. Yet their imposing forms revealed another telling aspect of the American character, and of O'Keeffe's distinctive vision.

Between 1925 and 1930, O'Keeffe painted more than twenty scenes of New York City. Some emphasized the sleek iconic towers rising high from midtown streets (pls. 27, 28); others encompassed the view from her lofty studio-home in the Shelton Hotel, the expansive, grayed industrial districts of Queens stretching like a valley of ashes beyond the East River to the smoky horizon (pl. 29). The views across the river evoke the mood of a previous generation of American artists and, as Bram Dijkstra wrote, express "a melancholy sense of her loss of contact with earlier American values."[151] By contrast, O'Keeffe's paintings of skyscrapers celebrated the present and the monuments that were suddenly giving New York its distinctive identity; these new constructions attracted the attention of many artists and visitors, appearing both "tellingly American and dis-

tinctly modern."[152] The architectural theorist Claude Bragdon (who was also a friend and neighbor of Stieglitz and O'Keeffe in the new Shelton Hotel) recounted the comments of visiting Europeans that the skyscraper was one of the best expressions of the American spirit. "Not only is the skyscraper a symbol of the American Spirit – restless, centrifugal, perilously poised – but," he explained, "it is the only truly original development in the field of architecture to which we can lay unchallenged claim."[153] For O'Keeffe, the urban skyscraper, a gleaming symbol of native enterprise and American invention, provided the modern-age corollary to her rural barns, which were expressive of American agrarian traditions.

Ultimately, however, she opted for the country rather than the city, reclaiming her rural birthright. After Stieglitz's death in 1946 and her settlement of his complicated estate, O'Keeffe decamped Manhattan for the American Southwest, there to settle permanently in the New Mexico homes (Ghost Ranch and Abiquiu) that she had prepared for herself. The experience of another famous Wisconsin offspring, Frank Lloyd Wright, anticipated O'Keeffe's own choice. Wright spoke often of the deep impact that his homeland had on him: "From sunrise to sunset there can be nothing so surpassingly beautiful in any cultivated garden as these wild Wisconsin pastures."[154] The architect's rural upbringing was at the root of his revulsion for the urban architecture of Chicago when he began his practice there; in contrast to the Wisconsin farm where he had "learn[ed] how really to work," in the city "all this I saw around me seems affectation, nonsense, or profanity. The first feeling was hunger for reality and sincerity, a desire for simplicity."[155] Similar in kind and intensity was O'Keeffe's eventual reaction against the prevailing tastes in her field of painting, and against the urban environs where she had spent much of her early career. The simplicity and reduction so often remarked on in her work reflect a Wright-like reverence for the basics, inspired by the teachings of nature and strengthened by memories of her early years.

When the artist moved from New York to New Mexico, she made her primary residence in Abiquiu, in a historic adobe that she had transformed into an elegant studio and home. Before this remodeling, at the time she purchased it from the Catholic church, the structure was in ruins and was being used by the local community as stabling for cattle and pigs. In retrospect, it seems fitting, perhaps even predestined, that Georgia O'Keeffe – whom critics once hailed as "the high priestess" of modern art – should, finally, be at home in a barn.[156]

AMERICAN NATURE

THE RURAL experience, life attuned to natural cycles and forces, was once shared by many Americans, and even in a modern environment it still exerted its traditional appeal. "What children and adults need," Henry Ford once told a reporter, "is a chance to breathe God's fresh air and to stretch their legs and have a little garden in the soil." Following his own advice, the automaker, accompanied by Thomas A. Edison and the tire baron Harvey Firestone, between 1914 and 1924 annually escaped from

the complexities of urban life in order to breathe, stretch, and otherwise pursue the simple pleasures of life close to nature. The naturalist John Burroughs, whose company was enlisted on these memorable camping trips, recalled that they "cheerfully endure wet, cold, smoke, mosquitoes, black flies, and sleepless nights, just to touch naked reality once more."[157]

Ford placed great value in nature and ruralism, espousing a nostalgic attitude shared by many Americans in the years around World War I. In Ford's case, it led to his choice of small towns instead of large cities as sites for his factories, in order that his workers might be closer to beneficent nature, to stretch their legs and till the soil, perhaps to touch reality.

The ideal of the cultivator's life close to nature had a long and powerful hold on the American imagination, stretching from Henry Ford back beyond the founding fathers. As early as 1719 an anonymous New England author had declared the central position in a young America of "the Plow-Man that raiseth Grain."[158] Thomas Jefferson expressed the belief for his generation more eloquently; writing from Paris in 1785, he declared: "Cultivators of the earth are the most valuable citizens. They are the most vigorous, the most independent, the most virtuous, and they are tied to their country and wedded to its liberty and interests by the most lasting bonds."[159] Jefferson's independent yeoman-farmer, drawing vigor and virtue from his agrarian pursuits and returning that strength to the community and the republic, was long considered central to the national character. Henry Ford's assembly-line worker, with his little garden in the soil, was the heir of a grand American tradition. So, too, was Georgia O'Keeffe, who was raised in a rural culture of which Ford and Jefferson would have approved. Such origins gave her a special allure in the cosmopolitan circle around Alfred Stieglitz; among that coterie of mostly eastern and urban men, the Wisconsin farmer's daughter stood out.

Agrarian metaphors were often used to describe midwesterners such as O'Keeffe, even by their own accounts. The Ohio-born Sherwood Anderson, for instance, called himself "a countryman. The warm earth feeling gets me hardest" – perhaps accounting for O'Keeffe's fondness for him.[160] The image of the peasant was often invoked in discussions of these Americans from the "Middle Border"; it was particularly favored by the critic Waldo Frank, the New York–born, Yale-trained, and European-traveled protégé of Alfred Stieglitz. Frank regarded the poet Carl Sandburg, for instance, as being endowed with a "peasant's mind" and possessing a "peasant innocence." To the urbane critic, such traits appeared both virtuous and vaguely exotic. Ultimately, according to Frank, Sandburg's peasantry was the basis for his success: "He has survived, and they love him, because he remains a peasant in Chicago!"[161] O'Keeffe's singular notice among New York critics and cognoscenti also depended, at least in part, on her roots in the agrarian culture of the Midwest. Whereas in 1913 the members of the Country Life Commission, a Federal panel, had officially worried that the growth of American cities would tend "to sterilize the open country and to lower its social status,"[162] a rural background did not seem to stigmatize O'Keeffe in New York a few years later, nor to lower her status. Indeed, as acclaimed by Frank, she was "a glorified American peasant."[163]

A farm child in the Midwest at the turn of the century would naturally have absorbed the rhythms of the seasons, the patterns of growth and decay, the cycles of planting and harvest; many decades later, in recalling the Wisconsin hay wains of her youth, O'Keeffe showed how enduring were such lessons from her childhood. These early experiences provided the artist with a special affinity for certain subjects, such as the barn, which "is something that I know."[164] Chief among the legacies of Sun Prairie, however, were not built structures but the forms of nature. The unfurling of a flower, the curve of branch or bone, spring greening, and the palette of autumn foliage – such were the daily and seasonal encounters with nature which later found echo in O'Keeffe's paintings. For this artist, as for other early modernists in America, "the landscape became, in effect, part of their autobiography."[165] This was especially true for the artists of the Stieglitz circle, in whose midst O'Keeffe played an important role, from her arrival in 1918 onward.

Many of O'Keeffe's most familiar motifs – trees and leaves, flowers and fruit, barns, bones, and landscapes – were the products of an American tradition, of a life in the country close to nature. Also, her depictions of such subjects stemmed from habits of seeing that were deeply ingrained in the national past. The discovery of didactic lessons in nature has been a central aspect of American thought, at least since the emergence of the transcendentalists in the nineteenth century. To the observer of rare perspicacity, such as Henry David Thoreau, the natural world provided guidance for the conduct of social affairs and for the development of a personal faith. Thoreau believed that "in society you will not find health, but in nature. . . . To him who contemplates a trait of natural beauty no harm nor disappointment can come."[166] Such contemplation led to the equation of being and nature, which was at the root of his philosophy.

An attunement to nature led Thoreau to Walden Pond on the Fourth of July 1845; two years later, he wrote of taking from Walden a new understanding, of himself and of his world. "The knowledge of the seasons was the most important addition to Thoreau's thought after 1850," declared the literary critic Sherman Paul. "It made possible the metaphors of ripening and completion that give his last work a tone of acceptance and quiet satisfaction; and it made possible the fable of the renewal of life in *Walden*."[167] Georgia O'Keeffe's early introduction to the forms and forces of nature, a familiarity that was renewed in Texas in the 1910s and at Lake George in the 1920s, provided a comparable ripeness to her vision.

Thoreau, Emerson, and their transcendentalist colleagues had been long absent by the time modernism arrived in American art. Yet their precedent and inspiration continued to be crucial for Alfred Stieglitz and his associates, as well as for many other Americans. The transcendentalist legacy was appreciated with new fervor after the turn of the century; by 1903 even the popular press had acclaimed its timeliness: "The peculiarly ripe and modern character of Emerson's genius was never clearer than it is to-day," declared *Harper's Weekly*.[168] The modernity of Emerson's self-reliant philosophy, which was developed in the natural arena of Concord, Massachusetts, exerted a renewed appeal for Americans in an increasingly

urbanized, industrial, postfrontier society. The enduring truths that the transcendentalists had gleaned from nature provided solace and assurance as Americans faced a complex and uncertain future.

Like Emerson's, Thoreau's work enjoyed a new vogue in the early twentieth century; critics noted "his increasing value for American life and American thinking. . . . His value becomes greater in measure as it becomes more difficult to breed such independent livers and thinkers."[169] In 1917, on the occasion of his centennial, Thoreau was commemorated in *Seven Arts,* the important literary journal with which several of Stieglitz's associates were vitally involved. In an era of growing war fever, *Seven Arts* provided a consistent pacifist voice, and its editors predictably applauded in Thoreau the conscientious objector "which our indeterminate and facile democracy has always found . . . so hard to forgive." By the pacifists of a new era, including Stieglitz and O'Keeffe, Thoreau was prized as "a perpetual reminder, the most vivid reminder our history affords us, that it is the toughness, the intransigence of the spiritual unit which alone gives edge to democracy."

Thoreau's interest for the moderns transcended his pacifism, however, to engage all of personal experience. Once absorbed, the lesson of his life and philosophy could provide the key for understanding the contemporary condition. Noting that "the only men he really respected were men close to the elements, the forest, the sea, the soil," the editors of *Seven Arts* observed that although "in much that our generation holds dear Thoreau was poor indeed . . . he possessed a secret which we have lost. It was the secret of the sensuous life in a rich objective world."[170]

Although it had been lost by most Americans, Thoreau's "secret," the locus of life in nature, was appreciated by artists of the modern spirit. Frank Lloyd Wright early realized the need to "worship at the skein of nature" if one sought "fulfillment of life principles implanted in us."[171] John Marin believed that his art came from "the wedding of man and nature."[172] In a like vein, Marsden Hartley described O'Keeffe's art as "nature in her simplest appearance . . . consorted with." O'Keeffe's paintings, he wrote, whether descriptive of "mysteries from the garden" and "austerities from the forest" or more abstract interpretations of nature, act "like gates . . . through which the spirit must pass . . . in order to escape imprisonment in a world of defined limitations."[173]

Hartley's description of O'Keeffe's merger of self and nature, of spirit and matter, is resonant of transcendentalism. It recalls the most famous passage from Emerson's essay, "Nature":

I feel that nothing can befall me in life, — no disgrace, no calamity (leaving me my eyes), which nature cannot repair. Standing on the bare ground, — my head bathed by the blithe air and uplifted into infinite space, — all mean egotism vanishes. I become a transparent eyeball; I am nothing; I see all; the currents of the Universal Being circulate through me, I am part or parcel of God.[174]

Alfred Stieglitz likewise was indebted to the language and philosophy of an earlier era. In his evocation of evening on the hills above Lake George, he provided perhaps the purest echo of Emerson's rhetoric:

Standing outside up here on the hill – away from all humans – seeing these Wonders taking place before one's eyes – so silently – it is queer to feel that beyond the hills there are the Humans astir – & just the reverse of what one feels in watching the silence of Nature. – No school – no church – is as good a teacher as the eye understandingly seeing what's before it – I believe this more firmly than ever.[175]

As much as any of his generation, Alfred Stieglitz was the beneficiary of the transcendentalist legacy and its proselytizer for the modern age. His friends admired him as "a continuator in our time of the tradition launched by Emerson."[176] As such, he was part of a select community of creative Americans. "Like Frank Lloyd Wright," wrote one historian, ". . . Stieglitz took as his principal American hero Henry David Thoreau."[177] It was natural that the photographer should share this enthusiasm with his intimates, and it is no surprise that like-minded artists – Hartley, Dove, and Marin, and O'Keeffe as well – were welcomed to his intellectual and artistic orbit.

Stieglitz and his allies made – and forced – accommodations to the changed circumstances of the twentieth century, but in significant and telling ways they showed their grounding in the intellectual and aesthetic ideals of an earlier epoch. The critic Kenneth Baker aptly summarized O'Keeffe's simultaneous continuation of and departure from a long-standing American tradition in a single, paradoxical phrase: "A transcendentalist without God."[178]

SOUTHWESTERN SCENES

IN THOREAU'S essay "Walking," the philosopher typically suggested parallels between the commonplace and the cosmic, in one case, between an individual's "pettiest walk" and the "general movement of the race." "When I go out of the house for a walk, uncertain as yet whither I will bend my step . . . I finally and inevitably settle southwest . . . The future lies that way to me." His southwestwardness was the predilection of the nation: "Something like this," he wrote, "is the prevailing tendency of my countrymen." As Thoreau found himself "leaving the city more and more, and withdrawing into the wilderness," the direction of that withdrawal was as natural as it was invariable: "Eastward I go only by force; but westward I go free."[179] His explanation of his perambulations preceded by several generations the modern movement to the American Southwest, yet uncannily anticipated that later migration, of which O'Keeffe became a part in 1929.

AMONG the Stieglitz group, Marsden Hartley had been the first to work in New Mexico, where he spent the summers of 1918 and 1919 as the guest of Mabel Dodge Luhan. For him, it was a brief but significant experience in a restless career that kept him moving over the European and North American continents. In New Mexico, Hartley wrote: "I am an American discovering America. I like the position and I like the results."[180] For several years thereafter, from Berlin and Paris, he continued to ship to

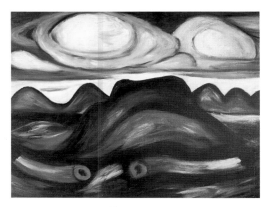

18. *New Mexico Recollection No. 12,* 1922–1923, oil on canvas. Marsden Hartley. Archer M. Huntington Art Gallery, The University of Texas at Austin. Gift of Mari and James A. Michener, 1992.

Stieglitz those results, the painted *New Mexico Recollections* (fig. 18), hauntingly expressive renderings of that distant and exotic landscape.

Among the members of the Stieglitz circle, O'Keeffe alone had a firsthand familiarity with the region that Hartley treated so powerfully. Only later, when they made their own visits to the Southwest, could others of the group appreciate that Hartley had "gotten further with the locality than any other painter."[181] In 1926 Paul and Rebecca Strand summered in New Mexico, returning to New York with his memorable photographs of the area and with tantalizing tales of their travels. That same year, Paul Rosenfeld also discovered the Southwest, and from historic Santa Fe wrote to Stieglitz with amusing accounts of the locale. Likening the New Mexican capital to an "Italian or perhaps Spanish hill-town," he thought the low, adobe structures gave it "a strange primitive effect." That impression was periodically relieved by comically pretentious structures, such as "a pink affair which looks like [a Parisian] palace" or the "writing would-be Aztec effects" in the artistic neighborhood where the local "daubers" lived.[182] Overall, however, he found the environs congenial, even the local arts community ("the artists, of course, being bad painters are mostly nice people"[183]). Rosenfeld thought that "America is really very lucky to have such a pungently spirited place," and he urged the weary Stieglitz to accept the invitation from the hospitable Mrs. Luhan, "perhaps the ideal roborant for you."[184]

Although Stieglitz never did make the trek, such communications doubtless rekindled his wife's interest in New Mexico. Finally, in April 1929, accompanied by her friend Rebecca Strand, O'Keeffe joined the migration of her generation to storied New Mexico.

MALCOLM COWLEY, an astute observer of the Lost Generation, in the 1950s drew a portrait of his contemporaries who had abandoned New York during the 1920s. He noted that at mid-decade, the motivation for the exodus "underwent an imperceptible but real change in emphasis. The earlier exiles had been driven . . . *in search of* something – leisure, freedom, knowledge, some quality that was offered by an older culture." In their wake, however, came a second wave that was not so much drawn ahead as "propelled from behind, pushed . . . by the need for *getting away from* something. They were not so much exiles as refugees."[185]

In 1929, en route to New Mexico, Georgia O'Keeffe was both refugee and exile or, more properly, pilgrim. She was a refugee from New York, from the crowds and concrete on which her husband thrived; her journey provided escape from the feverish art press, for whom she had become a favorite subject, and from the vexatious gatherings at Lake George. In explaining her gravitation to the Southwest, however, O'Keeffe did not dwell on these motives, but simply explained: "I was never a city person, always a country person."[186] Even as she was fleeing the familiar northeastern orbit, O'Keeffe was being drawn on a pilgrimage back to the New Mexico she had briefly visited twelve years earlier, whose drama had made a lasting impact on her. She once explained: "If you ever go to New Mexico, it will itch you for the rest of your life."[187]

In her changing attitude toward the metropolis, O'Keeffe was not

alone, either in her generation or among Stieglitz's intimates. Paul Rosenfeld was among the first to express the disaffection. "I go about wondering," he wrote as early as 1920, "where has gone the stimulus that New York once exerted on me? It used to thrill and fill me with dreams. . . . But now it seems a great scab; a great pile of refuse, and I would like to take out of my heart everything that holds me to the place and stamp on it."[188] By the end of the decade, he felt as if he and his fellow Maine vacationers were "in exile from New York."[189]

In the late 1920s another of the Stieglitz coterie, John Marin, sensed some of the same urban strains as had Rosenfeld and O'Keeffe. According to his biographer, Marin "felt the world was closing in on him. He was tired of 'living in herds,' of swimming in a 'common pool.' He found it hard to 'keep the spirit unsoiled' in the pool."[190] Marin suggested something of his discomfort with familiar urban patterns when, in 1928, he wrote that the "true artist" needed to "go from time to time to the elemental big forms – Sky, Sea, Mountains, Plan . . . to sort of re-true himself up, to recharge the battery."[191] The following summer found Marin ensconced at Mabel Dodge Luhan's home in Taos, close to the elemental big forms of the New Mexican landscape, trying to "re-true" himself.

Like Marin, O'Keeffe turned to New Mexico to recharge her creative battery. The Lake George landscape that had once so inspired her had a decade later become a confining and dispiriting environment. "Everything is very green," she lamented to Henry McBride. "I look around and wonder what one might paint – Nothing but greens – mountains – lake – green . . . leaves and waving grass – and Stieglitz sick."[192]

When he was not absorbed in his own ailments and problems, Stieglitz showed sympathy for O'Keeffe's plight. He once confided to Waldo Frank, for instance, that, even after years in the East, O'Keeffe "still dreams of the plains – of real Spaces. . . . If I were strong enough I guess I'd take her to Texas for a while."[193] But he never was, and never did.

Meanwhile, O'Keeffe's yearning for western spaces grew. "That was my country," she later wrote, "terrible winds and a wonderful emptiness."[194] Her attachment to her country was occasionally evinced in paintings such as *The Red Hills with Sun* (1927; Phillips Collection, Washington, D.C.), ostensibly a Lake George motif, but suffused with the vast spaces and glowing color of her works from Canyon, Texas. More often, reminders of western precincts came in friends' reports, verbal and visual, such as Hartley's paintings, Strand's photographs, and Rosenfeld's letters.

FROM TAOS, where Rebecca Strand and O'Keeffe had added their names to the growing guest list at the Luhan home, Strand reported to Stieglitz on their activities. In that "enchanted" place, "we both feel like princesses in a fairy tale," she gleefully wrote. She reassured Stieglitz, who had been quite reluctant to see O'Keeffe depart, about his wife's robust health, both physical and mental:

Red-cheeks, round face and ready for anything – with no bad after effects – eats everything – sleeps long and laughs a lot. I wish you could be here to see the visible

proof — I am afraid I am going to be a terrible disbeliever, when, in the future, I hear you say she is frail — here she seems as tough as a hickory root . . . [with] a strength that has come from finding what she knew she needed.[195]

Their host diagnosed O'Keeffe's condition in different terms, but toward the same happy conclusion. "When anyone has been living for years on the lower geographical planes," wrote Mabel Dodge Luhan,

and then suddenly reaches an altitude of seven or eight thousand feet there takes place an accelerated action of every part of one's mechanism. Everything in one is speeded up. The heart sends the blood racing to the brain, all the separate cells in the body seem to be enlivened, emotions are heightened and the different senses know a new swift life. It was so with Georgia O'Keeffe when she came to Taos . . . Take an exquisite sensitive mortal . . . and suddenly lift her from sea level to the higher vibrations of a place such as Taos and you will have the extraordinary picture of her making whoopee![196]

The pictorial challenges of the place were many, sufficient to induce "whoopee" in some visiting artists, and to deter others utterly. Stuart Davis, who visited Santa Fe in 1923, memorably concluded that the New Mexican landscape had "not sufficient intellectual stimulus" for his formal experiments, that it was rich only in its historical associations and in "forms made to order, to imitate." He complained of the scenery — "You always have to look at it" — and finally dismissed New Mexico as "a place for an ethnologist, not an artist."[197]

For others, the hard desert light posed special problems, most notably to Jules Pascin who, according to legend, upon debarking his train was assaulted by the brilliant sunshine — and promptly reboarded for the familiar, grayer East.[198] Most visiting artists, however, stayed a while and at least tried to capture something of the distinctive character of the region. For those who worked *en plein air,* the local conditions of light and the natural colors of the desert posed challenges they solved in individual ways: some softened their colors, others intensified their palettes, and still others drained it of color altogether and worked in black and white.[199] But few failed to note the remarkable brightness that "blinded into whiteness" and, according to the painter-teacher Robert Henri, obliterated the artist's distinction "between light and pigment so that anything like a translation can be made."[200]

For some visitors, the desert light was less an issue of aesthetics than of metaphysics. Ross Calvin, for example, thought the "supreme radiance of the Southwest . . . a sort of spiritual experience, a psychic phenomenon."[201] It certainly was that for the English novelist D. H. Lawrence, who in 1922 arrived in New Mexico, and was perhaps the greatest social trophy for his voracious host, Mabel Dodge Luhan. "The moment I saw the brilliant, proud morning shine high up over Santa Fe," he recalled, "something stood still in my soul, and I started to attend. . . . In the magnificent fierce morning of New Mexico one sprang awake, a new part of the soul woke up suddenly, and the old world gave way to a new."[202]

O'Keeffe's early reaction to the setting was less spiritual than touristic. Her exhibition at Stieglitz's new gallery, An American Place, in 1930

introduced her southwestern subjects, which recorded the artist's fascination with many of the attractions that drew other visitors to the high desert. She painted the Taos Pueblo, which Lawrence had likened to the great monasteries of Europe, "one of the choice spots of the earth, where the spirit dwelt."[203] The elegant buttressed apse of the Church of Saint Francis at Ranchos de Taos also caught O'Keeffe's attention. She thought that the historic adobe was "one of the most beautiful buildings left in the United States by the early Spaniards. Most artists who spend any time in Taos have to paint it."[204] She was inspired as well by the heavy ritual crosses that dotted the desert, monuments of the secretive Penitente sect which to O'Keeffe appeared "like a thin dark veil of the Catholic Church spread over the New Mexico landscape" (pl. 62).[205]

Craft objects, both those of traditional Hispanic origin (pl. 58) and those of modern commercial manufacture (a porcelain rooster from the Luhan home), figured in her still-life compositions.[206] Significantly, all of these paintings depicted or were inspired by manufactured objects, suggesting again the artist's typical entry to new subject matter through fabricated things rather than through landscape imagery.

During her first summer in New Mexico, O'Keeffe also essayed indigenous natural subjects, often working in familiar formats.[207] She continued her interest in floral motifs, choosing yellow or white desert blossoms, which she enlarged in her signature fashion. She also painted arboreal motifs of the type she had developed in Lake George, including a cottonwood grove at Glorietta and the pale shaft of a dead pine tree at Bear Lake (pl. 63). The towering ponderosa pine on D. H. Lawrence's ranch outside Taos inspired a painting now widely known as *The Lawrence Tree* (pl. 62); it was, however, initially exhibited as *Pine Tree with Stars at Brett's, N.M.,* in honor of Lawrence's companion in New Mexico, Dorothy Brett, who remained there after his departure and became O'Keeffe's friend.[208]

It is revealing that the nineteen New Mexico subjects unveiled at An American Place in 1930 included but two landscapes, both of them paintings of the sand hills at Alcalde, south of Taos in the Rio Grande valley. The scarcity of landscapes suggests the difficulty that O'Keeffe, like others, encountered in trying to capture the light, color, and space of the New Mexican desert country. Low and rounded (pl. 75), the Alcalde hills were more "human" in scale than other aspects of the landscape, less formidable than the limitless sweep through pellucid space; as with the Ranchos church subjects, O'Keeffe filled the composition with a profile of the hills, containing the view and blocking access to the vast distance. Thus did she defer tackling the awesome emptiness and enormous scale of the New Mexican desert, a country where, as Aldous Huxley noted, human presence pales to insignificance in the face of an "inhuman landscape."[209]

If the subjects of her work during that first New Mexican summer were to some degree predictable, her handling of them was distinctively her own. The famous Ranchos church, for instance, has inspired countless depictions over the years, perhaps more than any other building in the United States. Some of them (including one canvas by O'Keeffe; pl. 73) feature the facade, but the famous west end has excited the greatest

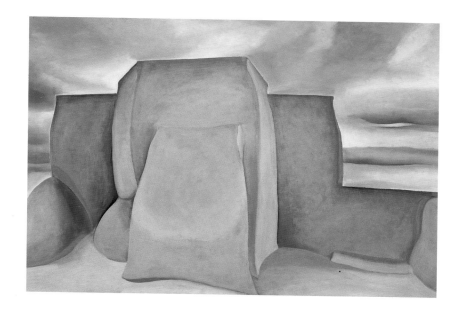

19. *Ranchos Church,* 1930, oil on canvas. Georgia O'Keeffe. Amon Carter Museum, Fort Worth.

curiosity. The most compelling feature of the church is the unique but-tressing of the apse, which figures prominently in O'Keeffe's series of four Ranchos church paintings (fig. 19). Through color and brush stroke she stressed the identification between the adobe of the church and the ground on which it sits – and of which it is made. The organic quality in the swelling, irregular planes of the building suggests a natural origin for the monument, rather than a built one. O'Keeffe's paintings of the little mission church evoke a faith that is rooted in the native soil.

Her paintings of ritual crosses erected in the southwestern landscape elicit similar reactions. The most famous of these canvases, *Black Cross, New Mexico* (fig. 20), presents a surprisingly close focus on the Penitente cross, which is truncated by the edges of the canvas and threatens to break through the borders of the composition. Behind the dark cruciform stretch miles of corrugated hills, each handled in the smooth, lobed form that came to typify O'Keeffe's New Mexican mountains. The vastness of this eroded landscape, which is lunar in its desolation, acts as a dramatic backdrop for the weighty form of the foreground cross. The blood red sunset at the horizon accentuates the somber effect of this painting, sug-gesting the severity of Spanish Catholicism in the land of the Penitente. It was through depictions of such monuments that the artist sought to convey something of the spirit of the region (pls. 60, 61). O'Keeffe told Henry McBride that "anyone who doesn't feel the crosses simply doesn't get that country."[210]

Though the crosses were expressive of an aspect of the New Mexico scene, they could not convey fully the challenging, rich appearance of the region. Over several visits, O'Keeffe continued her effort to capture the drama of the land. The sympathetic critic Lewis Mumford praised O'Keeffe's early crosses and skeletal subjects; he also acknowledged her "technical progress in the modelling of the landscape," but even he could not hide his disappointment that they "lacked the sense of sharp discov-ery" found in her previous works.[211] During her second and subsequent

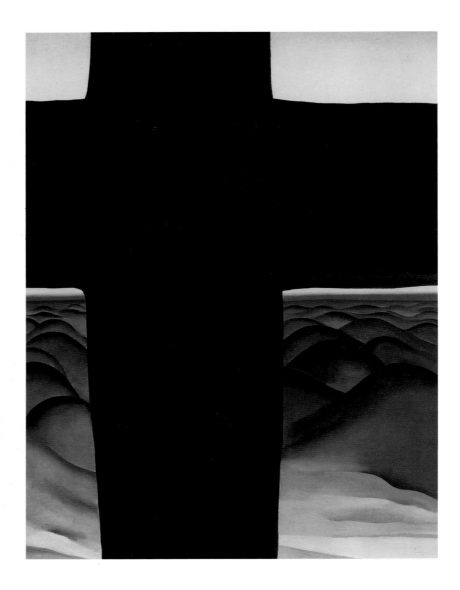

20. *Black Cross, New Mexico,* 1929, oil on canvas.
Georgia O'Keeffe. The Art Institute of Chicago,
Purchase Fund, 1943.95. Art photograph copyright
1992, The Art Institute of Chicago.

summers in the area, O'Keeffe struggled to come to pictorial terms with
the New Mexican landscape, to convey its appearance – the sense of the
vitality of nature there, the "sharp discovery" of her vision.

After several failed attempts, she was finally satisfied with a group of
canvases depicting the view from her studio (pl. 64). The vista was painted
from rented quarters at Alcalde, where the artist escaped Mabel Dodge
Luhan's social grasp and the noisome bonhomie of the Taos arts commu-
nity.[212] The painting, which looks westward toward a dark mesa and the
distant peaks near Abiquiu, summarized the forms and colors of the
landscape with new assuredness. O'Keeffe painted this view with a stroke
that, for her, was relatively loose and broad, giving the landmasses an
active quality; streaked and crumpled, the flanks of the mountains appear
organic, as if they were still in the process of being formed, a handling that
is particularly apt for the geology of northern New Mexico.

This tendency toward broadness can be found in a number of
O'Keeffe's initial encounters with new subjects, perhaps marking her
uncertainty as she began working with themes or series. As a subject

became more familiar and as a series progressed through several treatments, she tended to refine her technique and increasingly eliminated the vestiges of brush stroke, to the point that one critic could praise her best work for seeming "wished upon the canvas – the mechanics have been so successfully concealed."[213] Generally, she shared with Charles Sheeler an antipathy toward the slashing brushwork of their mutual teacher, William Merritt Chase. In the 1930s and later decades, she often suppressed brush strokes, the smooth, almost burnished surfaces of her works seeming to illustrate a statement once made by Sheeler: "I favor a picture which arrives at its destination without the evidence of a trying journey rather than the one which shows the mark of battle. An efficient army buries its dead."[214] Such a stroke could on occasion transform the nature of the object depicted; for instance, O'Keeffe transformed rough and desiccated bones and horns into smoothly polished, marmoreal forms.

SOUVENIRS OF THE DESERT

THROUGHOUT her life, O'Keeffe had been a gatherer, collecting natural souvenirs from various locales, leaves from the woods around Lake George, shells from Maine beaches, flowers from wherever she was. But in New Mexico, "there was nothing to see in the land in the way of a flower. There were just dry white bones. So I picked them up." She recalled that "people were pretty annoyed having their cars filled with those bones."[215] Stieglitz, too, was "pretty annoyed" when confronted with a freight bill for the shipping of a barrelful of bony souvenirs from Taos to Lake George, where they decorated his family's Victorian summer home.[216] O'Keeffe, however, was not easily deterred. To her,

the bones are as beautiful as anything I know. To me they are strangely more living than the animals walking around – hair, eyes and all, with their tails switching. The bones seem to cut sharply to the center of something that is keenly alive on the desert even though it is vast and empty and untouchable – and knows no kindness with all its beauty.[217]

In New York, the bleached bones provided her with inspiration for a winter-long excursion into still-life painting, during which she experimented formally with the souvenirs of the Southwest. Skulls were initially her favored subjects, but she also depicted animal ribs, jawbones, thigh bones, and, later, horns, vertebrae, and pelvises, admiring each in turn for its formal properties and geographical associations.

She referred to her unconventional subjects as her "symbols of the desert, but nothing more."[218] Others, however, were moved to more complicated interpretations. Critics often read the paintings as symbols of death, a modern *vanitas;* Henry McBride, for one, worried about her ruminating on the skull "with the perversity of a Hamlet," whereas Ralph Flint wrote of her "grim research into the mysteries of death in the desert."[219] Others have found in the empty pelvises a lamentation on childlessness, a symbol of menopause, an intimation of withering creativity. Recently, feminist scholars have discussed O'Keeffe's bones as "emblems of a female deity identified with the natural world," attributing to

the painter the reinvention of "archaic associations" of universal consequence, and linking the skeletal subjects to "shamanic belief" in bones as the source of "essential life force."[220]

Sometimes the bones were combined with pale artificial flowers, of the type commonly used to decorate Hispanic graves; these O'Keeffe gathered in her desert rambles and shipped eastward with the bones. A combination of blossoms and bones (fig. 21), which was the result of an unplanned gesture by the artist, provided a striking note.[221] Despite its serendipitous origins, the inclusion of the fabric flowers offered another apt symbol of the American Southwest.

However, to most eastern viewers, who were unfamiliar with New Mexican *camposantos* (cemeteries) and funerary traditions, the flower appeared incongruous, even surreal, and provided the occasion for much comment and interpretation. Critics saw the pairing of objects as evidence of O'Keeffe's "perverse humor," and spent much time remarking on her southwestern surrealism.[222] Rare was the critic of the time who, like Martha Davidson, emphasized the formal, decorative power of these canvases. When, in 1935, O'Keeffe released her skulls from their restricted space and floated them in the air above distant horizons, Davidson warned: "If these skulls . . . in their artistic arrangements with turkey feathers, pink poinsettias, or autumn leaves, are approached with the anticipation of finding symbolic expression of hidden mysteries, one will either feel cheated or disappointed."[223]

Although Davidson echoed O'Keeffe's own discounting of the surreal illogic of some compositions, the artist's "bonescapes" of the mid-1930s and beyond conveyed something undeniably compelling and unique. O'Keeffe explained them as her effort to capture the "wideness and wonder of the world as I live in it."[224] The method was accretive: "My paintings sometimes grow by pieces from what is around," such as flowers, bones, or leaves.[225] These still-life subjects were not randomly chosen, however, but always had for her an unusual personal significance, evoking place or time or mood. The compositions, however bizarre, were not dictated by conventional surrealist method, and the artist was not, as one critic charged, "deviating into the cul-de-sac of surrealism."[226]

O'Keeffe's images of wideness and wonder certainly deal with symbolic expression, even with "hidden mysteries," and therein lies their peculiar, enduring power. Her friend Lewis Mumford, while admitting that her "juxtapositions [were] no less unexpected than those of the Surrealistes," nevertheless drew an important distinction between the latter's irrational subjects and O'Keeffe's combinations, which "seem inevitable and natural, grave and beautiful."[227]

By the late 1930s, O'Keeffe had developed her authoritative treatment of the desert precinct through combinations of bone and land forms. The red hills and colorful cliffs of the Ghost Ranch country figured importantly in her repertoire, and provide a strong reference to the inspirational region. Being unfamiliar to most Americans, however, the eroded landscape failed to arouse the same interest as did, for instance, her magnified flowers, leading to the artist's complaint: "You have no associations with those hills – our waste land – I think our most beautiful country – You

21. *Horse's Skull with Pink Rose,* 1931, oil on canvas. Georgia O'Keeffe. The Georgia O'Keeffe Foundation.

may not have seen it, so you want me always to paint flowers."[228] Sometimes, O'Keeffe merged popular and personal tastes, painting blossoms lying on or embedded in the rugged landscape. More memorably, she depicted blossoms or bones hovering above the unloved wasteland, as in the powerful evocation of place *From the Faraway Nearby* (pl. 65).

This painting is charged by curious spatial plays, especially in the strikingly ambiguous relationship between the deer's skull and antlers in the foreground and the hills in the background; nothing mediates between the bony "here" and the distant "there," the middle ground having been dropped out of the composition. This tense contrast of closely viewed foreground details and hugely distant horizons depicted by O'Keeffe is not a mere optical illusion. The large scale, bright light, and clear air of the region permit the viewer to see, proverbially, "forever," and the juxtaposition of faraway and nearby is an integral aspect of desert vision. It is, moreover, a response common not only to visual artists.

For western writers, the contrast between distant beauty and close, sometimes-grim reality became a common literary device. Hamlin Garland was typical. In *Main-Travelled Roads,* his collection of western tales, he evoked a place where "the sky was magically beautiful over all this squalor and toil and bitterness." In the distance, "the falling sun streamed in broad banners across the valleys" while "blue mist lay far down . . . over the river; the cattle called from the hills in the moistening, sonorous air." Close at hand, however, hard reality awaited: "In the midst of it [the beauty], the younger man, in ill-smelling clothes and great boots that chafed his feet, went out to milk the cows, – on whose legs the flies and mosquitoes swarmed, bloated with blood, – to sit on the hot side of a cow and be lashed with her tail as she tried frantically to keep the savage insects from eating her raw." Garland's protagonist was caught between the pastoral and the particular: "The level, red light streamed through the trees, blazed along the grass, and lighted a few old-fashioned flowers into red and gold flame. It was beautiful, and Howard looked at it through his half-shut eyes as the painters do, and turned away with a sigh at the sound of blows where the wet and grimy men were assailing the frantic cows."[229]

D. H. Lawrence likewise regarded the New Mexican desert through a painter's eyes. In *St. Mawr* (1925), which he completed shortly after his stay in the state, he described a "New England woman" – like O'Keeffe, an outsider – who faced the dramatic realities of life in northern New Mexico. In a moving evocation of place, he offered another literary parallel to the dual vision of the desert painter. "But even a woman cannot live only into the distance, the beyond," he wrote.

Willy-nilly, she finds herself juxtaposed to the near things . . . and willy-nilly, she is caught up into the fight with the immediate object. The New England woman had fought to make the nearness as perfect as the distance: for the distance was absolute beauty. She had been confident of success. She had felt quite assured, when the water came running out of her bright brass taps, the wild water of the hills caught, trickled into the narrow iron pipes, and led tamely to her sink, to jump out over her sink, into her sink, into her wash basin, at her service. There! she said. I have tamed the waters of the mountain to my service. So she had, for the moment.

At the same time . . . while she revelled in the beauty of the luminous world that wheeled around and below her, the gray-rat–like spirit of the inner mountains was attacking her from behind. . . . The underlying rat-dirt, the everlasting bristling tussle of the wild life, with the tangle and the bones strewing. Bones of horses struck by lightning, bones of dead cattle, skulls of goats with little horns, bleached, unburied bones. The cruel electricity of the mountains. And then, most mysterious but worst of all, the animosity of the spirit of the place: like some serpent-bird forever attacking man.[230]

Garland's Howard, Lawrence's New England woman, and Georgia O'Keeffe shared the struggle with the near and the far. *From the Faraway Nearby* combines the "absolute beauty" of the distance with the "tangle and the bones strewing," as deer horns reach down to embrace and uplift the distant curve of hill. Forsaking any middle ground, the close and the infinite are locked together – the detailed skull and distant vista united in a kiss of horn and hill.

The painting of antlers above red hills enchants and haunts with a special spirit of place, one that has affected many viewers since its first presentation at Stieglitz's gallery in December 1937. Reviewers praised it as capturing "the very essence of the desert."[231] O'Keeffe included the impressive canvas in her major retrospective exhibition at the Art Institute of Chicago in 1943, but listed it under the title *Deer's Horns Near Cameron*.[232] This reference to an Arizona locale suggests that the painting was a souvenir of her tour through the West with the photographer Ansel Adams and other friends in 1937. Although initially inspired by a specific terrain and personal experience, the painting came to have emblematic status for the artist, eventually winning the name by which she alluded to her vast, beloved country: "the faraway." On this and other occasions, O'Keeffe moved beyond a pictorial essay on desert vision to create an icon of a special American precinct – the nation's exotic, the faraway nearby.

During his visit to O'Keeffe's Ghost Ranch country in 1937, Ansel Adams wrote excitedly to Alfred Stieglitz of his delight in the "magical" countryside. "The skies and land are so enormous, and the detail so precise and exquisite," he exclaimed, "that wherever you are, you are isolated in a glowing world between the macro and the micro – where everything is sidewise under you, and over you, and the clocks stopped long ago."[233] O'Keeffe's formal plays with near and far, with macro and micro, seem to illustrate Adams's poetic description; they also suggest other pairings: of the tangible and the infinite, of mortality and immortality, of the personal and the universal. In depicting the vast and magical spaces of the Southwest, O'Keeffe and Adams each discovered a metaphor whose romantic possibilities charged their artistic imaginations.

AFTER *From the Faraway Nearby,* little remained to be done with the skulls. Skeletal imagery, however, remained important to O'Keeffe, and, beginning about 1943, she was newly fascinated with the curving planes and cavities of pelvic bones. "For years in the country," she explained to an audience curious about this motif, "the pelvis bones lay about the house indoors and out – always underfoot" – like Lawrence's underlying "tan-

gle and . . . bones strewing." They were "seen and not seen as such things can be," and, although O'Keeffe could not recall when she first picked one up, she did know from her first notice that the pelvis would one day become a subject.[234]

In the initial canvases, O'Keeffe placed the pelvises – like the hovering skulls and antlers of the later 1930s – in an ambiguous relationship to the landscape, floating above it or cradling it in the cavity of the bone (pl. 66). The strange effects of these designs result partly from the spatial dislocations but even more from the unfamiliarity of the bony subject, whose shape is not as immediately legible as that of antlers or a skull. With the artist's cranial motifs, critics and viewers had at least a tradition of *vanitas* compositions and funerary symbolism on which to rely as they sought (however mistakenly) to come to terms with the subject. With the empty pelvises, however, there was less by way of iconographic tradition, and reviewers were left to struggle with the ambiguous white forms in the desert landscape.

The curator Daniel Catton Rich discovered in the new pictures a "fresh emotion . . . no longer concerned with death or after-death."[235] O'Keeffe wrote that she was "most interested in the holes in the bones – what I saw through them – particularly the blue from holding them up in the sun against the sky as one is apt to do when one seems to have more sky than earth in one's world."[236] For Rich, the skeletal forms closely viewed against the sky effected a similar merger of macro and micro whose novel inventiveness he thought stirring. "Bone and sky and mountain are welded," he concluded, "into a luminous affirmation . . . once again transformation has triumphed over observation."[237]

As the pelvic series progressed, O'Keeffe increasingly focused on the empty sockets in the bone, with which she framed the empty sky. Late in life, she alluded to the voids that had become such a familiar part of her formal invention: "I like empty spaces," she explained. "Holes can be very expressive."[238] On another occasion, in explaining the pelvic subjects, particularly the holes in the bones, she hinted at their symbolic value: "They were most wonderful against the Blue – that Blue that will always be there as it is now after all man's destruction is finished."[239] She initiated the pelvic series in 1943, in the bleak nadir of World War II, when "man's destruction" had reached unprecedented levels. From her early watercolors of another wartime era, the color blue – Kandinsky's spiritual hue – had held unusual interest for her; many years later, the enduring blue still held promise for the pacifist O'Keeffe. Thus, the series of sockets against the sky may be read as a pictorial appeal for peace.

It is the formal impact of the pelvic compositions that ultimately makes the series of the 1940s so crucial. The artist's vision of her world had been shaped by the bones, both literally and metaphorically, and the pelvic patterns persisted even when the skeleton itself was dropped. The hard arcs of red bone that contain the cosmos in *Pelvis Series – Red with Yellow* (pl. 82) are repeated in a simpler landscape format in another pivotal canvas of 1945, *Red Hills and Sky* (private collection).

The simple V enframing the limitless blue expanse suggests a close-up of landscape equivalent to the closely studied sockets in the pelvis; as with

her bony landscapes of the 1930s, the middle ground is again elided in this composition, a device that reduces her landscape inspiration to its simplest forms. The paring down of design and the hardening of contours appeared as well in other subjects at mid-decade, such as the starkly elegant *Bare Tree Trunks with Snow* (pl. 44). As with the view through red hills, such "immaculate studies of vacuum-cleaned tree trunks" (as Henry McBride called her paired paintings of bare trunks) were stripped of all incidental detail, their contours cleanly outlined, their swelling forms indicated through the most subtle transitions of hue.[240] The formal priorities of these works from the mid-1940s suggest the directions that her work was to follow increasingly in the decades ahead. For the short term, however, there was a hiatus in her production after the death of Stieglitz in July 1946, and the three-year-long settlement and distribution of his estate.

UNIVERSALS

WHEN O'Keeffe moved permanently to New Mexico in 1949, her themes diversified and changed, sometimes dramatically; in her formal vocabulary, however, can be traced the continuities in her work before and after the move. According to the faithful critic Henry McBride, who reviewed her show of 1950 in New York: "There does seem to be an increased urge to dispense with all fripperies and to do in paint what Brancusi does in sculpture; that is to say, to reduce everything to its essential principle, polishing the surfaces until they have an elegance strictly hygienic." McBride admitted that "this simplicity, however, had always been present, *chez* O'Keeffe," and that its manifestations after 1946 marked a more rigorous technique, rather than a different one.[241]

For the *New York Times*'s venerable and eminent critic Edward Alden Jewell, O'Keeffe's exhibition at the Museum of Modern Art in 1946 confirmed a long-held impression. "It seems to me," he wrote,

that Georgia O'Keeffe is in the ultimate sense a mystic. Her work . . . is charged with a spirit of universality, even when expression appears tethered to what is immediate and finite. She paints a flower, a leaf, a shell, a tree, the desiccated skull of an animal, portraying these objects as microcosms; and it will always be the macrocosm – the enveloping sum of elements peculiar to life and death – that presses in, giving the concept its final radiance.[242]

This "spirit of universality," as conveyed through microcosmic particulars, fairly describes the compositions of O'Keeffe's later years, especially those that reprise earlier types, such as still lifes of flowers or rocks. Among the most striking of all her late designs is *Ladder to the Moon* (pl. 80), which relies on the specifics of ladder, landscape horizon, and lunar crescent to convey the sensations of place. The ladder hovering above the profiled Pedernal Peak may simply reflect the ubiquity of ladders in O'Keeffe's New Mexican homes. On another level, however, it might serve to link terra firma with the cosmos, the here and now with the hereafter, in short, to tie together the microcosmic and the macrocosmic.

Although the ladder overhead was a unique image in O'Keeffe's oeuvre, other architectural elements provided the basis for ongoing series

in the 1950s, most notably, the dark door in the adobe wall of her Abiquiu patio. She claimed that this architectural feature is what made her initially covet the property, and she portrayed the adobe wall and its dark door of the patio on numerous occasions.

The first of her *Patio* paintings was completed during her brief visit in the summer of 1946. During her restorative Abiquiu sojourn two years later, she tackled the subject at least four more times, as if to bond herself pictorially to her new home and all its connotations. Throughout the 1950s, the combination of door and wall remained a favorite motif. It was depicted at all seasons, from springtime greenery (pl. 81) to winter snow, and it stimulated O'Keeffe to make various formal experiments.

Both as geometric pattern and as poetic allusion, the patio subject recalled the importance of place, of home. As a fragment of an architectural whole, it provided a microcosm of the larger environs, although not on the same scale as with her earlier subjects; indeed, in the transfer from the real world to the painted one, the door was reduced rather than enlarged. In its familiar frontal arrangement, the aperture in the wall suggests the threshold to a domestic interior, but the dark openings might also perform a role akin to the pelvic sockets, providing entry to a limitless and metaphoric space. In one late example, Barbara Rose discerned O'Keeffe's transcending of the simplified designs inspired by indigenous architecture to produce an image at once ambiguous and more ambitious.[243] The subtle gradations of hue in the door implied recession through an aerial perspective; for Rose, it was the entry to some vast space that (as O'Keeffe had once said) was "calling – as the distance has always been calling me."[244] In short, the door promised a glimpse into the infinite.

O'Keeffe's simple means elicited such interpretations from a new generation of critics and viewers. In the 1970s they discovered in her recent work the poetic overtones that had captivated her earliest enthusiasts but now were being enunciated in the metaphysics of minimalism. The patio door paintings evinced formal concerns that correlated with the most sophisticated abstractions of the period: a field of unified tone, implying a fragment of a large expanse, combined with a severe reduction of elements arrayed in a few broad planes of color. In all respects, these paintings conformed well to the canons of minimalism that were then preoccupying many younger artists. O'Keeffe joked that on first seeing a painting by Ellsworth Kelly – an artist she admired greatly – she thought, "'I could do that.' And then I realized I had!"[245] In turning to such compositions, O'Keeffe was reinventing herself, echoing the sparest designs of her youth.

For a brief period, she balanced the spare elegance of the hard-edged patio compositions with a softer, looser stroke, which she applied to the brushy forms of cottonwood trees. But the vaporous elegance of the *Winter Trees* series (pls. 76–78) did not persist beyond 1954, when the cottonwood paintings ended as abruptly as any other O'Keeffe series. In their place appeared more patio pictures and, by the last years of the decade, a new series of images inspired by her wide-ranging travels.

Until her visit to Mexico in 1951, O'Keeffe, Stieglitz's quintessential American artist, had remained "unsullied" by foreign training and travel.

22. *Misti–A Memory,* about 1957, oil on canvas. Georgia O'Keeffe. The Georgia O'Keeffe Foundation.

Beginning with that trip and continuing with longer and more distant travels over more than a decade, she finally discovered the world. The paintings that resulted were rarely of the tourist postcard genre; for example, in interpreting the Incan ruins at Machu Picchu or the Andean heights (fig. 22), she extracted design possibilities from the setting rather than detailing the archaeological specifics or the dramatic scenery.

However, the most innovative of O'Keeffe's late series were inspired less by particular tourist sites than by her experience of flight high above the clouds and land – an experience that was still a novelty for most Americans in the 1950s, the beginning of the jet age. O'Keeffe's global circuit in 1959 was of special consequence; flying over the deserts of the Near East, she was surprised to find riparian patterns even in the most arid areas. The aerial view was "fantastic – long twisting rivers over the land and then sometimes water with long twisting pieces of land through it. . . . It is amazing."[246] Memories of the sight, in addition to slight sketches of the watercourses drawn on tiny scraps of paper, quickly inspired a group of overhead views of rivers. She first treated the subject in a series of charcoal drawings (pls. 87–89), whose bold and simple patterns were reminiscent of her drawings from 1915 and 1916, and reflected a reversion to or, more properly, a survival of the influential compositional principles of Arthur Wesley Dow. From this sinuous flow of black and white, O'Keeffe turned to colorful oils, completing at least a dozen canvases in the year following her round-the-world trip (pls. 84, 86). The quantity of the work, as well as its vigor and freshness, suggests the consequential impact that the experience of travel had on her.

The river paintings merged the crisp, minimal patio forms of the early 1950s with the looser, more painterly technique of the cottonwood series. By looking down on her motif, she isolated the pattern from the larger landscape, as was her custom, using a fragment to represent the whole. Color, like water, flowed across the ground of the canvas, sometimes in a flood, sometimes in a trickle, always in arresting designs and hues. Looking down on the land, O'Keeffe remembered seeing "such incredible colors that you actually begin to believe in your dreams." When working in the studio to translate these impressions to canvas, she felt free to employ color arbitrarily, explaining to one viewer that "after all you can see any color you want when you look out the [airplane] window."[247]

The patterns of rivers were succeeded by those of roads, which she again studied from above, but obliquely rather than directly overhead. Unlike the river views, the terrain of the road pictures was a familiar one, examined from O'Keeffe's mesa-top studio in Abiquiu. Running past her town, the road led eastward toward "Espanola, Santa Fe and the world." "The road fascinates me with its ups and downs," she wrote, "and finally its wide sweep as it speeds towards the wall of my hilltop to go past me." In a rare excursion into Stieglitz's medium, O'Keeffe photographed the road, angling the camera to contain its entirety within the frame; although the result was accidental, she was pleased with the effect of the road "stand[ing] up in the air," and translated the form from photograph to painting.[248] *Winter Road I* (pl. 83) tracks its course across a snowy white ground as sparely and simply as a calligrapher's stroke, or as her *Black Lines* of nearly half a century earlier.

AIR TRAVEL provided the genesis for the artist's last major series, of clouds viewed from above. The overhead views of rivers and roads had still been landscapes, O'Keeffe's discoveries of design within nature, which had long been her prime inspiration. With the cloudscapes, however, the subject matter shifted from the tangibilities of terra firma to the evanescence of atmospherics. Although the vantage point remained elevated, the angle of vision changed from an overhead, vertical perspective, which created flat patterns across the ground, to a horizontal view across space; the artist focused outward and toward a horizon at some immeasurable distance. The resulting vistas of empty space represent a culmination of many of her pictorial and thematic concerns.

O'Keeffe likened the composition of *Sky above White Clouds I* (pl. 85) and other late compositions to the contemporaneous works of minimalists such as Kenneth Noland, whose horizontal bands of color formally parallel her division of the canvas into lateral zones of pale hue;[249] but the two painters and their works share little but an economy of design. The younger artists of the 1960s often employed minimal elements as an end in themselves; for O'Keeffe, the reduction of pictorial elements (sky and clouds) to two planes of color was but a further step in her continuing quest for an absolutism based on nature, a tendency that had characterized her work during most of her career. Years earlier, her fellow modernist Marsden Hartley had spoken of her approach to "the borderline between finity and infinity."[250] With her cloud pictures, O'Keeffe seemed finally to have moved beyond (and above) the finite subjects and concerns of this world, achieving that point toward which all her earlier efforts had been prologue.

From her early years on the Texas plains, she had expressed her preference for vacancy, for the "wonderful emptiness" of that landscape.[251] And late in life, as she was working on the cloud paintings, she reiterated the affection: "I've often thought how wonderful it would be to simply stand out in space and have nothing!"[252] The aspiration echoes Emerson's famed revery: "Uplifted into infinite space, – all mean egotism vanishes. I become a transparent eyeball; I am nothing; I see all." In confronting O'Keeffe's cloudscapes, the viewer does not have the sense of

looking *at* a scene constructed with conventional Renaissance perspective; instead, the spectator is imaginatively projected *into* the space, floating in the infinite void. In this, the viewer follows the artist, who projected herself, pictorially and imaginatively, into the ethers, having nothing, being nothing, seeing all.

"JUST AS A PAINTER"

THE HALF-LIFE of a reputation is fragile. O'Keeffe's, however, seemed to know no conventional laws. Late in her life, when most of her colleagues were deceased or at least retired, her star continued its ascendant arc. The recognition and honor that accrued to her during Stieglitz's lifetime were briefly eclipsed in the 1950s and 1960s, after her remove to New Mexico. During those decades, critical and popular attention was dominated by the muscular abstractions of the New York School and, later, the brash imagery of pop artists. Neither group had much affinity with O'Keeffe, and she was content to continue in her own path, apart from the field. When she reemerged from this period of critical neglect, with impressive solo exhibitions in Texas (Amon Carter Museum, Fort Worth, 1966) and New York (Whitney Museum of American Art, 1970), she found the adulation of a new audience. "Possibly the real importance of O'Keeffe in American art history," wrote E. C. Goossen in 1967, "lies in her faithfulness to her first intuition that she had in her possession the key to a new and yet traditionally valid art. The winds of fashion must have been very strong over the years, but like Matisse and Mondrian she has remained herself. Moreover, from the evidence . . . it appears she was right."[253]

Late in her life, as new enthusiasts flocked to her art and her example, she was claimed by many camps. After the triumph of her Whitney retrospective, O'Keeffe became a focus of interest for the culture at large. A resurgent feminist movement, seeking to anoint its founding mothers, might have canonized the artist, had she permitted it; their leaders had forgotten her disdain of gendered acclaim and her blunt assertion: "I am not a woman painter!"[254] An aging American population was newly fascinated with geriatric productivity and similarly looked to the octogenarian O'Keeffe as a model.

Among academics and curators she was also back in vogue. As the last survivor of the pioneering generation of modernists in the United States, she was the beneficiary of renewed scholarly interest in the now-distant modernist episode. Critics and historians found her work "stand[ing] precisely on the boundary between our time, now, and history in our time."[255]

Whereas the distinctive character of her work and life could be conveyed in solo shows over which she maintained strong control, over group exhibitions organized by others she had less authority; she found herself with increasing frequency in such ensembles, presented in various contexts not always to her liking. She dismissed, for instance, her inclusion in a landmark show of American precisionism as "an absurd idea. What can you do if people who own your pictures are willing to lend them to any exhibition?" Similarly, she complained that "I was in the surrealist show

when I'd never heard of surrealism. I'm not a joiner and I'm not a precisionist or anything else."[256] In a like vein, she probably would have rejected Goossen's characterization of her as an "existentialist" and would have disdained discussion of her paintings as examples of a southwestern "regionalism."

When O'Keeffe was asked how she would like to be remembered, the answer was simple and emphatic: "As a painter – just as a painter."[257] And it is properly through that vocation, and in those unqualified terms, that her achievement is to be judged.

for Jane, again

CURATOR'S ACKNOWLEDGMENTS

IN 1987, when Georgia O'Keeffe's one-hundredth birthday was celebrated with a major retrospective exhibition at the National Gallery of Art in Washington, D.C., many foreign visitors to the American capital were exposed to her art for the first time. From their delighted response developed the concept for the present exhibition, the first ever on so large a scale to introduce to a wider world the work of a pre–World War II American artist.

I am very grateful to my colleagues at InterCultura, a cultural exchange agency in Fort Worth, Texas, for the invitation to participate in this enterprise. The faithful support and assistance generously offered to this project by the dedicated staff of InterCultura, especially Gordon Dee Smith, former president; Peggy Booher; and Marcus Sloan, are deeply appreciated. A project as complex as this can result only from the efforts of many collaborators. For their exceptional contributions, I want to thank in particular Elizabeth Glassman and Agapita Judy Lopez, President and Secretary-Treasurer, respectively, of the Georgia O'Keeffe Foundation, Abiquiu, New Mexico, and their colleagues Melanie Crowley and Baird Ryan. For their keen judgment and patient assistance, I am grateful to my editors, Fronia W. Simpson and Robin Jacobson.

From the outset, the Dallas Museum of Art, Dallas, Texas, and the National Gallery of Art, Washington, D.C., have been key contributors to this project, providing various logistical and research assistance. For their good help, I am especially indebted to Richard Brettell, Consulting Director, and Eleanor Jones, Curator of American Art, at the Dallas Museum; and to J. Carter Brown, Director Emeritus, and Anne Robertson, Exhibitions Officer, at the National Gallery.

With any exhibition the generosity of lenders is crucial. We have been blessed with the assistance of many fortunate owners, private and institutional, of O'Keeffe's paintings. For their kindness in temporarily parting with their treasures and in sharing them with a wider audience, I am particularly appreciative.

My own considerations of Georgia O'Keeffe's work and life extend back nearly three decades. It would doubtless be foolhardy to attempt an enumeration of the many students and colleagues, librarians, artists and critics, and collectors and dealers who have added to my appreciation of her special achievement. To all who have taken an interest in this extended campaign, my sincere thanks; where this exhibition and publication enlighten, it is because of their contributions and insights.

Finally, I am indebted beyond words to my wife, Jane, for her patience and encouragement over the many months of the genesis of this show, and the many years of work that preceded it. As always, her name must come first, with love and gratitude.

CHARLES C. ELDREDGE, *Lawrence, Kansas, 1993*

THE FOLLOWING abbreviations are used through-out the notes to indicate sources cited.

AAA
Archives of American Art, Smithsonian Institution, Washington, D.C.

Art and Letters
Jack Cowart, Juan Hamilton, and Sarah Greenough, *Georgia O'Keeffe: Art and Letters* (Washington, D.C.: National Gallery of Art, 1987)

Lisle
Laurie Lisle, *Portrait of an Artist: A Biography of Georgia O'Keeffe* (New York: Seaview Books, 1980; rev. ed. New York: Washington Square Press, 1987)

Lynes
Barbara Buhler Lynes, *O'Keeffe, Stieglitz, and the Critics, 1916–1929* (Ann Arbor, Michigan: UMI Research Press, 1989)

Peters
Sarah Whitaker Peters, *Becoming O'Keeffe: The Early Years* (New York: Abbeville Press, 1991)

Robinson
Roxana Robinson, *Georgia O'Keeffe: A Life* (New York: Harper & Row, 1989)

Yale
Yale Collection of American Literature, Beinecke Rare Book and Manuscript Library, Yale University, New Haven (includes Alfred Stieglitz–Georgia O'Keeffe papers)

CHRONOLOGY

1. Robinson, p. 24.
2. Georgia O'Keeffe, *Georgia O'Keeffe* (New York: Viking, 1976), n.p.
3. Robinson, p. 24.
4. Sister Rose Catherine, O.P. (Mary Leonard), letter to author, Madison, Wisconsin, June 2, 1970; O'Keeffe, *Georgia O'Keeffe,* n.p. Another student corroborated O'Keeffe's recollection: "Sister Angelique held up her drawings for us to admire but did say Georgia drew too small and should 'fill the paper' " (Sister Francis de Sales [Rosalind Conklin], letter to author, Sinsinawa, Wisconsin, June 16, 1970).
5. O'Keeffe, *Georgia O'Keeffe,* n.p.
6. Christine McRae Cocke, letter to author, Williamsburg, Virginia, June 15, 1970.
7. Robinson, p. 52.
8. Ibid., p. 80.
9. Lisle, p. 109.
10. Georgia O'Keeffe, letter to unknown recipient [Leah Harris?], New York City, November 11, 1918 (Yale).
11. Herbert J. Seligmann, *Alfred Stieglitz Talking: Notes on Some of His Conversations, 1925–1931* (New Haven: Yale University Press, 1966), p. 69.

12. Although most accounts date the shipment to 1930, Roxana Robinson has pointed out that Stieglitz and O'Keeffe did not refer to the bones at Lake George until their correspondence of August 1931, following O'Keeffe's return from her third New Mexico outing. (Robinson, p. 596 n. 3).
13. Robinson, p. 371.
14. Georgia O'Keeffe, interview with the author, Abiquiu, New Mexico, June 1970.
15. Alfred Stieglitz, letter to Jean Toomer, New York City, January 30, 1934 (Yale).
16. Lewis Mumford, "Autobiographies in Paint," *New Yorker,* January 18, 1936, p. 48; reprinted in *Georgia O'Keeffe: New Paintings* (New York: An American Place, 1937), n.p.
17. "Georgia O'Keeffe Honored," *Equal Rights* (published by National Woman's Party), June 1942, n.p.
18. Georgia O'Keeffe, "About Painting Desert Bones," *Georgia O'Keeffe Paintings—1943* (New York: An American Place, 1944), n.p.
19. The story of the $10 real-estate transaction is re-peated in various accounts of the artist's life and her home (including Lisle, p. 325; Robinson, p. 449; Franklin Israel, "Architectural Digest Visits: Georgia O'Keeffe," *Architectural Digest,* July 1981, p. 81).
20. *Catalogue of the Alfred Stieglitz Collection for Fisk University* (Nashville, Tennessee, 1949), p. 5.
21. Calvin Tomkins, "The Rose in the Eye Looked Pretty Fine," *New Yorker,* March 4, 1974, p. 64.
22. Leo Janos, "Georgia O'Keeffe at Eighty-four," *Atlantic Monthly,* December 1971, p. 117.
23. Georgia O'Keeffe, letter to Peggie Kiskadden, Oaxaca, Mexico, December 13, 1957 (Yale).
24. J. R. M., "In the Galleries: Georgia O'Keeffe," *Arts* 32 (March 1958): 60; Eleanor C. Munro, "Five Shows out of the Ordinary: Georgia O'Keeffe," *Art News* 57 (March 1958): 38.
25. Georgia O'Keeffe, letter to Claudia O'Keeffe, Abiquiu, New Mexico, October 20, 1958 (Yale).
26. Georgia O'Keeffe, letter to Anita O'Keeffe Young, en route from Karachi to Teheran, April 29, 1959 (continuation of letter of April 25, 1959; Yale).
27. Mary Lynn Kotz, "A Day with Georgia O'Keeffe," *Art News* 76 (December 1977): 38.

ESSAY

1. New York: Anderson Galleries, 1923. A typewrit-ten list of the exhibition, annotated by Stieglitz, gives a count of 137 items (The Georgia O'Keeffe Founda-tion, Abiquiu, New Mexico). The exhibition bro-chure notes that 90 pictures were being exhibited for the first time; however, neither brochure nor price list provides titles for the works.
2. Elizabeth Luther Cary, "Art – Competitions, Sales, and Exhibitions of the Mid-season: Georgia O'Keeffe, American," *New York Times,* February 4, 1923 (in Lynes, p. 186).

3. Herbert J. Seligmann, "Georgia O'Keeffe, American," *MSS.*, no. 5 (March 1923; in Lynes, pp. 195, 196).

4. Georgia O'Keeffe, "To MSS. and Its 33 Subscribers and Others Who Read and Don't Subscribe!" *MSS.*, no. 4 (December 1922; in Lynes, p. 182.) The reference to Bellows's tutelage is confusing, for he did not begin teaching at the Art Students League until 1910, two years after O'Keeffe's departure from the school, and instruction with him prior or subsequent to that date is not elsewhere recorded.

5. Georgia O'Keeffe, *Georgia O'Keeffe* (New York: Viking Press, 1976; reprint New York: Penguin Books, 1985), opp. pl. 31.

6. Paul Strand, letter to Henry Tyrrell, quoted in Tyrrell, "Art Observatory: Exhibitions and Other Things," *New York World,* February 11, 1923 (in Lynes, pp. 193–94).

7. Alfred Stieglitz, letter to Paul Rosenfeld, September 5, 1923; in Sarah Greenough and Juan Hamilton, *Alfred Stieglitz: Photographs and Writings* (Washington, D.C.: National Gallery of Art, 1983), p. 212. Composers faced a similar challenge with relation to the dominance of German music. Arthur Farwell, an innovative composer and the founder of the American Music Society, warned that the "first correction we must bring to our musical vision is to cease to see everything through German spectacles" (Edward N. Waters, "The Wa-Wan Press: An Adventure in Musical Idealism," in *A Birthday Offering to Carl Engel,* ed. Gustave Reese [New York: Schirmer, 1943], p. 222).

Rosenfeld shared his correspondent's faith in their compatriots' work: "I know it is significant that the artists in whom I am most interested to-day are Amurkans [*sic*]. But of what is it significant? That I can't guess. Are they really better artists than the Europeans, in the sense that they are better workmen? I think not, on the whole; and yet, they seem like young men with the possibilities of careers while the Europeans seem pretty well cut out and defined. The first are like misty mornings; the second, like days pretty much advanced" (letter to Alfred Stieglitz, Westport, Connecticut, September 30, 1922 [Yale]).

8. Roberta Smith, "Paley's Gift to the Modern, A Paean to French Masters," *New York Times,* January 31, 1992, p. B1.

9. Quoted in Dorothy Seiberling, "Horizons of a Pioneer," *Life,* March 1, 1968, p. 50.

10. Arthur Wesley Dow, *Composition,* 5th ed. (New York: Baker and Taylor, 1903), p. 60.

11. Ibid., p. 32.

12. Arthur Wesley Dow, letter to Georgia O'Keeffe, New York, April 24, 1917 (Yale). The professor could not resist the chance to continue his instruction: "It did seem to me, however, that there were too many of those vague things. I remember your excellent work in color printing and think it would be worth your while next time to show a greater variety."

13. O'Keeffe, *Georgia O'Keeffe,* opp. pl. 12.

14. Ibid., opp. pl. 1.

15. Georgia O'Keeffe, statement, in *Alfred Stieglitz Presents One Hundred Pictures: Oils, Watercolors, Pastels, Drawings by Georgia O'Keeffe American* (New York: Anderson Galleries, 1923), n.p.

16. O'Keeffe, *Georgia O'Keeffe,* opp. pl. 1.

17. Calvin Tomkins, "The Rose in the Eye Looked Pretty Fine," *New Yorker,* March 4, 1974, p. 42.

18. Alfred Stieglitz, letter to Sherwood Anderson, Lake George, New York, October 27, 1924 (Yale).

19. Georgia O'Keeffe, *Some Memories of Drawings,* ed. Doris Bry (New York: Atlantis Editions 1974; rev. ed. Albuquerque: University of New Mexico Press, 1988), p. 102.

20. William Murrell Fisher, "The Georgia O'Keeffe Drawings and Paintings at '291,'" *Camera Work,* nos. 49–50 (June 1917; in Lynes, p. 169).

21. Henry Tyrrell, "New York Art Exhibitions and Gallery News: Animadversions on the Tendencies of the Times in Art – School for Sculpture on New Lines," *Christian Science Monitor,* June 2, 1916 (in Lynes, pp. 165–66).

22. Alfred Stieglitz, "Georgia O'Keeffe – C. Duncan – Rene Lafferty," *Camera Work,* no. 48 (October 1916); Fisher (both in Lynes, pp. 166, 169).

23. Henry Tyrrell, "New York Art Exhibition and Gallery Notes: Esoteric Art at '291,'" *Christian Science Monitor,* May 4, 1917 (in Lynes, p. 168). The work, which Tyrrell referred to as *Two Lives,* was most likely the famous watercolor *Blue Lines X* (1916; The Metropolitan Museum of Art, New York) or one of its preparatory studies in charcoal or ink (pl. 6). The critic apparently echoed Stieglitz, who often referred to the image as the tracing of male and female principles, arising from the same ground and pursuing parallel, but independent, courses. F. S. C. Northrop, one of the most prominent of midcentury philosophers, also saw in the image a metaphor for polarities, though cultural or philosophical rather than sexual opposites; he used the watercolor as the frontispiece for his major study *The Meeting of East and West* (New York: Macmillan, 1946). Yet others have seen the provocative piece as pure design, the ultimate expression of design principles enunciated by O'Keeffe's teacher Arthur Wesley Dow. The susceptibility of the artist's abstractions to such varied readings suggests the potency of her formal inventions and their capacity to convey significance independent of representation, even as they may have evolved from inspiration in the material world.

24. Fisher, "Georgia O'Keeffe Drawings and Paintings" (in Lynes, p. 169).

25. Georgia O'Keeffe, letter to unidentified recipient, March 21, 1937 (Yale).

26. Tyrrell, "Esoteric Art at '291,'" (in Lynes, p. 168).

27. Ibid. (in Lynes, p. 167).

28. Georgia O'Keeffe, letter to Anita Pollitzer, Columbia, South Carolina, October 20 [?], 1915 (in *Art and Letters,* p. 146).

29. Wassily Kandinsky, *Concerning the Spiritual in Art* (1912; reprint, New York: Wittenborn, 1966), pp. 45, 58–59.

30. The critic Henry McBride was typical of his generation. He showed his familiarity with "the occult scheme of things" when he noted that "pale blue is the highest and finest [color] to humans obtainable, and hints of this tint in Miss O'Keefe's [*sic*] career will be awaited with extreme interest" ("Stieglitz, Teacher, Artist; Pamela Bianco's New Work: Stieglitz-O'Keefe [*sic*] Show at Anderson Galleries, *New York Herald,* March 9, 1924 [in Lynes, p. 200]). In verse rife with Mallarméan imagery ("A blanched cygnet glides across the frozen lake"), Marsden Hartley employed typically chromatic language, drawing on the "blue plenteousness" of his time: "The situation is blue and white, / Inevitably" ("The Crucifixion of Noel," *The

Collected Poems of Marsden Hartley, 1904–1943, ed. Gail R. Scott [Santa Rosa, California: Black Sparrow Press, 1987], pp. 85–87).

31. For some, the color also conveys strong associations with nationality. For instance, the critic Michael Brenson wrote: "No country has been more drawn to the color blue than France." Citing the range from Poussin's figures clad in "powerful blue robes" to Matisse's "sometimes thin, sometimes saturated, often unfathomable blues," Brenson concluded that "blue is part of the artistic sensibility of a nation" ("'Poussin to Matisse': France to Russia to Met," *New York Times,* May 18, 1990, p. B5). However, given Stieglitz's Francophobia and the metaphysics he preached, the Kandinsky inspiration is a far more likely one for O'Keeffe's "blue period," about 1916 to 1917.

32. Georgia O'Keeffe, "About Painting Desert Bones," *Georgia O'Keeffe: Paintings, 1943* (New York: An American Place, 1944), n.p.

33. W. G. Bowdoin, "Georgia O'Keeffe Holds a Century Show of Her Work," *Brooklyn Evening World,* February 2, 1923 (clipping in O'Keeffe papers, Yale; not in Lynes).

34. Georgia O'Keeffe, letter to Ettie Stettheimer, Ghost Ranch, New Mexico, October 12, 1945 (Yale).

35. Charles Demuth, statement, *Georgia O'Keeffe: Paintings, 1926* (New York: Intimate Gallery, 1927), n.p.

36. Amy Lowell, "Violin Sonata for Vincent d'Indy" (quoted in Willis Wager, "Amy Lowell and Music," *A Birthday Offering to Carl Engel,* p. 212).

37. Alfred Stieglitz, letter to Sherwood Anderson, Lake George, New York, September 19, 1923 (Yale).

38. Rebecca S. Strand, letter to Alfred Stieglitz, New York City, July 16, 1923 (Yale).

39. Marsden Hartley, *Adventures in the Arts: Informal Chapters on Painters, Vaudeville, and Poets* (1921; reprint, New York: Hacker Art Books, 1972), pp. 116–19 (also reprinted in *Alfred Stieglitz Presents . . . Georgia O'Keeffe American* and in Lynes, pp. 170–71). Hartley's reference to O'Keeffe's being "impaled with a white consciousness" may have been inspired by the curious forms and pale colors of her recently completed *Series I, No. 7,* 1919 (The Georgia O'Keeffe Foundation).

40. Georgia O'Keeffe, interview with the author, Abiquiu, New Mexico, June 1970. As with many of O'Keeffe's declarations, the gist of this remark was often repeated and appears frequently in the literature.

41. Fisher, "Georgia O'Keeffe Drawings and Paintings" (in Lynes, p. 169).

42. Steven Z. Levine, "Monet's Pairs," *Arts Magazine* 49 (June 1975): 72.

43. O'Keeffe, interview with the author.

44. Georgia O'Keeffe, letter to Anita Pollitzer, Canyon, Texas, September 11, 1916 (in *Art and Letters,* p. 157).

45. Long Lake and the Indian Peaks wilderness are in what today is the Roosevelt National Forest, immediately south of Rocky Mountain National Park. O'Keeffe's attention was probably drawn to the region by publicity when the park was established in 1915. Although she was a relatively early visitor to the federally designated park, the region had lured adventurers and vacationers for generations, as it continues to do today; in 1991 Rocky Mountain National Park was the premier tourist attraction of Colorado.

46. William James, "Varieties of Religious Experience," quoted in Mrs. Forbes-Sempill, "Music Made Visible," *Illustrated London News,* February 12, 1927, p. 260; Gustav Kobbe, "The Music of a Woman's Face," *Cosmopolitan,* November 1901, p. 3.

47. Pamela Colman Smith, "Music Pictures" (manuscript), London, December 1907, p. 1 (Yale). The artist's statement was often cited or reprinted at the time, for example, in "Pictures in Music," *Strand Magazine* 35 (June 1908): 634–38; and "Pictured Music," *Current Literature* 45 (August 1908): 174–77.

48. M. Irwin Macdonald, "The Fairy Faith and Pictured Music of Pamela Colman Smith," *Craftsman* 23 (October 1912): 28.

49. Alfred Stieglitz, letter to Emma Goldman, New York, January 8, 1915 (Yale).

50. Mary Lynn Kotz, "A Day with Georgia O'Keeffe," *Art News* 76 (December 1977): 43. "Singing," the artist said on another occasion, "has always seemed to me the most perfect means of expression. Since I cannot sing, I paint" ("Austere Stripper," *Time,* May 27, 1946, p. 74).

51. Anita Pollitzer, *A Woman on Paper: Georgia O'Keeffe* (New York: Simon & Schuster, 1988), p. 168. O'Keeffe also had contagious "passions." One of the Stieglitz family retainers who knew him well admitted that "Mr. Alfred would never have been the photographer he later was if he hadn't got with Georgia. . . . He did wonderful street scenes, portraits, railroad tracks and all that before Georgia came. But after Georgia came, he made the clouds, the moon, he even made lightning. He never photographed things like that before" (*A Woman on Paper,* pp. 169–72).

52. The inscribed photograph is in the archive of the Georgia O'Keeffe Foundation, Abiquiu, New Mexico.

53. O'Keeffe, *Some Memories of Drawings,* n.p.

54. Macdonald, "Fairy Faith and Pictured Music," p. 33.

55. Georgia O'Keeffe, letter to Anita Pollitzer, Columbia, South Carolina, January 14, 1916 (in *Art and Letters,* p. 149). Curiously, even O'Keeffe's language echoes the precedent of Pamela Smith, who described her own synesthetic pictures as coming to her though "a hole in the air" (Forbes-Sempill, "Music Made Visible," p. 259).

56. Georgia O'Keeffe, letter to unidentified recipient, March 21, 1937 (Yale).

57. Alfred Stieglitz, "Statement" (Chapter 3), *Third Exhibition of Photography by Alfred Stieglitz* (New York: Anderson Galleries, 1924), n.p.

58. Paul Strand, "Stieglitz, An Appraisal," *Popular Photography,* July 1947, pp. 396, 398.

59. Waldo Frank [Search-Light, pseud.], *Time-Exposures* (New York: Boni & Liveright, 1926), p. 179.

60. O'Keeffe, letter to Henry McBride, n.p. [Abiquiu, New Mexico?], n.d. [1950s?] (Yale).

61. O'Keeffe, "About Painting Desert Bones," n.p.

62. Lisle, p. 107.

63. Dorothy Norman, *Alfred Stieglitz: An American Seer* (New York: Random House, 1973), p. 204.

64. Hartley, *Adventures in the Arts* (in Lynes, p. 170).

65. O'Keeffe, *Georgia O'Keeffe,* opp. pl. 55.

66. Neith Boyce (Hapgood), letter to Alfred Stieglitz and Georgia O'Keeffe, n.p., n.d. [1930s?] (Yale).

67. Laura Gilpin, "The Austerity of the Desert Pervades Her Home and Her Work," *House Beautiful,* April 1963, p. 199.

68. Wassily Kandinsky, quoted in Maurice Tuchman, "Hidden Meanings in Abstract Art," in *The Spiritual in Art: Abstract Painting, 1890–1985,* ed. Maurice Tuchman (New York: Abbeville Press, 1986), p. 35.

69. O'Keeffe, *Georgia O'Keeffe,* opp. pl. 88.

70. Albert Blohm, letter to Georgia O'Keeffe, Yonkers, New York, April 4, 1926 (Yale).

71. William Blake, "Auguries of Innocence," from "The Pickering Manuscript," 1801–1803 (first published by D.G. Rossetti, 1863).

72. Jean Toomer, letter to Georgia O'Keeffe, Doylestown, Pennsylvania, January 29, 1945 (Yale).

73. Norman F. Cantor, *Twentieth-century Culture: Modernism to Deconstruction* (New York: Peter Lang, 1988), p. 36.

74. Fernand Léger, "A New Realism –The Object: Its Plastic and Cinematic Value," *Little Review* (Winter 1926); reprinted in Beaumont Newhall, ed., *Photography: Essays and Images* (New York: Museum of Modern Art, 1980), p. 231.

75. O'Keeffe, *Georgia O'Keeffe,* opp. pl. 63.

76. Alfred Stieglitz, letter to Arthur Dove, Lake George, New York, August 15, 1918 (Yale).

77. Carol Duncan, "Virility and Domination in Early-twentieth-century Vanguard Painting," *Artforum* 12 (December 1973): 31.

78. Norman, *Alfred Stieglitz,* p. 131.

79. Giles Edgerton, "Is There a Sex Distinction in Art? The Attitude of the Critic toward Women's Exhibits," *Craftsman* 14 (June 1908): 249, 242.

80. O'Keeffe, interview with the author.

81. Lincoln Steffens, quoted in A. A. Brill, "The Introduction and Development of Freud's Work in the United States," *Journal of American Sociology* 45 (November 1939): 323.

82. Frank, *Time-Exposures,* pp. 95–100.

83. Alfred Stieglitz, letter to Dorothy Brett, New York, June 8, 1934 (Yale). Stieglitz's library contained many volumes by the British psychologist and author.

84. O'Keeffe recalled reading a contraband first edition of Lawrence's *Lady Chatterley's Lover* with Stieglitz in New York City before the publication was legally available in the United States (interview with the author).

85. Frank, *Time-Exposures,* p. 97.

86. Dorothy Brett, letter to Georgia O'Keeffe, Taos, New Mexico, [December 1929] (Yale).

87. Henry Tyrrell, "Art Observatory: High Tide in Exhibitions Piles Up Shining Things in Art: Two Women Painters Lure with Suave Abstractions," *New York World,* February 4, 1923 (in Lynes, p. 189).

88. Alexander Brook, "February Exhibitions: Georgia O'Keefe [*sic*]," *Arts* 3 (February 1923; in Lynes, p. 194).

89. Henry McBride, "Art News and Reviews – Woman as Exponent of the Abstract: Curious Responses to Work of Miss O'Keefe [*sic*] on Others; Free without Aid of Freud, She Now Says Anything She Wants to Say – Much 'Color Music' in Her Pictures," *New York Herald,* February 4, 1923 (in Lynes, pp. 187, 188–89).

90. F. Scott Fitzgerald, *This Side of Paradise* (1920; reprint New York: Charles Scribner's Sons, 1988), p. 282.

91. Malcolm Cowley, *Exile's Return: A Literary Odyssey of the 1920s,* 2d ed. (New York: Viking Press, 1951), p. 9.

92. Sarah E. Greenough, "From the American Earth: Alfred Stieglitz's Photographs of Apples," *Art Journal* 41 (Spring 1981): 49.

93. F. B. Housser, quoted in Bernard Smith, *Place, Taste, and Tradition: A Study of Australian Art since 1788,* 2d rev. ed. (Melbourne: Oxford University Press, 1988), p. 179.

94. Virgil Barker, "Notes on the Exhibitions," *Arts* 5 (April 1924; in Lynes, p. 215). Bram Dijkstra is among those who have taken issue with Barker's assumptions regarding feminine and masculine sensibilities, faulting the earlier writer's failure to consider O'Keeffe's method as "a conscious choice, an intellectual decision on her part, rather than the instinctual response of a woman guided by biological necessity" ("America and Georgia O'Keeffe," in Doris Bry and Nicholas Callaway, eds., *Georgia O'Keeffe: The New York Years* [New York: Alfred A. Knopf, 1991], pp. 122–23). In 1916 Charles Sheeler himself seemingly anticipated and disavowed Barker's critical premise: "I believe that human intellect is far less profound than human sensibility; that every thought is mere shadow of some emotion which casts it" (Peters, p. 348 n. 67).

95. Barbara Novak, *American Painting of the Nineteenth Century: Realism, Idealism, and the American Experience* (New York: Praeger, 1969), pp. 15, 20, 22.

96. Katherine Kuh, *The Artist's Voice: Talks with Seventeen Artists* (New York: Harper & Row, 1962), p. 200; emphasis is O'Keeffe's.

97. Novak, *American Painting of the Nineteenth Century,* p. 22.

98. John Wilmerding, *Important Information Inside: The Art of John F. Peto and the Idea of Still-life Painting in Nineteenth-century America* (New York: Harper & Row, 1983), p. 11.

99. Jonathan Edwards, quoted in Perry Miller, *Errand into the Wilderness* (Cambridge, Massachusetts: Harvard University Press, 1956), p. 177.

100. John Dewey, "Education as Engineering," *New Republic,* September 20, 1922, p. 89.

101. Bram Dijkstra, *The Hieroglyphics of a New Speech: Cubism, Stieglitz, and the Early Poetry of William Carlos Williams* (Princeton, New Jersey: Princeton University Press, 1969), p. 157.

102. Ibid., pp. 158–59.

103. Anne Janowitz, "*Paterson:* An American Contraption," in Carroll F. Terrell, ed., *William Carlos Williams: Man and Poet* (Orono, Maine: National Poetry Foundation, 1983), p. 303.

104. William Carlos Williams, *Paterson* (New York: New Directions, 1963), p. 14; repeated, p. 18. Although Book I of *Paterson,* which incorporated this aphorism, was not published until 1946, Williams coined the memorable saying earlier, and variants on it appear in his writing from the 1910s and 1920s, when he was closest to the Stieglitz circle.

105. Herbert J. Seligmann, "Georgia O'Keeffe," undated typescript (Yale).

106. Alfred Stieglitz, letter to Paul Strand, November 2, 1920 (in Greenough, "From the American Earth," p. 47).

107. Alfred Stieglitz, letter to Rebecca S. Strand, Lake George, New York, August 19, 1922 (in Greenough, "From the American Earth," p. 47).

108. Alfred Stieglitz, letter to Marie Rapp Boursault, October 6, 1920 (in Greenough, "From the American Earth," p. 47).

109. Henry David Thoreau, "Wild Apples," in *The Selected Works of Thoreau,* ed. Walter Harding (Boston: Houghton Mifflin, 1975), pp. 711, 713.

110. Meyer Schapiro, "The Apples of Cézanne: An Essay on the Meaning of Still-life," *Modern Art: Nineteenth and Twentieth Centuries* (London: Chatto & Windus, 1978), p. 35. In Genesis, the growth in the garden is described only as "the tree of knowledge," or "the tree of wisdom."

111. Thoreau, "Wild Apples," p. 713. Thoreau further analogized the fruit to human actions: "the apple emulates man's independence and enterprise" in its adaptation to the wild (p. 719).

112. Paul Rosenfeld, "The Paintings of Georgia O'Keeffe: The Work of the Young Artist Whose Canvases Are to Be Exhibited in Bulk for the First Time This Winter," *Vanity Fair,* October 1922 (in Lynes, pp. 176–77).

113. Paul Rosenfeld, *Port of New York: Essays on Fourteen American Moderns* (New York: Harcourt, Brace, 1924), pp. 203–204.

114. Jean Toomer, "The Hill," in Waldo Frank et al., eds., *America and Alfred Stieglitz: A Collective Portrait* (New York: Literary Guild, 1934), p. 299.

115. Dijkstra, *Hieroglyphics,* p. 149.

116. Helen Appleton Read, "News and Views on Current Art: Georgia O'Keefe [*sic*] Again Introduced by Stieglitz at the Anderson Galleries," *Brooklyn Daily Eagle,* March 9, 1924 (in Lynes, p. 202).

117. Alfred Stieglitz, letter to Paul Rosenfeld, Lake George, New York, November 9, 1924 (in Lynes, p. 334 n. 36).

118. Peters, p. 236.

119. Robinson, p. 261.

120. Paul Rosenfeld, letter to Alfred Stieglitz, New York City, September 4, 1929 (Yale).

121. Alfred Stieglitz to Marie Rapp Boursault, October 6, 1920 (in Robinson, p. 233).

122. Robinson, p. 233.

123. Georgia O'Keeffe, letter to Paul Strand, on a train from New York to Texas, June 3, 1917 (in *Art and Letters,* p. 161).

124. Willard H. Wright, quoted in Lisle, p. 91. Such interpretations persisted, even among O'Keeffe's friends. In 1931, for instance, the sympathetic Lewis Mumford wrote that O'Keeffe's work symbolized "the longing for the child" (*The Brown Decades: A Study of the Arts in America, 1865–1895* [1931; reprint, New York: Dover, 1955], p. 244).

125. C. J. Bulliett, *Apples and Madonnas* (Chicago: Pascal Covivi, 1927), p. 1.

126. Schapiro, "The Apples of Cézanne," p. 37 n. 64.

127. Thomas Craven, "Men of Art: American Style," *American Mercury,* December 1925, p. 427.

128. In 1914 Alfred Stieglitz presented a special exhibition of "Negro Sculpture" – the first exhibition anywhere of African carvings qua art! – at the 291 gallery. The two masks in O'Keeffe's home had been shown in that exhibition.

129. Peters, p. 274.

130. Ralph Waldo Emerson's journal, quoted in Greenough, "From the American Earth," p. 48.

131. Van Wyck Brooks, "On Creating a Usable Past," *Dial* 64 (April 11, 1918): 339.

132. Thomas Hart Benton, *An Artist in America* (New York: R. M. McBride, 1937), p. 268.

133. Howard Elliott. "Address Delivered at the Third National Apple Show" (Spokane, Washington, 1910), p. 4.

134. Rosenfeld, *Port of New York,* p. 7.

135. Ibid., p. 153.

136. Van Wyck Brooks, *Opinions of Oliver Allston* (New York: Dutton, 1941), p. 256.

137. Alfred Stieglitz, statement, *Alfred Stieglitz: Photographs* (New York: Anderson Galleries, 1921), n.p. The statement continued: "Photography is my passion. The search for Truth my obsession."

138. Nancy Newhall, *From Adams to Stieglitz: Pioneers of Modern Photography* (New York: Aperture, 1989), p. 109.

139. Barbara Rose, speaking in *Georgia O'Keeffe,* documentary film produced and directed by Perry Miller Adato for WNET, New York, 1977.

140. Greenough, "From the American Earth," p. 49.

141. Vachel Lindsay, "In Praise of Johnny Appleseed" (1920–1921), in Denis Camp, ed., *The Poetry of Vachel Lindsay,* vol. 2 (Peoria, Illinois: Spoon River Poetry Press, 1984), p. 434.

142. O'Keeffe, letter to Catherine O'Keeffe Klenert, February 8, 1924 (in Robinson, pp. 263–64).

143. Ibid. (in Robinson, p. 264).

144. Quoted in Charlotte Willard, "Portrait: Georgia O'Keeffe," *Art in America* 51 (October 1963): 95. O'Keeffe's sentiments for the Midwest were not unalloyed; she was especially ambivalent about "Chicago . . . [which] I hate – but get quite excited over when I go to it – lived there for two years (Chicago) and loathed it – now when I go through it always seems a bit fantastic to me" (Georgia O'Keeffe, letter to Ettie Stettheimer, Lake George, New York, October 10, 1933 [Yale]. O'Keeffe was referring to the period between 1908 and 1910, when she worked as a commercial artist in the city). In this she differed from her friend Frank Lloyd Wright, who thought that "Chicago is the national capital of the essentially American spirit" (Frederick A. Gutheim, ed., *Frank Lloyd Wright: Selected Writings, 1890–1940* [New York: Duell, Sloan and Pearce, 1941], p. 85).

145. Tomkins, "The Rose in the Eye Looked Pretty Fine," p. 41.

146. Lisa Mintz Messinger, *Georgia O'Keeffe* (New York: Thames and Hudson, 1988), p. 42.

147. Georgia O'Keeffe, letter to Anita Pollitzer, Canyon, Texas, September 11, 1916 (in *Arts and Letters,* pp. 156–57).

148. Alfred Stieglitz, letter to Sherwood Anderson, Lake George, New York, November 28, 1923 (Yale). Stieglitz's resulting photographs of the barns were particularly impressive: "Those [photographs of] luminous old barns that I saw unmounted last summer fairly haunt me," Paul Rosenfeld recalled to the artist (Paul Rosenfeld, letter to Alfred Stieglitz, Santa Fe, New Mexico, August 31, 1926 [Yale]).

149. Georgia O'Keeffe, letter to Mitchell Kennerly, New York City, January 20, 1929 (in *Arts and Letters,* p. 187).

150. Robinson, p. 375.

151. Dijkstra, "America and Georgia O'Keeffe," p. 127.

152. Anna C. Chave, "'Who Will Paint New York?': 'The World's New Art Center' and the Skyscraper Paintings of Georgia O'Keeffe," *American Art* 5 (Winter–Spring 1991): 91.

153. Claude Bragdon, "The Shelton Hotel, New York," *Architectural Record* 58 (July 1925): 1. Bragdon's other exemplar of the American spirit was jazz music.

154. Frank Lloyd Wright, *An Autobiography* (New York: Duell, Sloan and Pearce, 1943), p. 26.

155. Grant Carpenter Manson, *Frank Lloyd Wright to 1910* (New York: Reinhold, 1958), p.111n.

156. Helen Appleton Read, "The Feminine Viewpoint in Contemporary Art," *Vogue*, June 15, 1928 (in Lisle, p. 293).

157. Roderick Nash, *The Nervous Generation: American Thought, 1917–1930* (Chicago: Rand McNally, n.d.), p. 158.

158. James Truslow Adams, *Our Business Civilization: Some Aspects of American Culture* (New York: Albert & Charles Boni, 1929), p. 241. The farmer's lofty position came at the expense of the eighteenth-century artist: "The Plow-Man that raiseth Grain is more serviceable to Mankind than the Painter who draws only to please the Eye."

159. Joseph B. Ross, "The Agrarian Revolution in the Middle West," *North American Review,* September 1909, p. 376.

160. Sherwood Anderson, letter to Alfred Stieglitz, Elizabeth, New Jersey, May 28, 1931 (Yale). In similar terms, he expressed his admiration for the "grand earthiness" of O'Keeffe's paintings (letter to Alfred Stieglitz, Marion, Virginia, December 18, 1935 [Yale]). O'Keeffe explained her friendship for Anderson: "I always felt about him that it is like meeting some one from home – I like him very much" (letter to Marjorie Content Toomer, Bermuda, [1934; Yale]).

161. Frank, *Time-Exposures,* pp. 55, 57.

162. Report to Country Life Commission, quoted in Sir Horace Plunkett, *The Rural Life Problem of the United States: Notes of an Irish Observer* (New York: MacMillan, 1913), p. 72.

163. Frank, *Time-Exposures,* p. 32. Stieglitz took exception to Frank's characterization, and chided his one-time associate for it: "What you have written . . . re the 'peasant' phase of Georgia – That's your affair. I certainly have nothing to say about it . . . you introduce in your article on Georgia something grossly misrepresenting facts" (Alfred Stieglitz, letter to Waldo Frank, New York City, April 4, 1927 [Yale]).

164. Georgia O'Keeffe, letter to Mitchell Kennerly, New York City, January 20, 1929 (in *Art and Letters,* p. 187).

165. Matthew Baigell, "The Emersonian Presence in Abstract Expressionism," *Prospects* 15 (1990): 105.

166. Thoreau, "Natural History of Massachusetts" (1842), in *Selected Works of Thoreau,* p. 642.

167. Sherman Paul, *Repossessing and Renewing: Essays in the Green American Tradition* (Baton Rouge: Louisiana State University Press, 1976), p. 34.

168. "Our National Genius and Our National Art," *Harper's Weekly* 175 (February 28, 1903): 349.

169. Henry Seidel Canby, "The Modern Thoreau," *Dial* 59 (July 15, 1915): 54–55.

170. "The Seven Arts Chronicle: Henry David Thoreau, 1817–1917," *Seven Arts* 2 (July 1917): 383–85.

171. David W. Noble, *The Progressive Mind, 1890–1917* (Chicago: Rand McNally, 1970), p. 124.

172. Matthew Baigell, "American Landscape Painting and National Identity: The Stieglitz Circle and Emerson," *Art Criticism* 4 (1987): 35.

173. Marsden Hartley, "Georgia O'Keeffe: A Second Outline in Portraiture," in *Georgia O'Keeffe: Exhibition of Recent Paintings, 1935* (New York: An American Place, 1936), p. 4.

174. Ralph Waldo Emerson, "Nature" (1836), in *Selections from Ralph Waldo Emerson,* ed. Stephen E. Wicher (Boston: Houghton Mifflin, 1957), p. 24.

175. Alfred Stieglitz, letter to Aline Meyer Liebman, November 8, 1920 (in Margaret Liebman Berger, *Aline Meyer Liebman: Pioneer Collector and Artist* [privately printed, 1982], p. 29).

176. Harold Rugg, "The Artist and the Great Transition," in Frank et al., eds., *America and Alfred Stieglitz,* p. 205.

177. Charles C. Alexander, *Here the Country Lies: Nationalism and the Arts in Twentieth-century America* (Bloomington: Indiana University Press, 1980), pp. 52–53. In Stieglitz's library were multiple volumes by Emerson and Thoreau; O'Keeffe retained these books after Stieglitz's death.

178. Kenneth Baker, "What Went Wrong?" *Connoisseur* 185 (November 1987): 173.

179. Thoreau, "Walking," in *Selected Works of Thoreau,* pp. 667–68.

180. Marsden Hartley, "America as Landscape," *El Palacio* 5 (December 11, 1918): 340.

181. Paul Rosenfeld, letter to Alfred Stieglitz, Santa Fe, New Mexico, August 15, 1926 (Yale).

182. Paul Rosenfeld, letter to Alfred Stieglitz, Santa Fe, New Mexico, July 17, 1926 (Yale). The homes with "Aztec effects" were on the Camino del Monte Sol, today one of the town's fashionable neighborhoods.

183. Paul Rosenfeld, letter to Alfred Stieglitz, Santa Fe, New Mexico, August 15, 1926 (Yale).

184. Paul Rosenfeld, letters to Alfred Stieglitz, Santa Fe, New Mexico, July 17, 1926, and August 31, 1926 (Yale). Sherwood Anderson added to the temptations, writing from the West to O'Keeffe that he wished "you were both out here in the presence of these mountains I know you love" (letter to Georgia O'Keeffe, Reno, Nevada, March 2 [?], 1923 [Yale]).

185. Cowley, *Exile's Return,* p. 240. Emphasis is Cowley's.

186. Henry Seldis, "Georgia O'Keeffe at Seventy-eight: Tough-minded Romantic," *Los Angeles Times West Magazine,* January 22, 1967, p. 17.

187. "'My World Is Different . . . ,'" *Newsweek,* October 10, 1960, p. 101.

188. Paul Rosenfeld, letter to Alfred Stieglitz, New York City, October 29, 1920 (Yale).

189. Paul Rosenfeld, letter to Alfred Stieglitz, York Harbor, Maine, August 12, 1927 (Yale).

190. MacKinley Helm, *John Marin* (New York: Pellegrini and Cudahy, 1948), p. 64.

191. John Marin, *The Selected Writings of John Marin,* ed. Dorothy Norman (New York: Pellegrini and Cudahy, 1949), p. 127.

192. O'Keeffe, letter to Henry McBride, Lake George, New York, May 11, 1928 (Yale).

193. Alfred Stieglitz, letter to Waldo Frank, Lake George, New York, August 25, 1925 (Yale).

194. Quoted in Anita Pollitzer, "That's Georgia," *Saturday Review of Literature,* November 4, 1950, p. 42.

195. Rebecca S. Strand, letter to Alfred Stieglitz, Taos, New Mexico, May 14, 1929 (Yale).

196. Mabel Dodge Luhan, "Georgia O'Keeffe in Taos," *Creative Art* 8 (June 1931): 407, 410.

197. Quoted in James Johnson Sweeney, *Stuart Davis* (New York: Museum of Modern Art, 1945), p. 15.

198. Elaine de Kooning, "New Mexico," *Art in America* 49 (1961): 56.

199. The stark New Mexican winter taught the Taos painter Ward Lockwood "a very important thing . . . this black and white palette range – that is a dark and light breadth of scale" (Lockwood's journal, February 24, 1933; in John Ward Lockwood Papers [AAA]).

200. Robert Henri, *The Art Spirit,* comp. Margery Ryerson (Philadelphia: J. B. Lippincott, 1930), p. 171.

201. Ross Calvin, *Sky Determines* (New York: Macmillan, 1934), p. 30.

202. D. H. Lawrence, "New Mexico," *Survey Graphic* (May 1931); reprinted in *Phoenix: The Posthumous Papers of D. H. Lawrence,* ed. Edward D. McDonald (New York: Viking Press, 1936), p. 142.

203. D. H. Lawrence, "Taos," *Dial* 74 (March 1923): 251.

204. O'Keeffe, *Georgia O'Keeffe,* opp. pl. 63.

205. Ibid., opp. pl. 64.

206. These were joined in 1930 by O'Keeffe's paintings of Hopi kachina figures, a subject that into the 1940s she continued periodically to depict.

207. O'Keeffe was sensitive to the challenges of travel and the risk of applying habitual vision to new motifs. Apropos Hawaii, but also pertinent to other places (such as New Mexico in 1929), she puzzled: "Maybe the new place enlarges ones world a little. Maybe one takes one's own world along and cannot see anything else" (Georgia O'Keeffe, statement, *Georgia O'Keeffe: Exhibition of Oils and Pastels* [New York: An American Place, 1940], n.p.).

208. *Georgia O'Keeffe: Twenty-seven New Paintings, New Mexico, New York, Lake George, Etc.* (New York: An American Place, 1930), n.p. Titles of O'Keeffe's works often changed over time, a circumstance that complicates research on provenance and exhibition records; the alterations in nomenclature occasionally were made by her, but more often by others. O'Keeffe once explained that "I don't put names on them [her paintings]. I never do. Other people always put the names on my pictures – quite funny names I think. I don't think it's necessary." Like titles, signatures also were unnecessary. "If there is any personal quality in them, then that will be signature enough" (quoted in Ralph Looney, "Georgia O'Keeffe," *Atlantic Monthly,* April 1965, p. 109).

209. Aldous Huxley, preface, in Knud Merrild, *With D. H. Lawrence in New Mexico* (London: Routledge and Kegan Paul, 1964), p. xvii.

210. Henry McBride, "O'Keeffe in Taos," *New York Sun,* January 8, 1930 (in *The Flow of Art: Essays and Criticisms of Henry McBride,* ed. Daniel Catton Rich [New York: Atheneum, 1975], p. 261).

211. Mumford, "Autobiographies in Paint," p. 48.

212. Unlike Rosenfeld's tolerant attitude toward the resident Santa Fe painters, many of the celebrated visitors to Taos took special delight in mocking the art colonists there. Marsden Hartley did little to endear himself to the local community, which he dismissed as "the stupidest place I ever fell into . . . a society of cheap artists from Chicago and New York" (letter to Harriet Monroe, Taos, New Mexico, August 22, 1918 [Elizabeth McCausland papers, AAA]). By 1930, when the critic Edmund Wilson arrived for a visit, the situation had not appreciably changed; he wrote of his encounter with an "extraordinary population of rich people, writers and artists who pose as Indians, cowboys, prospectors, desperadoes, Mexicans and other nearly extinct species" (quoted in Sanford Schwartz, "When New York Went to New Mexico," *Art in America* 64 [July–August 1976]: 93). O'Keeffe echoed the sentiment: "The Taos country – it is so beautiful – and so poisonous – the only way to live in it is to strictly mind your own business . . . your own pleasures" (letter to Dorothy Brett, n.p., n.d. [Yale]).

213. Henry McBride, "Georgia O'Keeffe's Exhibition," *New York Sun,* January 14, 1933, p. 10.

214. Charles Sheeler, quoted in Alexander Eliot, *Three Hundred Years of American Painting* (New York: Time, 1957), p. 180.

215. Seiberling, "Horizons of a Pioneer," p. 42.

216. Lisle, pp. 240–41. Stieglitz family members were nonplussed by this alteration of decor. "My bones cause much comment," O'Keeffe noted wryly (letter to Rebecca S. Strand, Lake George, New York, August 9, 1931 [in Robinson, p. 596 n. 3]).

217. Georgia O'Keeffe, "About Myself," *Georgia O'Keeffe: Exhibition of Oils and Pastels* (New York: An American Place, 1939), n.p.

218. Seiberling "Horizons of a Pioneer," p. 42.

219. Henry McBride, quoted in "New York Criticism," *Art Digest* 6 (January 15, 1932): 18; Ralph Flint, "1933 O'Keeffe Show a Fine Revelation of Varied Powers," *Art News* 31 (January 14, 1933): 9.

220. Elizabeth Duvert, "With Stone, Star, and Earth: The Presence of the Archaic in the Landscape Visions of Georgia O'Keeffe, Nancy Holt, and Michelle Stuart," in Vera Norwood and Janice Monk, eds., *The Desert Is No Lady: Southwestern Landscapes in Women's Writing and Art* (New Haven: Yale University Press, 1987), p. 208. Duvert's conclusions about shamanic beliefs were anticipated by an earlier visitor to O'Keeffe's Abiquiu home. According to one report, the painter enjoyed telling the story of a Native American who, after seeing her collection of bones, remarked: "Everything is so alive in your house" ("O'Keeffe's Woman Feeling," *Newsweek,* May 27, 1946, p. 94).

221. "I was looking through them [the artificial flowers] one day when someone came to the kitchen door. As I went to answer the door, I stuck a pink rose in the eye socket of a horse's skull. And when I came back the rose in the eye looked pretty fine, so I thought I would just go on with that" (Tomkins, "The Rose in the Eye Looked Pretty Fine," p. 50).

222. Review from *Brooklyn Eagle;* quoted in "New York Criticism," *Art Digest* 6 (June 15, 1932): 18.

223. M[artha] D[avidson], "O'Keeffe's Latest Decorative Paintings," *Art News* 35 (February 27, 1937): 13.

224. O'Keeffe, "About Painting Desert Bones."

225. O'Keeffe, *Georgia O'Keeffe,* opp. pl. 70.

226. Royal Cortissoz, review, *New York Herald Tribune,* January 12, 1936 (reprinted in *Georgia O'Keeffe: New Paintings* [New York: An American Place, 1937], n.p.).

227. Mumford, "Autobiographies in Paint," p. 48.

228. O'Keeffe, "About Myself." A half century later, her red hills still gave problems to some viewers, such as the young New York matron overheard by the

author at the O'Keeffe centennial retrospective when it was shown at the Metropolitan Museum of Art: "I'm not particularly keen on the rust color; it doesn't do anything for me."

229. Hamlin Garland, "Up the Coolly," *Main-Travelled Roads* (1891; reprint, New York: Harper & Brothers, 1899), pp. 102–103.

230. D. H. Lawrence, *St. Mawr: The Later D. H. Lawrence* (1925; reprint, New York: Alfred A. Knopf, 1952), p. 159.

231. Alice Graeme, "Miss O'Keeffe's Desert Scenes Evoke Careful, Critical Study," *Washington Post,* January 16, 1938, sec. 6, p. 5.

232. Daniel Catton Rich, *Georgia O'Keeffe* (Chicago: The Art Institute of Chicago, 1943), pp. 33, 36. In the Chicago catalogue, the painting is incorrectly dated 1938.

233. Ansel Adams, letter to Alfred Stieglitz, Ghost Ranch, New Mexico, September 21, 1937 (in Nancy Newhall, *Ansel Adams: The Eloquent Light* [San Francisco: Sierra Club, 1963], p. 98).

234. O'Keeffe, "About Painting Desert Bones."

235. Daniel Catton Rich, "The New O'Keeffes," *Magazine of Art* 37 (March 1944): 110.

236. O'Keeffe, "About Painting Desert Bones."

237. Rich, "The New O'Keeffes," pp. 110–11.

238. Robinson, p. 460.

239. O'Keeffe, "About Painting Desert Bones."

240. Henry McBride, "Georgia O'Keeffe of Abiquiu," *Art News* 49 (November 1950): 57. So spare were the forms of tree trunks that McBride (with tongue firmly in cheek) claimed to have mistaken an upside-down photograph of the work for "a version of Marlene Dietrich's celebrated legs encased in black nylons."

241. McBride, "Georgia O'Keeffe of Abiquiu," p. 56.

242. Edward Alden Jewell, "O'Keeffe: Thirty Years," *New York Times,* May 19, 1946, sec. 2, p.6.

243. Barbara Rose, "Georgia O'Keeffe: The Paintings of the Sixties," *Artforum* 9 (November 1970): 42–46.

244. O'Keeffe, *Georgia O'Keeffe,* n.p.

245. O'Keeffe, interview with the author.

246. Georgia O'Keeffe, letter to Anita O'Keeffe Young, en route from Bangkok to Calcutta, March 6, 1959 (continuation of letter of March 1, 1959; Yale).

247. Kuh, *The Artist's Voice,* pp. 202, 200.

248. O'Keeffe, *Georgia O'Keeffe,* opp. pl. 104.

249. O'Keeffe, interview with the author.

250. Marsden Hartley, "Georgia O'Keeffe: A Second Outline in Portraiture," n.p.

251. Pollitzer, "That's Georgia," p. 42.

252. Looney, "Georgia O'Keeffe," p. 110.

253. E. C. Goossen, "O'Keeffe," *Vogue,* March 1, 1967, p. 177.

254. Lisle, p. 427.

255. Peter Plagens, "A Georgia O'Keeffe Retrospective in Texas," *Artforum* 4 (May 1966): 27.

256. Kuh, *The Artist's Voice,* p. 202.

257. O'Keeffe, interview with the author.

THE LITERATURE on Georgia O'Keeffe was already extensive during her lifetime, and it has grown enormously since her death. This selected bibliography represents monographs and exhibition catalogues (all in English) as well as a seminal film devoted to the artist. For those who require a more complete listing, publications with extensive bibliographical information are indicated by an asterisk (*). In addition to these publications, numerous unpublished documents of value to the appreciation of Georgia O'Keeffe's life and art are deposited in the Stieglitz-O'Keeffe archives at the Beinecke Rare Book and Manuscript Library, Yale University, New Haven.

Adato, Perry Miller, producer and director. *Georgia O'Keeffe (Portrait of an Artist,* no. 1). Film, 59 min. New York: WNET, for Women in Art, 1977. Distributed by Films, Inc. / Home Vision, New York.

Bry, Doris; and Nicholas Callaway, eds. *Georgia O'Keeffe: In the West.* New York: Alfred A. Knopf, 1989.

_____. *Georgia O'Keeffe: The New York Years.* New York: Alfred A. Knopf, 1991.

Callaway, Nicholas, ed. *Georgia O'Keeffe: One Hundred Flowers.* New York: Alfred A. Knopf, 1987.

Castro, Jan Garden. *The Art and Life of Georgia O'Keeffe.* New York: Crown Publishers, 1985.

*Cowart, Jack; Juan Hamilton, and Sarah Greenough. *Georgia O'Keeffe: Art and Letters.* Washington, D.C.: National Gallery of Art, 1987.

Eisler, Benita. *O'Keeffe and Stieglitz: An American Romance.* New York: Doubleday, 1991.

Eldredge, Charles C. *Georgia O'Keeffe.* New York: Harry N. Abrams, 1991.

Frazier, Nancy. *Georgia O'Keeffe.* New York: Crescent Books, 1990.

Giboire, Clive, ed. *Lovingly, Georgia: The Complete Correspondence of Georgia O'Keeffe and Anita Pollitzer.* New York: Simon & Schuster / Touchstone Book, 1990.

Goodrich, Lloyd; and Doris Bry. *Georgia O'Keeffe.* New York: Whitney Museum of American Art, 1970.

Haskell, Barbara. *Georgia O'Keeffe: Works on Paper.* Santa Fe: Museum of New Mexico Press, 1985.

Hoffman, Katherine. *An Enduring Spirit: The Art of Georgia O'Keeffe.* Metuchen, New Jersey: Scarecrow Press, 1984.

Hogrefe, Jeffrey. *O'Keeffe: The Life of an American Legend.* New York: Bantam Books, 1992.

Lisle, Laurie. *Portrait of an Artist: A Biography of Georgia O'Keeffe.* New York: Seaview Books, 1980; rev. ed. New York: Washington Square Press, 1987.

*Lynes, Barbara Buhler, *O'Keeffe, Stieglitz, and the Critics, 1916–1929.* Ann Arbor, Michigan: UMI Research Press, 1989.

Merrill, Christopher; and Ellen Bradbury, eds. *From the Faraway Nearby: Georgia O'Keeffe as Icon.* Reading, Massachusetts: Addison-Wesley, 1992.

Messinger, Lisa Mintz. "Georgia O'Keeffe." *The Metropolitan Museum of Art Bulletin* 42, no. 2 (Fall 1984): entire issue.

_____. *Georgia O'Keeffe.* New York: Thames and Hudson, 1988.

Newman, Sasha. *Georgia O'Keeffe.* Washington, D.C.: The Phillips Collection, 1985.

O'Keeffe, Georgia. *Georgia O'Keeffe.* New York: Viking Press, 1976; reprint New York: Penguin Books, 1985.

_____. "Introduction." *Georgia O'Keeffe: A Portrait by Alfred Stieglitz.* New York: The Metropolitan Museum of Art, 1978.

_____. *Some Memories of Drawings.* Ed. Doris Bry. New York: Atlantis Editions, 1974; rev. ed. Albuquerque: University of New Mexico Press, 1988.

Patten, Christine Taylor; and Alvaro Cardona-Hine. *Miss O'Keeffe.* Albuquerque: University of New Mexico Press, 1992.

*Peters, Sarah Whitaker. *Becoming O'Keeffe: The Early Years.* New York: Abbeville Press, 1991.

Pollitzer, Anita. *A Woman on Paper: Georgia O'Keeffe.* New York: Simon & Schuster, 1988.

Rathbone, Belinda; Roger Shattuck, and Elizabeth Hutton Turner. *Georgia O'Keeffe and Alfred Stieglitz: Two Lives.* New York: Callaway Editions, in association with The Phillips Collection, 1992.

Rich, Daniel Catton. *Georgia O'Keeffe.* Chicago: The Art Institute of Chicago, 1943.

_____. *Georgia O'Keeffe: Forty Years of Her Art.* Worcester, Massachusetts: Worcester Art Museum, 1960.

Robinson, Roxana. *Georgia O'Keeffe: A Life.* New York: Harper & Row, 1989.

Saville, Jennifer. *Georgia O'Keeffe: Paintings of Hawai'i.* Honolulu: Honolulu Academy of Arts, 1990.

Wilder, Mitchell A., ed. *Georgia O'Keeffe.* Fort Worth: Amon Carter Museum of Western Art, 1966.

IN THE DIMENSIONS GIVEN,
height precedes width.

1. *Special No. 17*, 1919
Charcoal on paper
50.8 x 32.4 cm (20 x 12¾ in.)
The Georgia O'Keeffe Foundation

2. *Special No. 14*, 1915
Charcoal on paper
62.55 x 46.99 cm (24⅝ x 18½ in.)
Anonymous loan

3. *Early No. 2*, 1915
Charcoal on paper
61 x 47.3 cm (24 x 18⅝ in.)
The Georgia O'Keeffe Foundation

4. *Drawing No. 8 (Special No. 8)*, 1915
Charcoal on paper
61.6 x 47.94 cm (24¼ x 18⅞ in.)
Whitney Museum of American Art, New York.
Purchase, with funds from the Mr. and Mrs.
Arthur G. Altschul Purchase Fund
(Exhibited in London)

5. *Black Diagonal*, 1919
Charcoal on paper
62.2 x 50.2 cm (24½ x 19¾ in.)
The Crispo Collection

6. *Black Lines*, 1916
Watercolor on paper
62.2 x 46.99 cm (24½ x 18½ in.)
The Crispo Collection

7. *Special No. 16*, 1918
Charcoal on paper
62.2 x 45.09 cm (24½ x 17¾ in.)
Anonymous loan

8. *Special No. 12*, 1917
Charcoal on paper
60.33 x 47 cm (23¾ x 18½ in.)
The Georgia O'Keeffe Foundation

9. *Morning Sky with Houses No. 2*, 1916
Watercolor on paper
22.9 x 30.5 cm (9 x 12 in.)
The Georgia O'Keeffe Foundation

10. *Blue Abstraction*, 1917
Watercolor on paper
40 x 27.6 cm (15¾ x 10⅞ in.)
Courtesy of Mr. and Mrs. Gerald P. Peters,
Santa Fe, New Mexico

11. *Evening Star VI*, 1917
Watercolor on paper
22.9 x 30.5 cm (9 x 12 in.)
Private collection
(Exhibited in London and Mexico)

12. *Tent Door at Night*, about 1915
Watercolor on paper
48.3 x 62.9 cm (19 x 24¾ in.)
University Art Museum, University of New Mexico.
Purchase through the Rolshoven Fund with the
assistance of the Friends of Art
(Exhibited in Japan)

13. *Sunrise and Little Clouds No. II*, 1916
Watercolor on paper
22.9 x 30.5 cm (9 x 12 in.)
Private collection

14. *Nude No. IV*, 1917
Watercolor on paper
22.9 x 30.5 cm (9 x 12 in.)
Private collection

15. *Nude Series III*, 1917
Watercolor on paper
30.5 x 25.4 cm (12 x 10 in.)
The Georgia O'Keeffe Foundation

16. *Nude Series, Seated Red*, 1917
Watercolor on paper
30.5 x 22.5 cm (12 x 8⅞ in.)
The Georgia O'Keeffe Foundation

17. *Pink and Green Mountains No. I*, 1917
Watercolor on paper
22.9 x 30.5 cm (9 x 12 in.)
Spencer Museum of Art, The University of Kansas.
Letha Churchill Walker Fund

18. *Pink and Green Mountains No. II*, 1917
Watercolor on paper
22.9 x 30.5 cm (9 x 12 in.)
Edward Lenkin and Katherine Meier
(Exhibited in London)

19. *Pink and Green Mountains No. IV*, 1917
Watercolor on paper
22.9 x 30.5 cm (9 x 12 in.)
Edward Lenkin and Katherine Meier
(Exhibited in London)

20. *Pink and Green Mountains No. V*, 1917
Watercolor on paper
22.9 x 30.5 cm (9 x 12 in.)
Anonymous loan
(Exhibited in Japan)

21. *Blue and Green Music*, 1919
Oil on canvas
68.6 x 58.4 cm (27 x 23 in.)
The Art Institute of Chicago, Alfred Stieglitz Collec-
tion. Gift of Georgia O'Keeffe
(Exhibited in London and Mexico)

22. *Lake George, Coat and Red*, 1919
Oil on canvas
68.6 x 58.4 cm (27 x 23 in.)
The Georgia O'Keeffe Foundation

23. *From the Plains*, 1919
Oil on canvas
70.8 x 60.01 cm (27⅞ x 23⅝ in.)
The Crispo Collection

24. *Pink Abstraction,* 1929
Oil on canvas
91.4 x 76.2 cm (36 x 30 in.)
Collection of Phoenix Art Museum.
Gift of Friends of Art

25. *Little House with Flagpole,* 1925
Oil on canvas
90.2 x 44.45 cm (35½ x 17½ in.)
Collection of The Gerald Peters Gallery,
Santa Fe, New Mexico

26. *Pool in the Woods, Lake George,* 1922
Pastel on paper
44.45 x 71.1 cm (17½ x 28 in.)
Reynolda House, Museum of American Art,
Winston-Salem, North Carolina

27. *City Night,* 1926
Oil on canvas
121.9 x 76.2 cm (48 x 30 in.)
Lent by The Minneapolis Institute of Arts. Gift of the
Regis Corporation, Mr. and Mrs. W. John Driscoll,
the Beim Foundation, the Larsen Fund, and by public
subscription
(Exhibited in Japan)

28. *Radiator Building, Night, New York,* 1927
Oil on canvas
121.9 x 76.2 cm (48 x 30 in.)
The Alfred Stieglitz Collection, The Carl Van Vechten
Gallery of Fine Arts, Fisk University

29. *East River No. 1,* 1926
Oil on linen
91.4 x 45.7 cm (36 x 18 in.)
Wichita Art Museum. Gift of the Friends of the
Wichita Art Museum, Inc., Volunteer Alliance

30. *Calla in Tall Glass No. 2,* 1923
Oil on board
81.3 x 29.2 cm (32 x 11½ in.)
Courtesy of The Gerald Peters Gallery,
Santa Fe, New Mexico

31. *Lake George Barns,* 1926
Oil on canvas
54 x 81.3 cm (21¼ x 32 in.)
Collection Walker Art Center, Minneapolis.
Gift of the T. B. Walker Foundation, 1954

32. *Dark and Lavender Leaves,* 1931
Oil on canvas
50.8 x 43.2 cm (20 x 17 in.)
Museum of Fine Arts, Museum of New Mexico.
Promised gift of the estate of Georgia O'Keeffe

33. *Green Oak Leaves,* about 1923
Oil on canvas mounted on wood
22.9 x 30.5 cm (9 x 12 in.)
The Newark Museum. Bequest of
Miss Cora Louise Hartshorn, 1958

34. *Four Dark Red Oak Leaves,* 1923
Oil on canvas
22.9 x 30.5 cm (9 x 12 in.)
Peter and Widgie Aldrich

35. *Apple Family A,* about 1921
Oil on canvas
25.7 x 20.6 cm (10⅛ x 8⅛ in.)
Collection of Mr. and Mrs. Gerald P. Peters,
Santa Fe, New Mexico

36. *Barn with Snow,* 1934
Oil on canvas
40.6 x 71.1 cm (16 x 28 in.)
San Diego Museum of Art. Gift of
Mr. and Mrs. Norton S. Walbridge

37. *Green Apple on Black Plate,* about 1921
Oil on canvas
35.6 x 31.7 cm (14 x 12½ in.)
Collection of the Birmingham Museum of Art,
Birmingham, Alabama, U.S.A. Museum purchase
with funds from the 1983 Beaux Arts Committee,
Advisory Committee, Museum Store, and private
donors, and with matching funds from Mr. and
Mrs. Jack McSpadden

38. *Mask with Golden Apple,* 1924
Oil on canvas
22.9 x 38.1 cm (9 x 15 in.)
Marion Boulton Stroud

39. *Shell and Shingle VI,* 1926
Oil on canvas
76.2 x 45.7 cm (30 x 18 in.)
Saint Louis Art Museum. Gift of Charles E. Claggett
in memory of Blanche Fischel Claggett

40. *Line and Curve,* 1927
Oil on canvas
81.3 x 40.9 cm (32 x 16⅛ in.)
National Gallery of Art, Washington, D.C.,
Alfred Stieglitz Collection. Bequest of
Georgia O'Keeffe, 1987.58.6

41. *Series 1 No. 12,* 1920
Oil on canvas
50.8 x 43.2 cm (20 x 17 in.)
The Georgia O'Keeffe Foundation

42. *From the Lake No. 3,* 1924
Oil on canvas
91.4 x 76.2 cm (36 x 30 in.)
Philadelphia Museum of Art, The Alfred Stieglitz
Collection. Bequest of Georgia O'Keeffe

43. *Red and Pink,* 1925
Oil on canvas
40.6 x 30.5 cm (16 x 12 in.)
Private collection

44. *Bare Tree Trunks with Snow,* 1946
Oil on canvas
74.3 x 99.4 cm (29¼ x 39⅛ in.)
Dallas Museum of Art, Dallas Art Association

45. *Autumn Trees – The Maple,* 1924
Oil on canvas
91.4 x 76.2 cm (36 x 30 in.)
Collection of Mr. and Mrs. Gerald P. Peters,
Santa Fe, New Mexico

46. *A Celebration,* 1924
Oil on canvas
88.9 x 45.7 cm (35 x 18 in.)
The Georgia O'Keeffe Foundation

47. *Abstraction – Alexis,* 1928
Oil on canvas
91.4 x 76.2 cm (36 x 30 in.)
Private collection, New York

48. *Red, Yellow, and Black Streak*, 1924
Oil on canvas
100.3 x 81.3 cm (39½ x 32 in.)
The Georgia O'Keeffe Foundation

49. *Abstraction, White Rose II*, 1927
Oil on canvas
91.4 x 76.2 cm (36 x 30 in.)
The Georgia O'Keeffe Foundation

50. *Flower Abstraction*, 1924
Oil on canvas
121.9 x 76.2 cm (48 x 30 in.)
Whitney Museum of American Art, New York.
Fiftieth anniversary gift of Sandra Payson
(Exhibited in London)

51. *Brown and Tan Leaves*, 1928
Oil on canvas
101.6 x 76.2 cm (40 x 30 in.)
Courtesy of Mr. and Mrs. Gerald P. Peters,
Santa Fe, New Mexico

52. *Two Calla Lilies on Pink*, 1928
Oil on canvas
101.6 x 76.2 cm (40 x 30 in.)
Philadelphia Museum of Art, The Alfred Stieglitz
Collection. Bequest of Georgia O'Keeffe

53. *Petunia No. 2*, 1924
Oil on canvas
91.4 x 76.2 cm (36 x 30 in.)
Courtesy of Mr. and Mrs. Gerald P. Peters,
Santa Fe, New Mexico

54. *Purple Petunia*, 1927
Oil on canvas
76.2 x 91.4 cm (30 x 36 in.)
Collection of Mr. and Mrs. Graham Gund
(Exhibited in London)

55. *White Trumpet Flower*, 1932
Oil on canvas
75.6 x 101 cm (29¾ x 39¾ in.)
San Diego Museum of Art. Gift of Inez Grant Parker
in memory of Earle W. Grant

56. *Oriental Poppies*, 1928
Oil on canvas
76.2 x 101.9 cm (30 x 40⅛ in.)
Collection of the Frederick R. Weisman Art Museum,
University of Minnesota. Minneapolis Purchase
(Exhibited in Mexico and Japan)

57. *Petunias*, 1925
Oil on hardboard
45.7 x 76.2 cm (18 x 30 in.)
The Fine Arts Museums of San Francisco.
Gift of the M. H. de Young family
(Exhibited in Mexico and Japan)

58. *Wooden Virgin*, 1929
Oil on canvas
58.4 x 25.4 cm (23 x 10 in.)
Private collection
(Exhibited in London and Mexico)

59. *Jimson Weed*, 1932
Oil on canvas
101.6 x 76.2 cm (40 x 30 in.)
Courtesy of Mr. and Mrs. Gerald P. Peters,
Santa Fe, New Mexico

60. *Black Cross with Stars and Blue*, 1929
Oil on canvas
101.6 x 76.2 cm (40 x 30 in.)
Private collection, Chicago
(Exhibited in London)

61. *Black Cross with Red Sky*, 1929
Oil on canvas
101.6 x 76.2 cm (40 x 32 in.)
Courtesy of Mr. and Mrs. Gerald P. Peters,
Santa Fe, New Mexico

62. *The Lawrence Tree*, 1929
Oil on canvas
78.9 x 99.5 cm (31¹/₁₆ x 39³/₁₆ in.)
Wadsworth Atheneum, Hartford, Connecticut,
The Ella Gallup Sumner and Mary Catlin Sumner
Collection (Exhibited in London)

63. *Dead Tree, Bear Lake*, 1929
Oil on canvas
81.3 x 43.2 cm (32 x 17 in.)
Private collection, Dallas, Texas

64. *View from My Studio, New Mexico (Black Mesa;
Out Back of Marie's II; Landscape Near H & M Ranch,
toward Abiquiu, New Mexico)*, 1930
Oil on canvas
76.2 x 40.6 cm (30 x 16 in.)
Collection of The Gerald Peters Gallery,
Santa Fe, New Mexico

65. *From the Faraway Nearby*, 1937
Oil on canvas
91.45 x 101.9 cm (36 x 40⅛ in.)
The Metropolitan Museum of Art,
Alfred Stieglitz Collection, 1959

66. *Pelvis with Pedernal*, 1943
Oil on canvas
40.6 x 55.9 cm (16 x 22 in.)
Munson-Williams-Proctor Institute Museum of Art,
Utica, New York

67. *Rib and Jawbone*, 1935
Oil on canvas
22.9 x 60.96 cm (9 x 24 in.)
The Brooklyn Museum of Art.
Bequest of Georgia O'Keeffe, 87.136.5

68. *Small Purple Hills*, 1934
Oil on board
40.6 x 50.2 cm (16 x 19¾ in.)
Private collection

69. *Cliffs beyond Abiquiu, Dry Waterfall*, 1943
Oil on canvas
76.2 x 40.6 cm (30 x 16 in.)
The Cleveland Museum of Art. Bequest of
Georgia O'Keeffe, 87.141

70. *Horse's Skull on Blue*, 1930
Oil on canvas
76.2 x 46.6 cm (30 x 16 in.)
University Art Museum, Arizona State University,
Tempe. Gift of Oliver B. James

71. *Gray Hill Forms*, 1936
Oil on canvas
50.8 x 76.2 cm (20 x 30 in.)
University Art Museum, University of New Mexico.
From the estate of Georgia O'Keeffe

72. *Black Place No. 1,* 1944
Oil on canvas
66.04 x 76.5 cm (26 x 30⅛ in.)
San Francisco Museum of Modern Art.
Gift of Charlotte Mack

73. *Front of Ranchos Church,* 1929
Oil on canvas
61 x 91.4 cm (24 x 36 in.)
Courtesy of The Gerald Peters Gallery,
Santa Fe, New Mexico

74. *Series I: Near Abiquiu, N.M. – Hills to the Left,* 1941
Oil on canvas
30.5 x 76.2 cm (12 x 30 in.)
Private collection. Courtesy of Ira Spanierman
Gallery, New York
(Exhibited in London)

75. *Soft Gray, Alcalde Hill*
(Near Alcalde, New Mexico), 1929–1930
Oil on canvas
25.7 x 61.3 cm (10⅛ x 24⅛ in.)
Hirshhorn Museum and Sculpture Garden,
Smithsonian Institution. Gift of
Joseph H. Hirshhorn, 1972

76. *Winter Cottonwoods East No. V,* 1954
Oil on canvas
101.6 x 76.2 cm (40 x 30 in.)
Courtesy of The Gerald Peters Gallery,
Santa Fe, New Mexico

77. *Winter Trees, Abiquiu I,* 1950
Oil on canvas
61 x 50.8 cm (24 x 20 in.)
Private collection

78. *Winter Trees, Abiquiu No. II,* 1950
Oil on canvas
65.4 x 75.6 cm (25¾ x 29¾ in.)
Courtesy of The Gerald Peters Gallery,
Santa Fe, New Mexico

79. *Wall with Green Door,* 1952
Oil on canvas
76.2 x 121.6 cm (30 x 47⅞ in.)
In the collection of The Corcoran Gallery of Art.
Gift of The Woodward Foundation

80. *Ladder to the Moon,* 1958
Oil on canvas
101.6 x 76.2 cm (40 x 30 in.)
Collection Emily Fisher Landau, New York

81. *Patio with Green Leaf,* 1956
Oil on canvas
91.4 x 76.2 cm (36 x 30 in.)
The Georgia O'Keeffe Foundation

82. *Pelvis Series – Red with Yellow,* 1945
Oil on canvas
91.4 x 121.9 cm (36 x 48 in.)
Private collection

83. *Winter Road I,* 1963
Oil on canvas
55.9 x 45.7 cm (22 x 18 in.)
The Georgia O'Keeffe Foundation

84. *Blue B,* 1959
Oil on canvas
76.2 x 91.4 cm (30 x 36 in.)
Milwaukee Art Museum. Gift of
Mrs. Harry Lynde Bradley

85. *Sky Above White Clouds I,* 1962
Oil on canvas
152.4 x 203.2 cm (60 x 80 in.)
National Gallery of Art, Washington, D.C.,
Alfred Stieglitz Collection. Bequest of
Georgia O'Keeffe, 1987.58.8

86. *It Was Yellow and Pink II,* 1960
Oil on canvas
91.4 x 76.2 cm (36 x 30 in.)
The Cleveland Museum of Art.
Bequest of Georgia O'Keeffe, 87.137

87. *Drawing III,* 1959
Charcoal on paper
47.3 x 62.5 cm (18⅝ x 24⅝ in.)
The Georgia O'Keeffe Foundation

88. *Drawing IX,* 1959
Charcoal on paper
62.5 x 47.3 cm (18⅝ x 24⅝ in.)
The Georgia O'Keeffe Foundation

89. *Drawing V,* 1959
Charcoal on paper
62.5 x 47.3 cm (24⅝ x 18⅝ in.)
The Georgia O'Keeffe Foundation

CREDITS